Expressive Photography

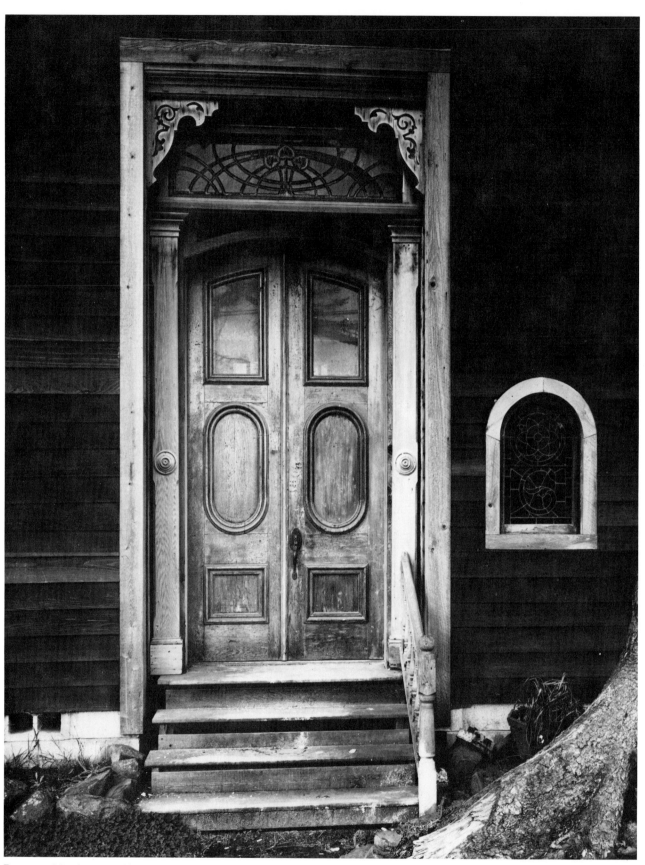

Doorway, Mendicino, California. Uncropped image from 4 x 5 negative exposed on an overcast day by the author.

Expressive Photography

Lou Jacobs Jr.

Goodyear Publishing Company, Inc.
Santa Monica, California

Library of Congress Cataloging in Publication Data

Jacobs, Lou.
 Expressive photography.

 Bibliography: p. 251
 Includes index.
 1. Photography — Popular works. I. Title.
TR149.J27 770 78-15600
ISBN 0-87620-283-0

Y-2830-1

Current printing (last digit):
10 9 8 7 6 5 4 3 2 1

Production Editor: Linda G. Schreiber
Copy Editor: Edward Day
Cover and Text Design: Don and Debra McQuiston

Printed in the United States of America

Contents

Introduction 1

1 What it Is, What it Ain't 9
Personal Expression 9
Impersonal Expression 12
Record or Interpret 15
Please Yourself First 18
Self-assignment 23
Chapter Checklist 24

2 Styles in Photography 27
Know the Past 29
 A Thumbnail History 29
Literal or Romantic, Sharp
 or Soft 32
The Creative Camera Eye 34
Style Is You 37
Chapter Checklist 39

3 Equipment and Creativity 41
Process and Perception 41
Cameras and Lenses 42
 Camera Formats 42
 Lenses and Focal Length 47
Color and Black-and-White
 Films 48
 Film Developing 48
 Black-and-White Printing 50
 Film Brands and Types 50
Photographic Accessories 50
Print and Slide Presentation 53
A Final Note 55
Chapter Checklist 55

4 In Transition 57
Increasing Awareness 59
Color Versus Black and White 60
Chapter Checklist 63

5 The Imitation Snapshot 65
Winging It 65
 Courting Chance 68
 Without Apologies 71
In the Snapshot Style 73
Snapshots, Pro and Con 75
New Directions 81
Chapter Checklist 81

6 Street Photography 83
The Street Look 85
People and Patterns 88
Humor and Distortions 94
Picture Projects 97
Chapter Checklist 99

7 Scenics and Studies 101
Realism and Sharpness 102
The Purist Tradition 105
Small-Format Exploration 106
Including People 109
Excerpting Reality 112
Still Life and Close-ups 115
 Close-ups 116
Chapter Checklist 119

**8 Social Comment and
Reportage** 121
Documentary Photography 122
 Social Comment 125
Meaning and Message 128
The Law and Self-Expression 131
Reportage 132
 Personal Reporting 132
Chapter Checklist 140

**9 Optical Illusions,
Patterns, and Abstractions** 143
Optical Illusions 143
Lens Illusions 145
The Beauty of Blur 149
Zoom Techniques 153
Abstracting Reality 154
Close-ups and Other Patterns 156
Chapter Checklist 157

**10 Fantasy, Symbolism, and
 the Bizarre** 159
Fantasy 159
Forms of Fantasy 161
Symbolism 162
The Bizarre 171
The Intentionally Obscure 173
The Empty Image 175
Chapter Checklist 177

11 Sequences 179
Sports 179
Stories 181
Obscurity and Guile 182
Chapter Checklist 185

12 The Nude 187
The Problems 187
Visual Solutions 190
Psychological Connections 193
Working with Models 199
Chapter Checklist 201

13 Portraits and Self-portraits 203
Likeness Portraits 203
Interpretative Portraits 204
Environmental Portraits 208
Story Portraits 210
Self-portraits 217
Chapter Checklist 221

**14 Multiple Images and
Darkroom Fantasies** 223
Multiple Exposures in
 the Camera 223
 Multiple-Image Techniques 225
Sandwiching Slides 226
Multiple Exposures in
 the Darkroom 227
A Master of Multiple Imagery 232
Photograms 235
The Sabattier Effect 239
 Reexposing Prints 241
Reticulation 243
Posterization 244
In the End 247
Chapter Checklist 248

Bibliography 251
*Vestal's Dictionary of
 Photo Obscenities* 255
Index 261

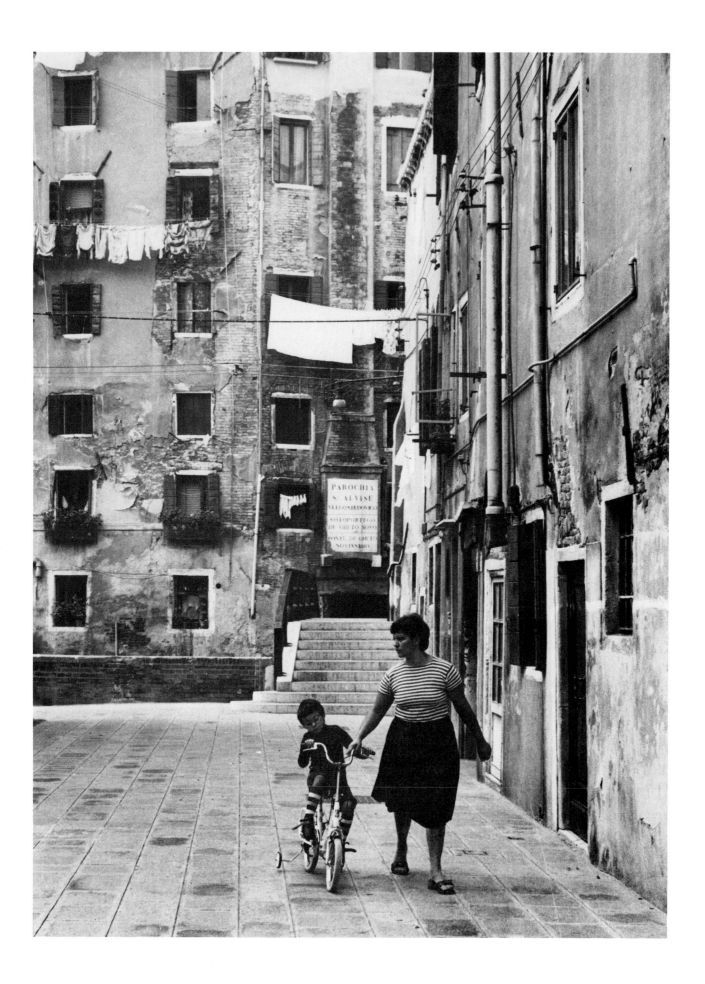

Introduction

In the past several years I've considered various titles for this book, ranging from *What to Do with a Camera* to *Exploring in Photography, Personal Adventures in Photography*, and *Set Yourself Free in Photography*. These I mention in order to better illustrate the nature of *Expressive Photography*, the title I finally chose. My objectives are as follows, and I hope they make lights flash and bells ring in your mind:

1. You can do whatever you want to with a camera; possibilities in the darkroom are also extensive. The important thing is to be aware of the numerous options. To explore these potentials farthest, you may have to pass through some mental roadblocks, which is how this book could be of some help.

2. Picture-taking may well be a lot more fun than it is now.

3. Prints and slides of any subject can be more exciting and satisfying. If your images elicit comments because they are odd, strange, or curious, that's satisfying: uniqueness is a celebration of individuality.

4. There are myriad styles of photography to explore, many of which are illustrated in this book along with do-it-yourself guidelines.

5. If you're relatively unskilled with a camera, experience is the remedy. It's feasible to work with an instant-load or instant-picture camera, but the name of the game is *control*, and this is best achieved with a single-lens reflex camera or any type with interchangeable lenses.

6. Seeing and feeling go together in the creation of pictures you may never have thought of taking.

7. The technical and creative aspects of photography can be learned and exploited at the same time. The mastering of technique doesn't make an "artist," but it does afford greater freedom to explore and take chances.

8. It's valuable to be aware of images made by other people. To be influenced by pictures you may have seen in books, magazines, or exhibitions isn't copying. Every photographer has been influenced at one time or another, but the influences are absorbed and become part of the individual. No two people see things exactly alike.

9. Visual imagination has no boundaries. No matter how unconventional the image, it can probably be shot, or created in the darkroom.

10. Photography is a marvelous medium because it offers so many avenues to

1—Wherever you go, at home or abroad, the challenge of photography offers pleasure and fulfillment. This street scene was captured in Venice, Italy.

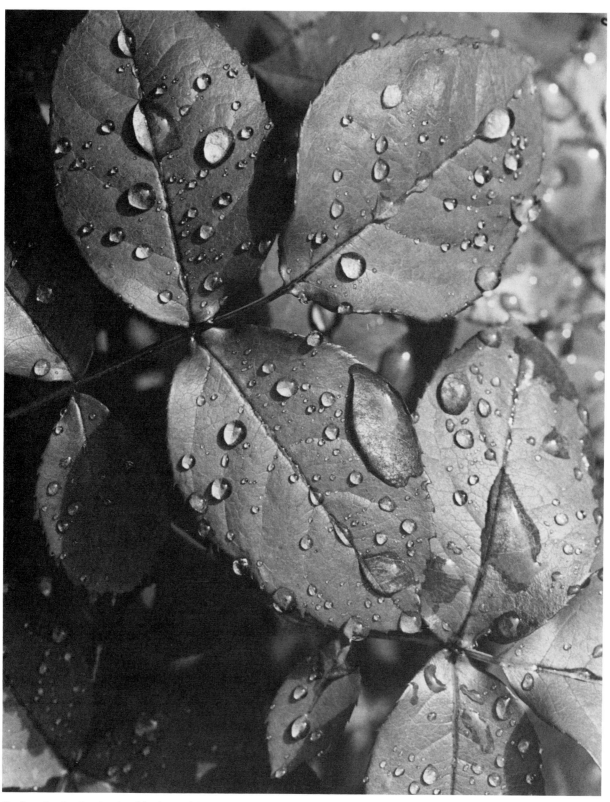

2—Imagination is stimulated by beautiful patterns and relationships of form and tone, as embodied by leaves after a fresh rain.

self-expression—through cameras, lenses, films, papers, and, most of all, imagination.

11. The key to discovering your own potential is to *do* your own thing; don't just talk about it.

Visual vs. Verbal

It may occur to you as it has to me, that trying to evaluate visual images by verbal means is often difficult. It's easy to become tangled in a web of misleading and presumptuous words. In this book I'll try to avoid ambiguous, fancy language. Verbal gymnastics annoy me, especially when employed by critics and photographers trying to explain the cerebral process. I'm turned off when photography is made out to be some kind of a mystique.

What makes a picture distinguished? Make your own decisions as you read. I'll discuss images I feel have merit, and some that do not. My choices may help you to discover values in your own pictures, as well as to assess photographs by others. You don't have to agree with me in order to develop and trust your own aesthetic views.

I see a lot of pictures that are proclaimed "outstanding" for one reason or another, but which actually seem inferior and sometimes even phony. This suggests that the language of photographic criticism which has evolved from criticism of other forms of self-expression can easily lead to confusing frustration. Critics, curators, and gallery owners have their right to praise the outrageous or the profound; they can extol or condemn as they see fit. Photographers are free to exhibit the ridiculous or the sublime in conventional or bizarre format. The viewer must retain an open mind while sharpening his or her discernment of visual deception.

3—Photograph in response to your feelings, and evaluate your pictures without inhibitions or formulas. A serious snapshot has its own validity.

4—Is it artistic or arty? If a picture pleases you, labels are unnecessary.

Make an effort to think for yourself. To avoid superficiality, you must first identify it.

There's no such thing as instant visual awareness. Professor Robert Routh of the California State University at Long Beach tells the story of taking his History/Criticism of Photography students to a photo gallery, where many are "thrown into a virtual rage," he explains, "by the audacity of a gallery director who presents much of the gallery contents as 'worthwhile.' This attitude is inevitably changed during the course of the semester as the many possibilities for perceiving photographs become obvious. It's always a minor miracle to see anger supplanted by understanding and appreciation."

A related transformation has come over me as I worked on this book. Though I do not identify individuals by name whose work I don't like, I do point out styles I dislike. Such judgments lead to healthy differences of opinion, change, stimulation, and growth.

A Theme

There are many valid ways of seeing, recording, interpreting, and expressing yourself with a camera. If you haven't explored them all, it doesn't mean you're in a rut—but perhaps that's how you feel. A rut can be misleadingly comfortable, especially when the things you do well (and thus do over and over again) are accepted by viewers. If such is the case, you'll find new paths to self-expression in this book. Give yourself the gift of creative excitement.

I want to *provoke* you into feeling more freedom to take better pictures. Most of us have photographic inhibitions, and if you feel a bit uneasy while glancing at the pictures in this book, it could be a sign you're ready for a

change. I hope you will find stimulation in the smorgasbord of image styles included in each chapter.

But in order to explore the new and unusual, you must first be confident about the fundamentals of photography. Learn to take conventional-type photographs, then begin experimenting. Probe your mind and emotions for inventive forms, compositions, symbols, and relationships. It won't hurt to bite off more than you can chew; just figure out ways to be encouraged by failure.

Over the years I've discovered that changes in taste are constant—in other words, value systems are always in a state of flux. For example, a few years ago I made a number of black-and-white prints from half a dozen rolls of film taken on a visit to New York. A few months ago I was looking at those New York proof sheets again and discovered the image in photo 5. Why, I asked myself, hadn't I printed it previously? It appeals to me now because my visual perceptions and sensitivities have changed. I see photographic images differently than I did several years ago. My consciousness has expanded, and I now appreciate new visual approaches. My basic aesthetic values haven't changed, but I can apply them more flexibly. Even so, I don't get starry-eyed at photographic "inner vision" or pictorial obscurity, no matter how lavishly it's praised or sanctified on gallery walls or printed pages. One man's beauty is another man's garbage.

5—Once passed over, this image was later discovered and enjoyed when my aesthetic values changed.

The Risks You Take
If you have the time and the equipment, the only thing standing between you and self-expression is—you! Where's your curiosity? One way to improve anything is to take risks and make mistakes.

You'll enjoy photography more if you:

- Accentuate the positive. (Avoid thinking, "There's nothing new to photograph around here.")
- Analyze the photographs you see. Strong likes and dislikes are healthy, as long as you're open-minded, too.
- Take pictures regularly.
- Work in the darkroom whenever possible.

Be critical of your own work, but don't be shy about images that please you: it's healthy to like something you've created. And stop playing it safe. Experiment, and stretch the limits of photography. What can you lose?

Checklist

1. As camera and darkroom skills increase, you should be willing to try anything you've seen or imagined, in any style or combination of techniques.

2. To be influenced by the photographs of others is not the same as copying. Influences are absorbed and become part of the individual.

3. Photography is a dynamic medium, despite its seeming simplicity.

4. Trying to evaluate visual images by verbal means often causes communication problems.

5. Make a list of words that describe both outstanding and mediocre photographic images. Compare your definitions with those of friends or colleagues.

6. The perception of style, content, and technique in photography changes as one's consciousness grows.

7. Take risks and invite criticism, for in this way you increase your potential.

6—A multiple exposure on film that is reexposed during development involves taking risks, with visual excitement as the payoff. Technical details for this type of photograph are discussed in chapter 14.

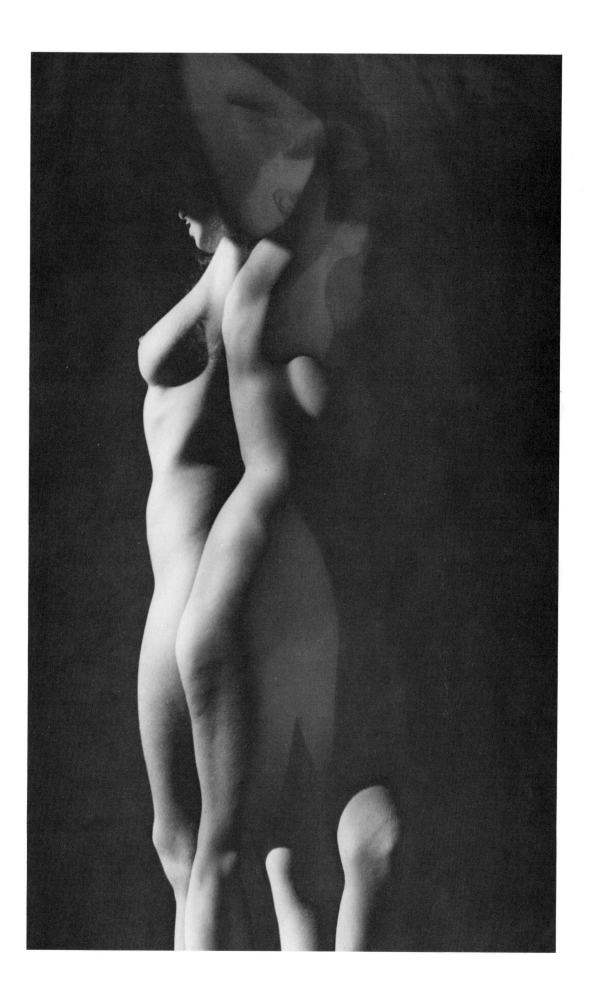

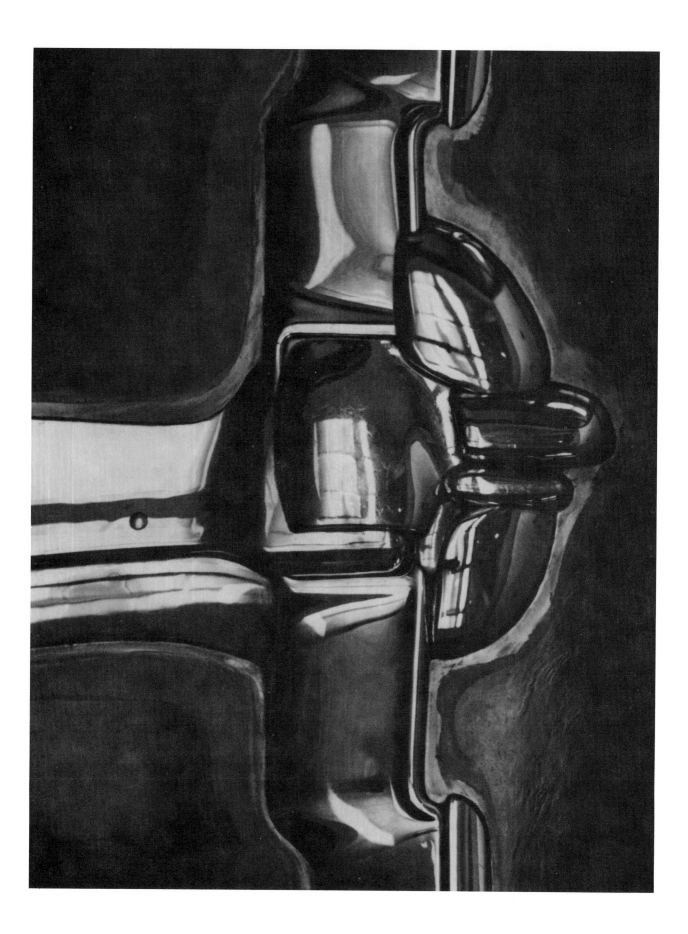

What It Is, What It Ain't 1

I've borrowed the title for this chapter from Cam Smith Solari, a friend of mine who wrote and illustrated a book about her experiences as a teacher called *What It Is, What It Ain't*. Here I want to make a distinction between personal and impersonal approaches to photography. My definitions are somewhat subjective but will serve as points of reference.

Personal Expression
Personal expression in photography includes the many kinds of self-fulfillment provided by a camera in addition to subsequent efforts in the darkroom. In this broad category, images are self-originated and self-directed. Expressive photographs may not be taken primarily with the marketplace in mind, though many prints and slides do eventually find buyers.

Styles and subjects of personal expression are numerous and may include anything that appeals to the photographer. If you like an image for one or more reasons—because it's beautiful, experimental, imaginative, mysterious, bizarre, or emotionally revealing—it

1—Michael N. Carpenter won a Kodak International Snapshot Award for this imaginative photograph of a bumper sculpture created by Sidney Buchanan. Mr. Carpenter made a strong composition in mixed incandescent light and daylight using a 135mm lens on a single-lens reflex camera loaded with Vericolor II film. This black-and-white image was made from the Vericolor negative.

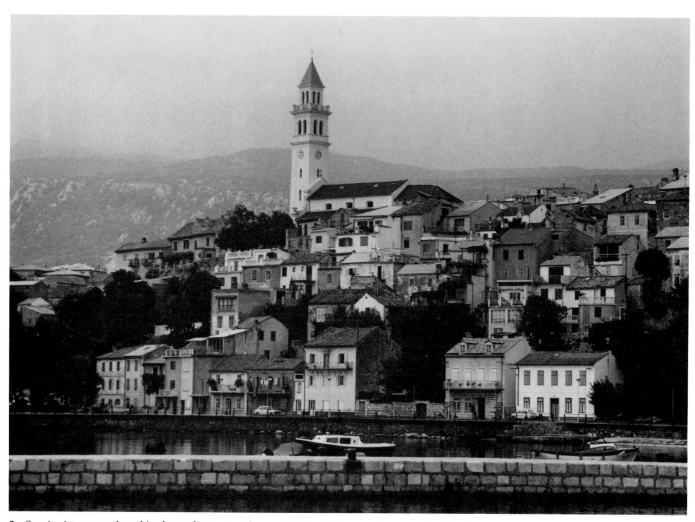

2—Scenic pictures, such as this photo of a town on the coast of Yugoslavia, may be conventional and aesthetically individual at the same time.

really doesn't matter if you can explain it to others. When you're turned on to a print or slide that nobody likes, chances are you'll reevaluate it eventually.

The "conventional" photograph also takes many forms. It may originate from a personal, inner urge, but it's usually a recognizable subject with a fairly traditional composition. The scenic picture is the best example of a traditional approach, and there's nothing wrong with it—unless of course it starts boring you. If so, find ways to see landscapes, seascapes, or cityscapes in new and unusual lights. This may mean trying new camera angles, unusual filters or films, more daring compositions, or other intriguing experiments. The same evolution applies to portraits and most other topics.

The snapshot is the most familiar type of photograph. *Webster's Dictionary* describes it as "a casual photograph made typically by an amateur with a small hand-held camera and without regard to technique." We might also define a snapshot as "a dirty eight-letter word." Such images have meaning to the picture-taker and the subject but rarely have lasting aesthetic value. When the photographer has mastered the basics, he or she usually feels superior to those unsophisticated souls who can't do better than snapshoot. Millions of people are happy merely with "clear" prints or slides. When their pictures don't "come out," they get upset without realizing that the fault may lie with camera movement, poor focus, exposure errors, and related ineptitude. On the other hand, when a snapshot has any semblance to artistry in the maker's eyes, it is enlarged, framed, hung, and cherished.

We'll get into this again in chapter 5. For the moment it's fair to say that the average snapshot is made without visual awareness. The

3—The average snapshot captures a memory on film; it's a visual record without pretense.

amateur uses a camera like the beginner plays the piano—with one finger. The only visible asset is spontaneity, which can be learned and exploited with an educated instinct the snapshooter doesn't enjoy.

There's another facet of expressive photography that I consider to be important, and that is *serendipity*. The word embodies one of my favorite aspects of life and is defined in the *Random House Dictionary* as "the faculty of making desirable discoveries by accident." As visual acuity improves and more photographic chances are taken, the ability to exploit serendipity increases. You'll hear more about this throughout the book; it's related to being lucky, but it's not quite the same thing.

Impersonal Expression

This section might also be called "Photography Primarily for Profit." It's taken for granted that those who make a living with a camera use their talent, technique, and training as deftly and artistically as possible. But the professional photographer takes pictures to please others, usually clients; the opportunity for personal statement rarely presents itself in commercial situations. However, there are instances when personal creativity prevails in photography for profit.

Commercial portraits. Photographs of individuals and groups shot in a studio or on location usually attempt to flatter the subjects. Many portraits are taken by applying a formula for lighting, poses, and backgrounds, and often these images are retouched. This is *not* meant as a put-down, but merely to point out that portrait and wedding photographers have limited opportunity to experiment and

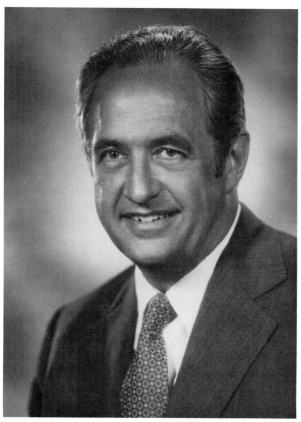

4—A commercial portrait usually is made to please the subject and is rarely a means of self-expression for the photographer. This is an Eastman Kodak executive photographed in the best tradition of the commercial medium by a Kodak photographer.

express aesthetic urges and may be loath to take chances. They shoot pictures to please the conditioned tastes of clients who rarely want something "different."

Product and advertising photographs. Companies selling everything from breakfast foods to insurance use the camera for its powers of persuasion. Thousands of excellent pictures are taken to sell products, build reputations, create moods, and stimulate business. This type of photography can be highly skilled and very effective, but it just isn't self-expression as defined within the context of this book. Though commercial photographers may fulfill their inner needs and do well financially, visual tastes other than their own must be satisfied first while on the job. I've often heard successful colleagues explain, "I shoot pictures to please *myself* on weekends."

Postcard and stock photographs. The phrase "pretty as a postcard" is meaningful to many people and usually connotes a kind of formal pictorialism. I've shot a lot of scenics that could have served as postcard illustrations and still enjoyed the satisfaction of self-expression. Eventually I discovered that while good postcard and stock photographs can be impressive personal statements, too often they are static, trite, and dull. It comes down to a matter of whether the photograph records or interprets, which I'll discuss shortly.

5—Warning: Postcard pictures may be hazardous to your aesthetic health when they are nothing more than trite, pictorial records such as this of Mission Santa Barbara.

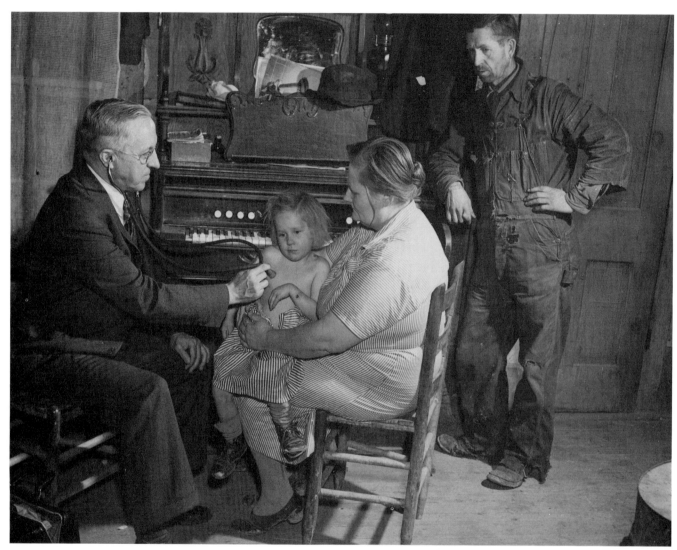

6—In 1942 John Vachon (who later became a top *Look* photographer) photographed a doctor making a house call in Scott County, Missouri, for the Farm Security Administration, which began its famous documentation of America in 1936.

News and reportage photography. A news photographer often must shoot expeditiously to capture a fire, celebrity, or event on film. Instinct and speed are important, along with a sense of instant composition. If time permits, the newspaper photographer may arrange more careful illustrations and make editorial portraits, adding imagination and creating images that have some depth of meaning.

When a photographer works for a publication or client with longer deadlines than those required by a newspaper, he or she has more of an opportunity to make a personal statement that also satisfies an editorial need. The great picture essays published in *Life*, *Look*, *National Geographic*, and other magazines, as well as in many photo books, are examples of interpretative photojournalism. The work of W. Eugene Smith is outstanding in this respect. Smith's intensity and perception motivated him to shoot pictures that satisfied his own emotional compulsions, and his talent made those images beautiful, forceful, and of lasting value.

When a photographer can work with creative freedom, the line between commercial and personal expression is slim or nonexistent. In chapter 8 we'll discuss the Farm Security Administration (FSA), a government agency of the 1930s and '40s which hired a relatively small number of men and women to document the effects of the Great Depression. These men and women lifted the realistic documentary photograph to the level of art, largely because their camera work was both personal and functional. If you are not familiar with the FSA, look for a book called *In This Proud Land* by Roy Stryker, who headed the photo project; he selected several hundred of the best images. In *A Vision Shared*, compiled by Hank O'Neal, are many other FSA pictures by eleven photographers.

Record or Interpret

Why do we take pictures? Think about this answer: We use a camera either to *record* or to *interpret* a subject. That's a simple statement, but what does it mean? Here are my views.

During the picture-taking process, and afterwards when we evaluate images, we must visualize and understand the differences between recording and interpreting. To record a subject, emphasis is placed on showing it "the way it is." On a recent European trip, I often turned (almost apologetically) to my

7—Switzerland is a photographer's dream where one must apply individual vision in order to make the extraordinary scenery more personal. This was taken with an 80–200mm zoom lens set at 200mm.

wife and said, "I photographed it because it's there." "It" may have been a scene in the Alps, a canal in Venice, or a view of the Parthenon. I tried to see these subjects with some kind of personal vision, but chances are I shot pictures similar to those taken by thousands of tourists. I had merely recorded scenes, but I enjoyed doing them my way.

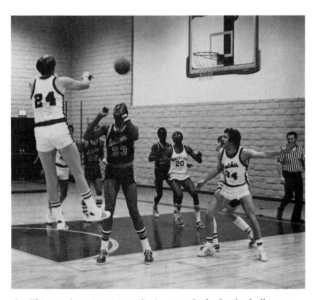

8—This peak-action journalistic record of a basketball game tells a factual story.

When a subject is interpreted, its image filters through the photographer's consciousness and is influenced by imagination. Let's compare recording and interpreting in three pictures taken at a high school basketball game. In photo 8 I recorded an exciting play by shooting at moments of peak action. My intent was to show it like it is, trying for a pleasing and effective view of the action.

I also experimented with more impressionistic images. Photo 9 was taken with a slow shutter speed, such as 1/15 or 1/8 second, as the camera was panned or moved in conjunction with the action. I knew there would be blurring, so I shot a lot of these, anticipating patterns as well as possible but knowing serendipity would take a hand in the procedure. In photo 10 I zoomed a 65–135mm lens during a half-second exposure for another kind of interpretation. (These techniques are discussed in chapter 9.)

In a situation closer to home, try photographing a child's birthday party. While the kids are seated around the table eating ice cream (funny hats and all), ask them to look your way as you snap the shutter. If the group is in focus and your exposure is okay, you'll have a meaningful record of the occasion. You might also want to circle the table, photographing the kids as they have fun, trying not to be conspicuous. This way you can interpret journalistically the mood and atmosphere of the party. Then you'll have pictures of how the scene *looked* in addition to an impression of how the children were *feeling* at the time.

Of course, there's often an overlap between recording and interpreting, for a fine photographic record may be both expressive and artistic. Examine the beautiful nature images of Edward Weston or Wynn Bullock, or the incisive documentary photographs by Walker Evans, whose career began with the Farm

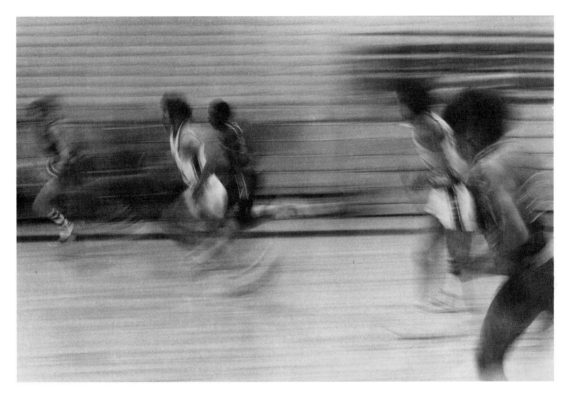

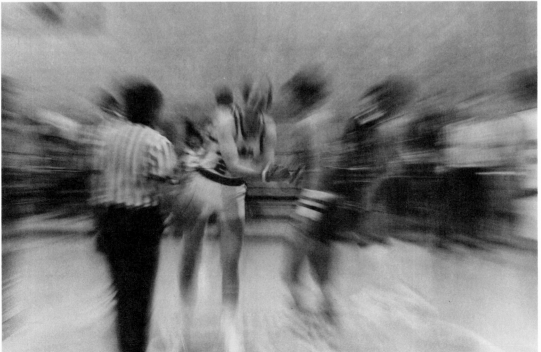

9 (top)—A slow shutter speed creates an impressionistic image of the same basketball game.

10 (bottom)—Zooming the lens during a half-second exposure is another means of manipulating reality.

Security Administration. When the photographer tempers reality with imagination and is sensitive to design, symbols, and human emotions, his or her images may well have lasting aesthetic value.

Please Yourself First
Let's examine certain expectations. A commercial photographer can please a client with sharp, well-lit, neatly composed prints and slides. A news photographer doesn't have to worry about whether or not his pictures are "art," as long as his sense of timing is good and he gets the event on film. The fine-art photographer tries to interpret hidden meanings and may consider the photograph to be a symbolic metaphor (see chapter 10). In direct contrast to the commercial or news photographer, fine-art image-makers usually are unconcerned with viewer comprehension of their pictures.

Whether you shoot a subject to show how the eye perceives it (recording) or use an approach or technique that includes mystery, distortion, or some other quality of the imagination (interpretation), your first loyalty is to your visual sense, no matter what stage of sophistication it happens to be in. This is called self-stimulation—taking pleasure in making pictures, with the camera or in the darkroom. And these pictures can be enjoyed without outside restrictions or inhibitions. In doing, the photographer grows and learns to distinguish a good record from an artistic interpretation.

The mixture of success and pleasure begins when you see—or visualize—something that could make a likely photograph. First responses tend to be emotional and then become more intellectual as the image is viewed through the finder. The photographer's senses then begin to evaluate the relationships

11—When she was asked by a young friend to take his picture, Helen Miljakovich felt what she called "coiled-up tension." She tried to show her impression in the pose and composition.

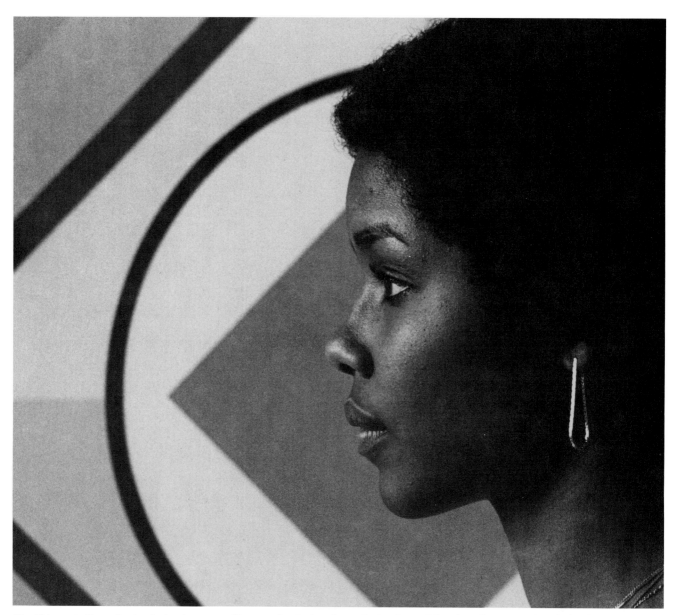

12—This portrait, made simply to please myself, came about when I posed a lovely model against the geometric painting in the background. The Konica Autoreflex nT3 camera with 50mm lens was loaded with Ilford HP5 film.

of forms or people; expressions and colors are noted as he or she analyzes the design potential within the format of the camera. The mind should be open, the imagination flowing. During this creative process photographers realize that they will like only some of the images they shoot, but their enthusiasm isn't diluted. There's satisfaction in experimenting, knowing all along that "you can't win 'em all."

Ask yourself these questions: "What creative urge am I trying to realize with a camera?" "Why do I take the pictures I do?" "What kinds of images or subjects am I looking for through the viewfinder?" "What am I missing?" The answers can be revealing when you dig into your consciousness and are honest with yourself. It's certainly acceptable to be happy with the slides and prints you produce and not to want to change your approach. If that's the case, be sure you're enjoying the results, but continue to examine your motives.

Most picture-takers want to make new discoveries in personal photography and hope to achieve greater expressive dimensions and visual meaning. Don't get tangled in the semantics about being "original." If you admire a particular style or technique, give it a try. It's not illegal or immoral to attempt what others have done; your own imagination, or personal twist, will give individuality to pictures that otherwise might not have been taken.

As you evaluate your prints and slides, avoid terms such as *good* or *bad.* They're loose, relative words coated with ambiguity. Decide first in what ways your images are successful. With this in mind, try to determine how they might be improved. Build on success, knowing it may take a while to achieve your expectations.

13—Taking risks with in-camera multiple exposures is a healthy and stimulating means of self-expression. It helps to expand your vision and imagination.

Self-assignment

Sometimes when I have the urge to use a camera and there's no place in particular I want to go, I'll wander through my own neighborhood. Looking at the obvious, I try to see beyond it. I'm sensitive to design, form, the play of light, the contrast in colors, and the interaction of people. On just such a stroll I focused on a shopping center under construction a mile from home. For deliberate discipline I decided to shoot from a tripod. As I explored the subject I intentionally shot several double exposures, one of which is photo 13. Since there were few people around, I concentrated on abstract compositions of unfinished buildings, and the subject turned me on. From the roll I exposed, most of the frames will not be enlarged, but I felt free to experiment. The "risk" of failure was nonexistent. I decided to suit myself, which I find a nonthreatening way to fill a creative need.

When you originate photographic projects, select material from what you see, and add a model when it seems appropriate. Personal, expressive photography has no clients to please; its success is not measured in dollars and cents. Rather, it evolves from the pleasure of photography and from *images* that please. You have choices. You have freedom. With these and motivation, you can be expressive in your own style. When the urge to photograph isn't there, muse in the sun or meditate under a tree; don't force the creative process.

However, be aware that there are pictures wherever you go. The girl next door or even your own child may be a fine model. A vacant house or a yard nearby can be a terrific set. Streets, tidepools, junkyards, museums, or bridges—all these and more may stimulate your visual interest, close up or at a distance. Your skill at composition will grow with your judgment about what makes satisfying, exciting, expressive photographs. You'll develop sensitivity through both the commonplace and the esoteric.

Keep your mind open. Give wings to your imagination.

Chapter Checklist

1. Personal expression in photography is attained through images that are self-originated and self-directed. However, there's also satisfaction in taking pictures for the marketplace.

2. Conventional photographs include scenics, snapshots, and portraits. Traditional approaches evolve as time passes.

3. Serendipity is the faculty of making desirable discoveries by accident. But it also helps to aim yourself in a certain direction; otherwise, lucky accidents may go unrecognized.

4. Impersonal expression is a reference to, among other things, commercial portraits, product and advertising pictures, and news photography.

5. Passionate involvement with subject matter (in the manner of W. Eugene Smith and certain Farm Security Administration photographers) is a quality that can lead to distinguished pictures.

6. To *record* a subject, emphasis is placed on showing it the way it is without special pictorial emphasis. When a subject is *interpreted*, it filters through the photographer's imagination enabling the viewer to "see" beyond the factual image on paper and to share in the aesthetic consciousness that created it.

7. Please yourself first—others come later.

8. Slow shutter speeds and exposure zooms are just two of the many ways to interpret with a camera. Used thoughtfully for visual effects, these techniques are stimuli, not gimmicks.

9. Analyze the terms *good* and *bad*, and then abandon them.

10. Self-assignments are low-risk challenges which often produce satisfying, creative photographs.

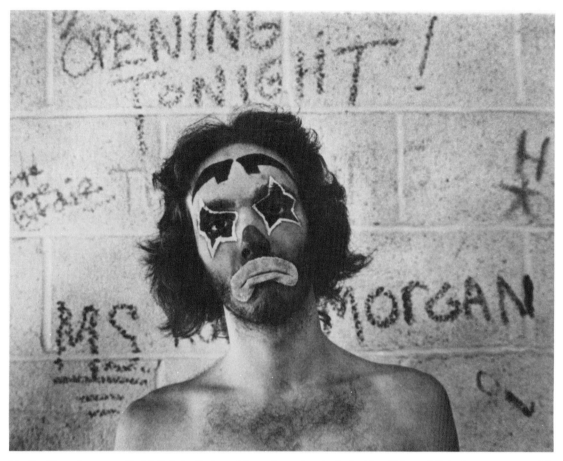

14—Jan Heyneker won a Kodak/Scholastic Award for a planned portrait of a friend taken while both were on a special arts/study program. Jan chose a background in keeping with the model's makeup.

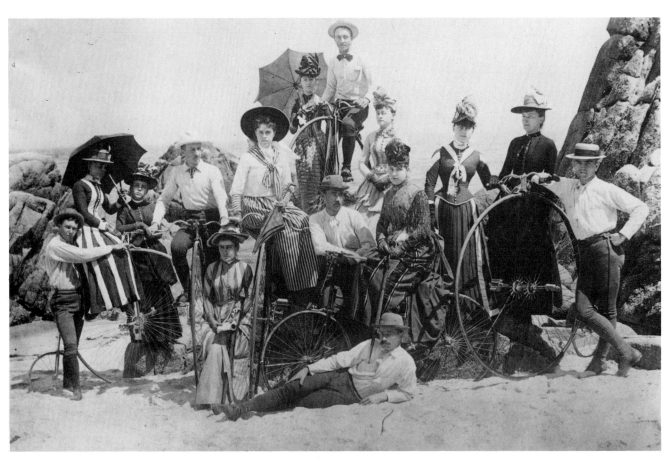

1—Snapshots taken at the turn of the century are fascinating today because of the clothing and poses.
Courtesy of the California State University Library Collection.

Styles in Photography 2

Style in any creative medium is the personal stamp of identity an artist puts on his or her work. It's a way of seeing and interpreting unique to the individual. Where photography is concerned, style involves the visual character of the work evident in its composition, lighting, spontaneity, or subject matter. A photographer's style may be influenced by the approaches others have used, but usually distinctions evolve from the ways in which he or she solves a visual problem.

Style doesn't necessarily mean trying to be "different." There are a lot of successful, outstanding photographers whose photographs cannot be picked from a group because their styles aren't especially recognizable. Trying to develop a style for its own sake is an affectation that could undermine your best efforts. It's far more important to become familiar with the wide variety of styles in both photography and painting. With this knowledge you'll be more inclined to experiment with several styles. By creating problems for yourself and trying to solve them with a camera or in the darkroom, you'll find an identity of your own. Just remember to please yourself first. Let your imagination be your only guide, self-appraisal your primary critic.

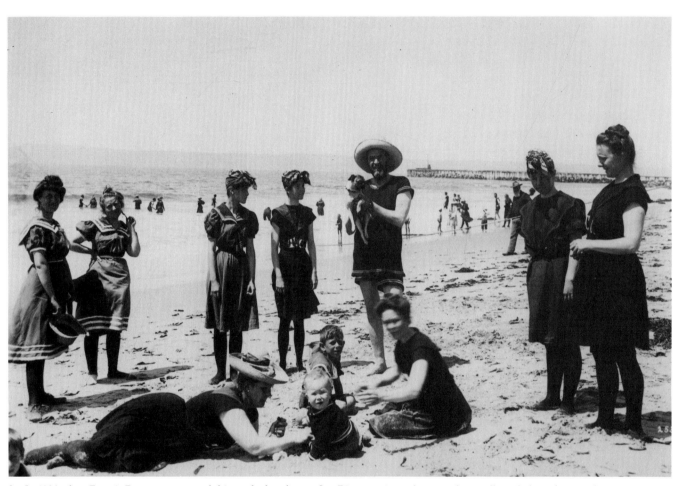

2—In 1904 when Francis Patterson snapped this on the beach near San Diego, serious photographers still used glass plates and large cameras on tripods. Courtesy of Historical Collection, Title Insurance and Trust Co., San Diego, California.

Know the Past

There's no way to overemphasize the value of becoming familiar with the photographic legacy bequeathed to us by many hundreds of photographers working in the medium from the early nineteenth century to this very day. These visual gifts record styles that history has passed by and styles that still stir the senses. Both the beautiful and the profane offer valuable lessons to increase visual awareness.

In studying the history of photography, you'll discover that, while technical innovations have continued unabated, the nature of the medium hasn't changed much in theory since its "official" birth in 1839 with the announcement of the daguerreotype. The basic process was and is to capture images on sensitized materials in a lighttight box with a lens mounted to it. You'll also discover that photography and painting have always had a lot in common, though the two mediums borrow from each other and thereby create artistic and critical conflict.

A Thumbnail History

Early photographers had no film as we know it today. They used metal plates coated with chemical mixtures that when developed produced poisonous fumes. Their images were rather faint and one of a kind. Later there were glass-plate negatives, but they too had to be coated and exposed while wet. Cameras were cumbersome, and photography was almost the exclusive domain of professionals and rich hobbyists with strong backs.

With these "primitive" tools, Matthew Brady and his colleagues recorded the Civil War, and William Henry Jackson literally put Yellowstone Park on the map with his beautiful shots of pristine wilderness. These early images are photographic documents which artistically mirror history.

In the 1880s photography became accessible to the average person with the introduction of the hand-held camera and roll film by George Eastman. By the beginning of the twentieth century millions of people were able to take snapshots of their families or any other subject —if there was enough light. Eastman's slogan proclaimed, "You push the button, we do the

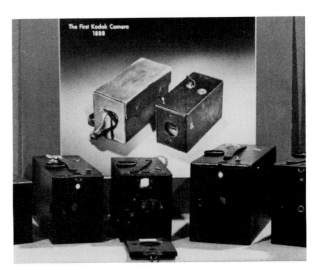

3—Some of George Eastman's first Kodaks. Box cameras helped spread photography to millions of people.

rest." This may not have encouraged creativity, but it made photography Everyman's pictorial medium.

Today's space-age techniques and hardware would amaze and confuse Daguerre and Eastman, but there were photographers before the turn of the century who stretched the possibilities of the medium. By 1856 Oscar G. Rejlander (1813–1875), a Swedish painter who studied in Rome and worked in Paris and London, was making large composite prints from several negatives. Photo 4 is a rather simple example of this called "Two Gentlemen Taking Wine." Rejlander became famous for his artificial scenes complete with retouching and arty atmosphere. He also experimented with combination prints. Photo 5, which is called "Spiritistical Photo," was made from two plates in 1860. Considering the limits on his materials and techniques, the multiple-image effect of photo 5 speaks well of Rejlander's inventiveness. (This personal approach will come up again before it's discussed more fully in chapter 14.)

The argument about whether or not photography is art began well before Rejlander arrived on the scene and hasn't ceased since. It's best to assume that photography is both an art and a craft rich in expressive potential. Styles that originated decades ago still thrive or periodically are revived. In the mere 150 years of camera images, there's an abundance of influences to study and follow, if you wish.

4 (opposite top)—By Oscar Rejlander: a composite somewhat less complex than those on which his reputation was built. From George Eastman House Collection.

5 (opposite bottom)—A multiple print by Oscar Rejlander made in 1860, when such imaginative use of the medium was rare. From George Eastman House Collection.

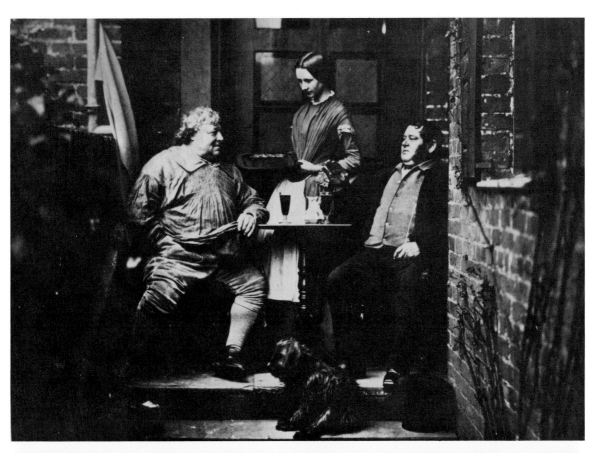

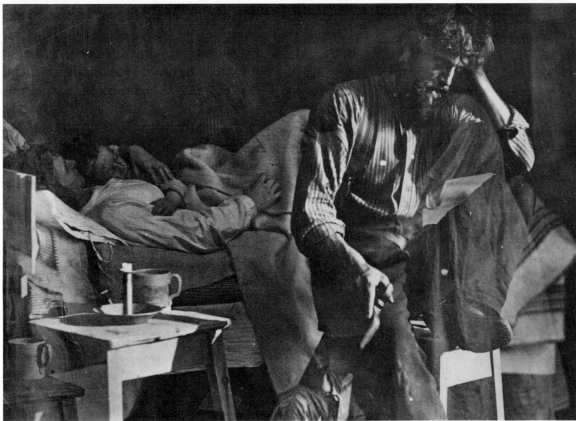

Literal or Romantic, Sharp or Soft

Though style in any creative endeavor should be dictated by the medium itself, painting has always had a great influence on photography. Camera-made images imitated paintings that were literal and precise or soft-edged and romantic. The art of the painter had stature, so emulating a widely accepted pictorialism was a natural reaction for many photographers. Along with Oscar Rejlander, another painter named Henry Peach Robinson also turned to photography, and his elaborately designed "art pictures" were acclaimed by many but rejected by others who found in them little "truth."

This brings up the old axiom, "The camera doesn't lie." And, to a certain extent, this is true: the *literal* eye of the camera depicts reality very clearly—the way it is. However, in the nineteenth century it was discovered that photography could create illusions as well, depending on the individual's subjective interpretation of the world. Great landscape and documentary photographers put the hard-edged core of reality on film, while soft-focus romantics played painterly games. Modern zoom-lens blurs, special-effect filters, and fisheye distortions lend another dimension to modifying reality, paralleling modes that painters have enjoyed for centuries.

Contemporary styles in design and painting, such as French Impressionism and German Bauhaus, revolutionized the arts, and photography dutifully followed suit. As abstract and surreal art caught public attention, photographers found their own medium more than capable of creating similar images, once again giving rise to the age-old question, "Is photography art?"

When you consider the enormous range of styles to be enjoyed with a camera and in the darkroom, the distinction between art in one medium and what it is in another becomes irrelevant. The point is still debated among critics and other trendsetters, and there never will be any unanimity about what types of photographs constitute art, but scoffing at the medium in general is a thing of the past. Critics have learned not to appraise photographs by the same criteria they use for paintings or block prints. "Pictorialism," or descriptive photography in the academic tradition, may still dominate some exhibitions, but there's no one "true" expression of the camera.

In the 1920s Edward Weston began taking strides toward giving stature to the literal

6 & 7—Photography may be literal one moment (photo 6, opposite left) and impressionistic the next (photo 7, opposite right). These were shot with a 75–150mm zoom lens during a half-second exposure. Photo 7 is titled "Electric Woman."

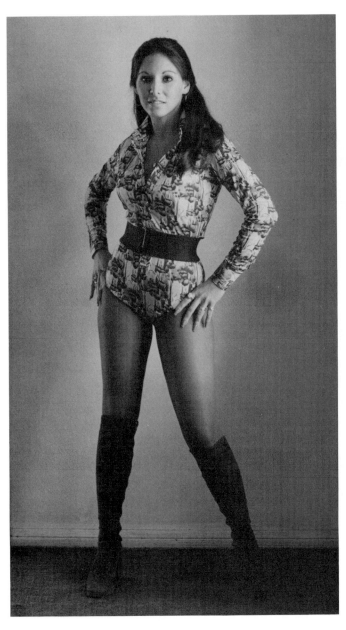

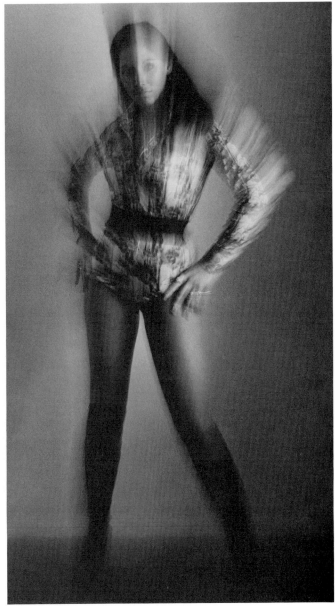

image that was also poetic. Man Ray began producing strange black-and-white prints without a camera by placing objects on sensitized paper and lighting them briefly from various angles. Alfred Stieglitz exhibited and championed both painters and photographers in his gallery and quarterlies. Edward Steichen melded the personal and the commercial with great success. In the 1930s *Life* and *Look* photographers gave maturity to photojournalism; but before that, Eugène Atget, Lewis Hine, Jacob Riis, and photographers of the FSA (see chapter 8) pioneered camera journalism and helped lift the interpreting of reality to an art form.

The pendulum still swings between popular and esoteric tastes, between the literal and the romantic, the sharp and the soft. However you choose to take pictures, if the images are stimulating to you, there will be others to enjoy them, too.

The Creative Camera Eye

Another term that is bandied about and often misused is *creativity*. What is really creative? Most people would agree that creativity is the application of innate talent to the achievement of images of some visual and artistic distinction. I say "some" because the degree of creative success varies.

Creativity breeds controversy. During a lecture, Man Ray is reported to have said, "All my life I've painted pictures so that certain people would drop dead when they looked at them." In effect, what this means is that Man Ray, photographer, painter, filmmaker, and major innovator of the twentieth century, enjoyed creating visual shock. However, his work was accepted because it had substance, whereas some photographs use visual shock solely for the sake of being unconventional.

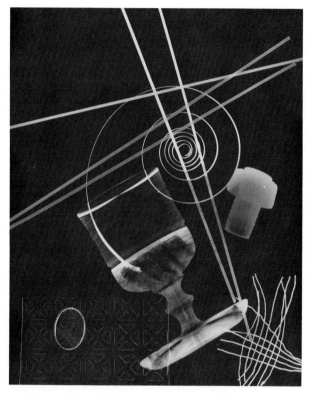

8—This photogram, like the type pioneered by Man Ray, includes a glass, a clock spring, a champagne cork, textured plastic, and sticks of uncooked spaghetti.

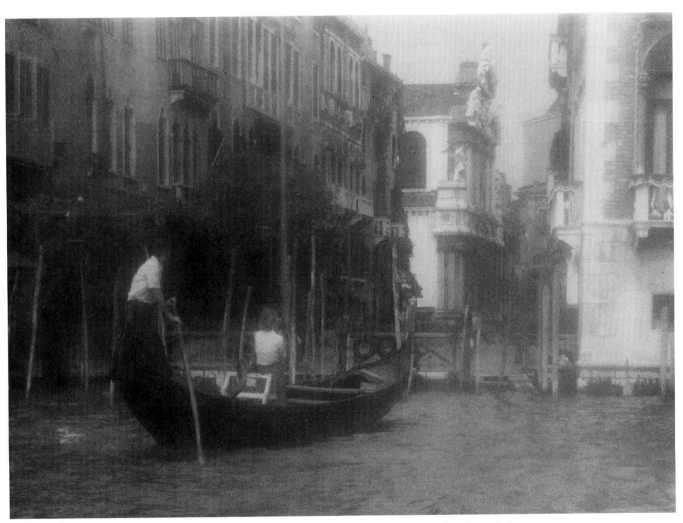

9—The soft-focus, painterly style of this Venice canal scene is the result of shooting through a dirty window.

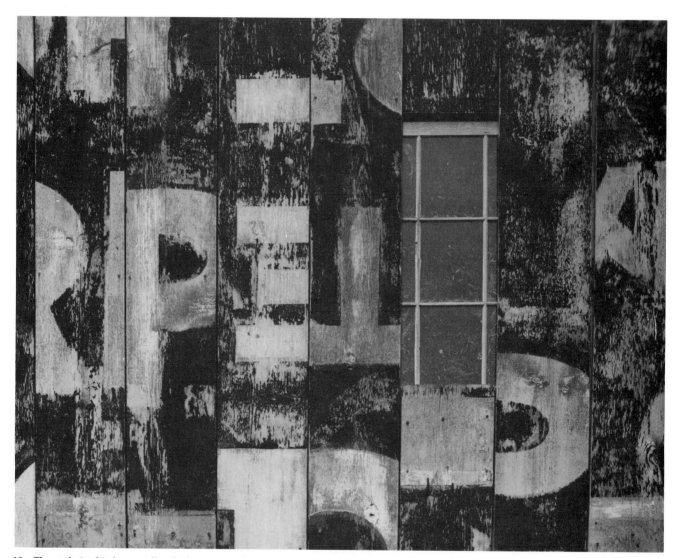

10—The style in this barn wall, which is made of planks cut from a sign, comes from its directness and an urge to combine design and visual clarity.

Style Is You

Style isn't an easy subject to discuss without sounding pretentious, so let's keep in mind these points:

1. The validity of style in photography depends on its intrinsic worth or relevance to the image at hand.

2. Familiarity with the many styles in photography is important to your visual development.

3. Opinions about a given style should begin with the senses, but can't help taking into account intellectual analysis.

4. Beware of suspicious terms like *inner visions* or *lucid explanation.*

5. Try to apply the criteria of "lasting aesthetic value" to images you may enjoy but suspect lack true artistic substance, including those that are erotic, impressionistic, or intentionally obscure.

On the path to photographic enlightenment there are guidelines to help distinguish between the arty and the artistic. The arty may be quite derivative, usually lacks depth, and is based on surface values meant to impress the viewer. Artistic images result from the solving of visual problems in ways that move minds and emotions.

11—Dan Steinhardt experimented with lighting and expression to achieve a simple, strong portrait style that won a Kodak/Scholastic Award.

Are you afraid of trying new styles or techniques? Does criticism unhinge you? Look at it this way: criticism is a sort of lubricant—like humor—on the wheels of aesthetic progress. Accept and digest worthy critiques, and defend yourself when you feel you must. In any case, criticism sustains and amplifies your own creative energy. Absorb the words and pictures of others—or anything that piques your curiosity. Every style ever produced by the camera or in the darkroom is yours to study.

Chapter Checklist

1. Style is an individual's way of seeing —as evidenced by composition, lighting, choice of subject, and other visual elements.

2. Familiarity with the legacy of photography is essential to anyone who hopes to enjoy full creative expression with a camera.

3. In the history of photography, Matthew Brady, William Henry Jackson, and George Eastman were pioneer pacesetters. Eastman brought photography to the average person. Prior to the hand-held camera, only an elite group could afford the massive equipment.

4. In the nineteenth century there were a number of soft-focus, romantic photographers, such as Oscar G. Rejlander, whose camera work was greatly influenced by painting.

5. When you see large prints that were made in the nineteenth century, usually you're looking at contact prints from huge negatives made by slow, almost ponderous means. Keep this in mind when pictorialism is a topic of discussion.

6. In the twentieth century photographers such as Lewis Hine, Paul Strand, and Edward Weston began showing the literal world in sharp focus—and yet, in many cases, poetically.

7. *Creativity* and *creative* are skillfully misinterpreted words—use with caution.

8. A photogram may be a beginner's exercise, but Man Ray, who introduced this form to the medium in the 1920s, used it artistically. His "Rayograms," as he called them, have lasting aesthetic value.

9. Should one set out to develop an individual style, or should personal style evolve through seeing and problem solving? If one consciously attempts to create a style, are the results likely to be contrived?

10. Make a list of your photographic aspirations. What techniques or approaches are you eager to attempt? In chapter 5, look for examples of the categories you listed.

12—We all look, but we don't always see; fascinating subjects pass unnoticed while our minds focus on different approaches. This was shot in France in the 1950s with a 4 x 5 view camera when Edward Weston's style was a strong influence on my seeing.

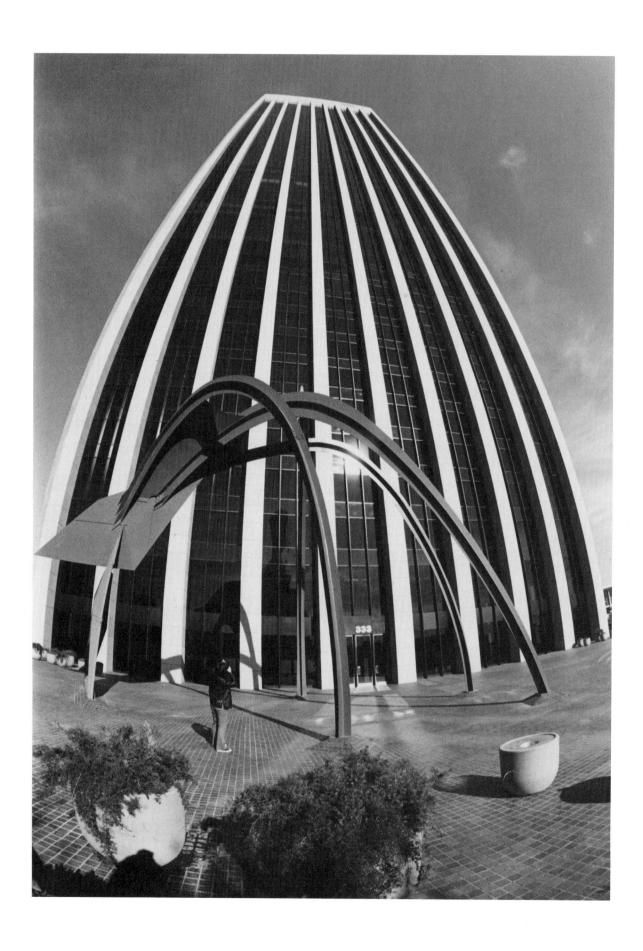

Equipment and Creativity 3

You may have heard it said that nobody asks a successful author the brand of his or her typewriter, because it's the words themselves that are important. The point is then made that the brand, type, or size of a camera is equally insignificant, because the images produced are all that matter. I don't think the comparison is valid.

Though both typewriter and camera are used to bring ideas to life, the camera and its accessories very often can influence the nature of an image simply because of the incalculables of optics, electronics, chemistry, and the physical essence of the photographic medium itself. A wide-angle lens, a slow shutter speed, and a fast film are just a few of the variables that have no counterparts on a typewriter. On the other hand, inadequate or inappropriate equipment and materials make it impossible to convey a visual idea, no matter how skilled the photographer.

In this chapter we'll discuss the uses of equipment and materials and their relation to the creative process. The tools of the trade are numerous—so much so, in fact, that one has to read the various photographic publications to stay on top of all that's current.

1—New cameras, lenses, and other equipment may help inspire creativity, but they're only hardware. Here a 15mm fisheye lens offers an intriguing, distorted view of an Alexander Calder sculpture and the skyscraper in the background.

Process and Perception

Photographers often are seduced by fancy equipment. We all know people who own expensive cameras and lenses but who nevertheless take lousy pictures with them. A sophisticated metal-and-glass apparatus is a thing of joy and a status symbol. But eventually the people in the status trap must discover what I heard Arnold Newman once say: "We don't take pictures with our cameras. We take them with our brains, our hearts, and our emotions. Our ideas are shaped by our imaginations, and *then* by our lenses." In other words, the photographer, not the camera, is responsible for being creative.

Along with the fascination for equipment, a photographer may be overly involved with the *process* of taking pictures, wherein a camera is used with little depth of feeling, and experimentation is looked upon as a risky business. Professor Robert Routh says he often cringes at the average student's work. "Thousands of pieces of paper and rolls of film are processed with images on them," he explains, "but the pictures are mostly meaningless. The student may know technique but doesn't use it effectively, because his or her *perception* is underdeveloped."

By perception he means the ability to conceive of a visual idea and interpret it with a degree of emotional or graphic impact. When

stimulus comes from the hypnotic combination of equipment and process rather than, for instance, from the effects of light on form and color, film and paper are used merely to reproduce mirrorlike imitations of scenes and nothing more.

Again, my point is this: there's a valid need for good photographic equipment, but creativity originates within the individual. We depend on our tools and materials to execute and display what is visualized. The process is not a substitute for perception.

Cameras and Lenses

In terms of personal expression, there are several ways in which equipment amplifies the ability to be creative, to experiment, and to be free.

Camera Formats

35mm cameras. There are more 35mm cameras than any other type. (A large number of cameras using 110-size film are also marketed, but their negative and slide images are too small to be practical for serious workers.) The most versatile of all 35mm equipment is the single-lens reflex (SLR) camera, which I once termed "a view camera on a neckstrap." To focus and compose you look through the lens, as you do with a view camera, but the SLR is completely portable. The 35mm single-lens reflex is your best bet for solving a wide variety of photographic problems unless a larger format SLR better suits your vision and approach.

There are so many excellent SLR cameras for sale that choice becomes a matter of personal convenience. How comfortable does the camera feel in your hands? Does the viewfinder fit your visual needs well enough? Is the price right for your budget? These items are a lot more important than brand name.

In addition, if a particular brand doesn't include a lens or accessory you need for your camera, chances are that another manufacturer makes one to fit it. There are literally thousands of accessories available for the best-known single-lens reflexes, and quality control in the industry is amazingly consistent. It's silly to burden yourself with a costly status symbol; you won't take better pictures with a given camera simply because it's "in."

One recommendation I will make based on experience: a camera offering automatic exposure allows greater opportunity to concentrate on composition, expression, action, and all the other ingredients of a good picture. A camera with manual exposure controls (or a "match-needle" type) can be just as accurate but distracts you from the creative aspect of taking pictures. Whether you adjust the aperture ring or the shutter speed of an automatic camera is optional and a matter of preference. Both methods work beautifully, and both free the mind of most exposure hang-ups, so you can think about picture content.

Larger-format cameras. On top of the list are the SLRs with image sizes of 6 x 6 centimeters (2¼ x 2¼ inches), 6 x 7 centimeters, or 6 x 4.5 centimeters, and the 6 x 6 centimeter twin-lens reflex (TLR). These cameras are heavier

2—Taken with a 35mm SLR camera and medium-range zoom lens, this scene in Venice, Italy, is a natural for versatile, easily handled equipment.

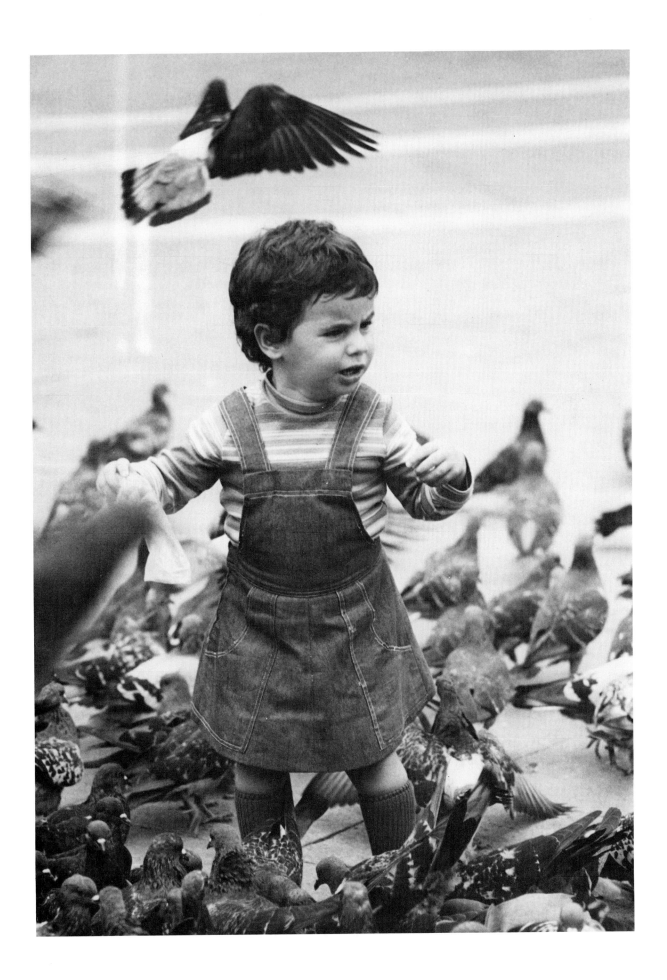

than a 35mm SLR and fewer lenses and accessories are made for them, but they are versatile, and some people prefer working with larger negatives and slides. It's also easier to see and compose through a finder larger than that found on a 35mm camera, but you pay for this facility in weight and bulk. Twin-lens reflexes are lighter and smaller than

3—One advantage of using a medium-format camera, such as the 2¼ x 2¼ Bronica (with which this was taken), is being able to enlarge a small portion of the negative or slide considerably without loss of definiton. The original photograph includes the model from waist up.

large-format SLRs making equivalent image sizes, but TLR lens options are severely limited. In addition, some larger-format SLRs offer built-in and automatic exposure meters, electric motor drives, and a wide choice of

lens focal lengths. Of course, an enlargement of a larger-format negative or transparency is inherently sharper than one made from 35mm films.

View cameras. There's a lot to be said for shooting with a 4 x 5 view camera—*if* you're mentally geared for slower, more deliberate photography. Using cut-film holders and composing and exposing one image at a time, the photographer is forced to think more carefully with a view camera, a process which may stimulate creativity in some people. And even though the image is upside down on the 4 x 5 ground-glass finder, subject and depth of field are seen more distinctly, enabling the photographer to compose more precisely.

Of the view cameras available, most are fairly heavy and some cost as much as a late-model used car, but there are several inexpensive lightweight 4 x 5s. The Ikeda and the Nagaoka, two fold-up portable 4 x 5s weighing a mere 2.6 pounds each without lens, are quite suitable to self-expression indoors or on location. In addition, Polaroid makes both 4 x 5 and 3¼ x 4¼ film adapters for 4 x 5 cameras that make it possible to use instant color or black-and-white films. One black-and-white film, Type 665, even produces a fully developed negative as well as a print. These negatives are excellent if exposure is correct, but you do have to carry a special container with solution to clear the negatives almost immediately.

Other cameras. There are still a few 35mm rangefinder (RF) models producing high-quality images; they are quieter than single-lens reflexes, but aren't as versatile. Fewer lenses are made for RF cameras, and composing in a separate finder isn't as precise as viewing through a lens. However, as sec-

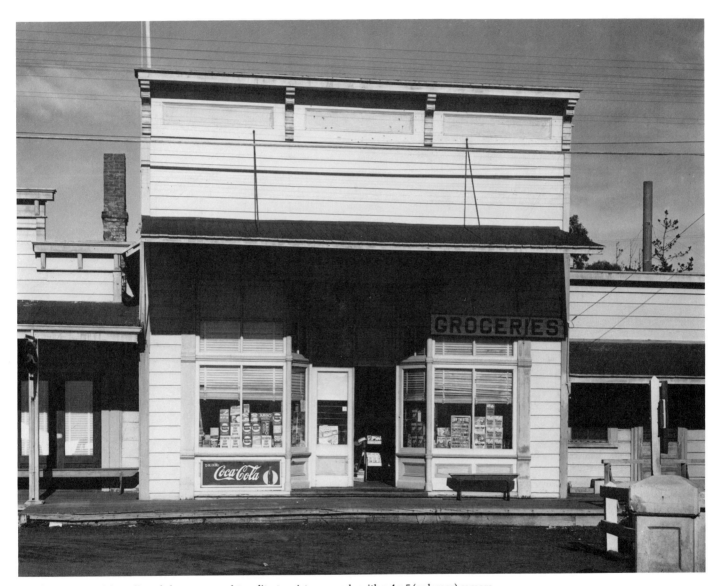

4—There's a special quality of sharpness and tonality to pictures made with a 4 x 5 (or larger) camera. This old store on a California highway is both design and social document.

ond or third cameras, there are fine compact rangefinder types which do not have interchangeable lenses. These cameras work with focal lengths in the 38–45mm range, but as compensation, they're tiny, have relatively large aperture lenses, full automation, and produce professional-quality slides and negatives.

Serious photographers can also work with instant-picture cameras such as the Polaroid SX-70, or Polaroid Models 180 and 195. The SX-70 makes color prints in a square format only, and many creative pictures have been made with this type of equipment. The other two Polaroid models have conventional lens and shutter settings, requiring the use of a hand-held exposure meter.

Lenses and Focal Length

A "normal" lens sold with a 35mm SLR has a focal length close to 50mm. Such lenses are good in many situations, especially with an f/1.8 or f/1.4 aperture when shooting at night or in low light levels. Some photographers don't care for the normal or standard lens, which is neither wide-angle nor telephoto enough for their tastes.

Wide-angle lenses are great for broad views of a subject, for their excellent depth-of-field characteristics, and for their ability to distort perspective and/or size relationships in an image. In choosing a wide-angle lens, try one each of the 21mm, 28mm, and 35mm focal lengths on your camera and then decide which best suits your needs. A superwide fisheye lens, such as 15mm or 16mm, is very specialized and usually isn't the first short-focal-length lens one buys.

5—A wide-angle lens, such as the 35mm focal length on a 35mm camera, is a natural for scenes like this. Photographed in Switzerland by Barbara Jacobs.

Telephoto lenses are wonderful for "reaching out" at distant subjects to provide a larger-than-average image on film. Again, try an 85mm, a 105mm, and a 135mm lens on your camera and make a selection based on anticipated needs. Longer focal lengths, such as 200mm, 300mm, and beyond, are specialized and valuable in a number of situations.

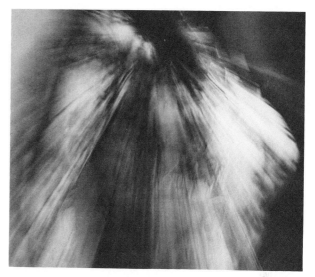

6—A zoom lens on which the focal length was shifted during a one-half-second exposure accounts for the decorative blur of this semiabstract photograph.

Zoom lenses are the optical industry's gift to photographers, and every month new focal-length ranges are announced. A zoom lens is longer, heavier, and generally more expensive than a single-focal-length lens, but its versatility far outweighs any disadvantages. Short-range zooms, such as 35–100mm or 65–135mm, and medium-range focal lengths, such as 80–200mm, are lighter and shorter than they were a few years ago, and many

include a macro mode, which means they're capable of shooting close-ups at a choice of focal lengths without accessory lenses. You'll find that one zoom lens costs less than several separate lenses, and, again, they're well worth the investment in terms of flexibility. However, if wide maximum apertures are important to you, choose individual focal lengths. Most zoom lenses have maximum apertures of either f/3.5 or f/4, limiting their use in dim-light situations, particularly indoors.

Lens prices vary considerably, but most brands are acceptably sharp. For a 35mm SLR, a good starting assortment might include a wide-angle lens, a normal focal length, and a zoom ranging from 70–150mm.

Color and Black-and-White Films

Ideas can be expressed in the monotone of black and white or the more "realistic" medium of color. We're used to seeing vintage photographs in black and white from an era when there was no such thing as color film. Today many serious photographers prefer the potential of expression and manipulation offered in black and white.

Color adds a graphic dimension to photography, but it's a more complex medium to master. We're not talking about exposure problems—today's equipment is as easy and accurate to operate with color film as it is with black and white—but rather about a photographer's options *after* a color negative or slide has been developed. To properly present a color slide, a projector is needed; and while a slide can always be cropped with masking tape, it's not as satisfying as cropping and enlarging a print. Copying a slide to enlarge or tint the image is possible but requires special equipment and techniques. As for color prints, the photographer usually is dependent on the judgment and skill of a professional lab, which means an important creative stage is out of his or her hands.

Of course, do-it-yourself color printing is becoming easier, but a single 8 x 10 color print may require 60 minutes or more to prepare and develop, though it may cost less than $1.00, depending on the materials used. It's not unusual to take thirty minutes to perfect a black-and-white print, but the experienced darkroom worker averages ten minutes per print, and the cost is around twenty-five cents.

Film Developing

Almost every style or approach to photography may be enjoyed either in black and white or color, but unless you shoot a lot of it regularly, developing color film is an impractical, costly procedure.

The same *cannot* be said of black-and-white film developing or printing. It only takes half an hour to develop several rolls of black-and-white film, and personal variations of time or temperature can help influence image quality. Chemicals are relatively inexpensive and last for months (unlike color chemicals), and though good darkroom equipment isn't cheap, most of it lasts a lifetime. Therefore, if you shoot black-and-white film, it's worth the small effort involved to process it yourself.

7—Robert Barclay develops his own black-and-white film and has control over contrast and cleanliness. In printing, he chose to accent the vertical format of this casual scene.

Black-and-White Printing

The advantages—and pleasures—of printing black-and-white negatives are many. In fact, you owe it to yourself to make enlargements of your own negatives. It's a natural step in the enjoyment of expressive photography to carry the creative process through from the exposure of an image to its completion as a print. Crop and compose to suit your own aesthetic tastes and translate the original idea into a sparkling—or subtle—image on paper.

8—Camera hobbyist Edgar Gelabert set out to photograph his new son in a way "that would be more meaningful than the ordinary baby shot," and in the process won first prize in a Kodak International Newspaper Snapshot contest.

Of course, a professional printer can also enlarge negatives to order, but the photographer's visual concepts are apt to lose something in translation in the hands of another person. Even if a custom lab can, for the present, achieve better print quality than the beginner can, darkroom skills increase with experience, and during this time a photographer's own visual sensitivity is included in the final product—the print. Discovering the nuances of the printing process helps make you a better photographer. With an enlarger, a top-quality lens, and a minimum of equipment set up in a darkened kitchen or bathroom, the pleasures of photographic expression come full circle.

Film Brands and Types

The best way to find out about films is to read, ask questions, and experiment. In low light levels, a fast film may be very useful, but a slower film allows the photographer to blur an image. In the average outdoor location, a fast film copes well with bright sun, but again, a slower one may be easier to expose without using a neutral density filter. The slowest films offer the finest grain, which is important only in making very big enlargements.

In color, the choice usually is between negative and positive films. Choose a negative film if color prints are desired and a positive film for slides. (Each type is convertible, however, and prints can be made from slides and slides made from negatives.) Film speed and relative contrast are related in color films as they are in black and white. However, there's usually more color saturation (depth of hue) in a slow slide film than in a fast one.

Try several black-and-white and color films, and find one of each that can be trusted under many conditions. Most expressive photography is produced with conventional films, but unusual images may result through the use of certain filters, special developers, and manipulative darkroom techniques. Nevertheless, the original perception of a subject on film and in a print usually is more important than the type or brand of film itself.

Photographic Accessories

To begin exploring the range of expressive photography, you need a camera and perhaps

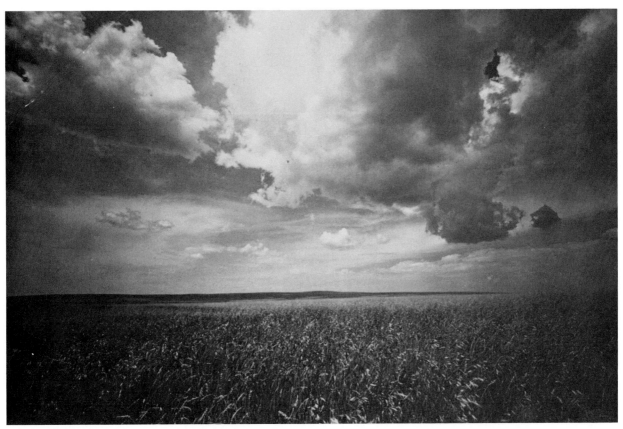

9—Professional photographer Fred J. Maroon often uses a tripod with a 35mm camera, which accounts for the exceptional sharpness of his pictures. Photograph © Fred J. Maroon 1975 from *These United States*, with text by Hugh Sidney. Published by EMP Publications, McLean, Virginia.

a couple of lenses—and not much else. Here's a short list of useful possibilities.

Tripod. Even though a 35mm camera can be held successfully by hand, a tripod is a definite must. It's an invaluable tool for shooting at night, for achieving great depth of field in poor light, and for capturing certain effects of light on film. Don't buy a flimsy model that folds down to eight inches or a fifteen-pounder more suitable for a large view camera. Instead, choose a tripod of comfortable weight with a head that extends at least five-and-a-half feet high with a full complement of movements.

10—Two 500-watt floodlights aimed into a reflector umbrella for strong, simple lighting were used to shoot this family portrait.

Exposure meter. If your camera has a built-in meter, another exposure meter is unnecessary. If it doesn't, there are several compact, versatile meters on the market at reasonable prices. Fancy, expensive models aren't essential, nor is a spot meter needed. Buy a model that takes either reflected- or incident-light readings—both methods can be used to advantage.

Filters. There's an endless array to types and sizes of filters, but for a start you should have a skylight filter (1A) for correction of some types of color film under overcast skies. A polarizer is also valuable to darken skies and control surface reflections. Both 2X and 4X neutral density filters can be very handy in "taming" intense light and/or fast films. The remainder of the filter list offers color and optical effects that can be delightful or contrived, depending on how they're used.

Electronic flash. When available light or other illumination is inadequate, or when fast-action shots are desired, flash (and the electronic type is preferable to cubes or bulbs) is an expedient light source. If it can be removed from the camera or bounced (reflected) from a ceiling, wall, or umbrella reflector, the use of a flash will not be as obvious. Buy an auto-exposure unit, preferably with a thyristor circuit.

Floodlights. The compleat photographer uses several types of floodlighting. These may include reflectors, reflector bulbs, or quartz bulbs. A telescoping stand, or at least a clamp, is needed for each light. With these lights I suggest using a reflector umbrella (or an improvised reflector, such as white illustration board) for portraits or still lifes. Daylight and ambient indoor light often may be appropriate, but artificial lighting can be very effective when properly used.

Close-up lenses. The normal lens of a single-lens reflex camera focuses to between twelve and eighteen inches, but sometimes being closer is better. Close-up lenses, or extension rings, allow the photographer to focus a few inches from subjects, and they're relatively inexpensive.

Darkroom equipment. Inquire at a local camera shop about enlargers, timers, trays, and other gear necessary for developing film and making black-and-white or color prints. There's also guidance to be found in the many publications dealing with photography and photographic supplies, including my own *Photography Today* (1976) from the publisher of this book.

Incidentals. A soft brush to clean lenses and the inside of the camera should be used often. Lens tissue and lens cleaning fluid are also musts, because other "soft" substances (such as facial tissue) aren't safe.

Other helpful extras: a cable release for time exposures (helps prevent camera shake) and a good cloth tape to mark film containers with. Use a piece of tape to identify film types, so you don't have to carry the boxes; when film is exposed, place the tape across the side and top of the container to distinguish it from unexposed rolls. You can also number your rolls or make exposure/development notes on the tape.

Print and Slide Presentation

The cardinal principle of print presentation is to amplify the beauty of the image without being pretentious and without calling attention to the mounting materials. A subtle, understated presentation is most likely to enhance a photograph. For the purposes of a show, print mounts should be uniform, but otherwise it's nice to vary print presentation.

Black-and-white and color prints should be dry-mounted to a suitable mountboard using a dry-mount press. Spray-on adhesives may be chemically safe but usually aren't permanent enough, and rubber cement and other such adhesives aren't chemically pure and eventually will cause prints to stain.

Whether a print is bleed-mounted (mounted without borders) or mounted with borders depends on the photographer's own taste and, to some extent, on the photograph itself. Large prints seem more appropriately displayed with bleed mounts and covered with glass or plastic sheets. Smaller prints often look best with borders on white stock, and light gray stock also works well; but colored backgrounds usually will compete with the picture.

Prints can also be *framed* in a number of attractive ways. Check at an art supply store

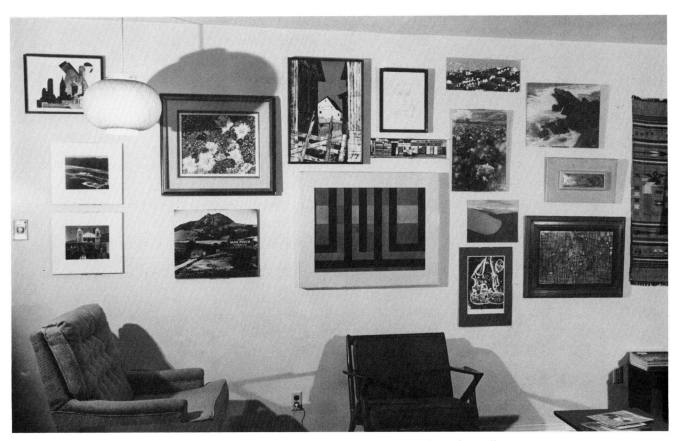

11—Photographs mounted in several different ways are mixed with other art on the author's den wall. At left are two prints by Edward Weston.

or frame shop for appropriate materials and guidance.

When presenting slides, the sequence should evolve from the subject matter itself. However, slides may be arranged according to the time period in which they were taken, contrasts between subjects, cause and effect, or other functional or aesthetic concepts. Be as selective as possible in editing to avoid repetition. Once you've mastered the art of producing a slide show with one projector, check into the possibilities of using two or more projectors connected by an optical blender. Music and/or commentary may also help enhance a slide presentation, depending on its content.

A Final Note

Negatives, prints, and slides should be carefully filed, because it's very important to be able to retrieve a photograph made in the past or to identify it with a cross-reference number that gives it individuality. Number your rolls of film and keep an index of them. This isn't professional gloss—it's plain old common sense.

Chapter Checklist

1. Photographic equipment is important because it's the means by which photographers express visions of the world, literal or otherwise.

2. Superb hardware doesn't automatically produce meaningful photographs.

3. Think of visual perception as the key to making the most of your equipment. It certainly helps to use first-class equipment, but it's no guarantee of quality.

4. An automatic-exposure camera makes it possible for the photographer to pay more attention to composition and timing, eliminating the physical adjustments required by manual-exposure cameras.

5. While using a view camera (4 x 5 or larger) is a slow and deliberate operation, the definition and image quality it produces are superior to those of smaller formats.

6. The tremendous assortment of lens focal lengths available for 35mm SLR cameras makes shopping for one a difficult chore. Try to match lenses with the types of pictures you take, or hope to take, most often.

7. Most photographic situations offer a choice between color and black-and-white films. The alert photographer will not get hung up on one or the other but will interchange them when the time seems right.

8. Developing color film is largely a mechanical process with little opportunity for creative manipulation. Black-and-white film processing offers several options to the photographer, making it worthwhile to do it yourself.

9. Color printing is becoming less complex and more feasible for the noncommercial photographer to enjoy—straight or experimentally. Black-and-white printing is an extension of the creative process every photographer, serious or not, should try. Rent or borrow a darkroom during an orientation period.

10. Some accessories—such as tripods, polarizing filters, neutral density filters, close-up lenses, and a suitable shoulder bag in which to carry everything—are invaluable to most photographers.

11. The art of presenting your own prints and slides is worth acquiring, even though the work involved is sometimes tedious. Learn what you can from other photographers, and inquire at professional framing shops.

12. Edit your slides carefully; be very selective and show only your best.

13. If you don't have an adequate filing system for negatives, prints, and slides, start one now.

In Transition

4

We're almost ready to talk about specific types of pictures and how they're made. But first let's review from previous chapters.

1. You can do anything that pleases you with a camera or in the darkroom. Skill increases with experience, but self-motivation is always a must. Don't let mistakes inhibit you, because taking risks is the key to satisfying self-expression.

2. Be your own boss; the demands of the commercial or artistic worlds need not concern you right now. The boundaries of free expression in photography are infinite, and even the limitations of "good taste" are what you make them—at least until you show your work publicly.

3. We've all inherited a vast storehouse of styles from the past and present. In the work of others, there are discoveries to be made that will guide and inspire the photographer to see and create as an individual.

4. Equipment and materials are important, but they must remain servants of imagination.

5. Developing and printing your own pictures, especially when working in black and white, are integral steps to creativity.

1—There are almost no limits to what you can do in photography. If you're so motivated and wish to print a portrait with grain texture, nothing should stop you.

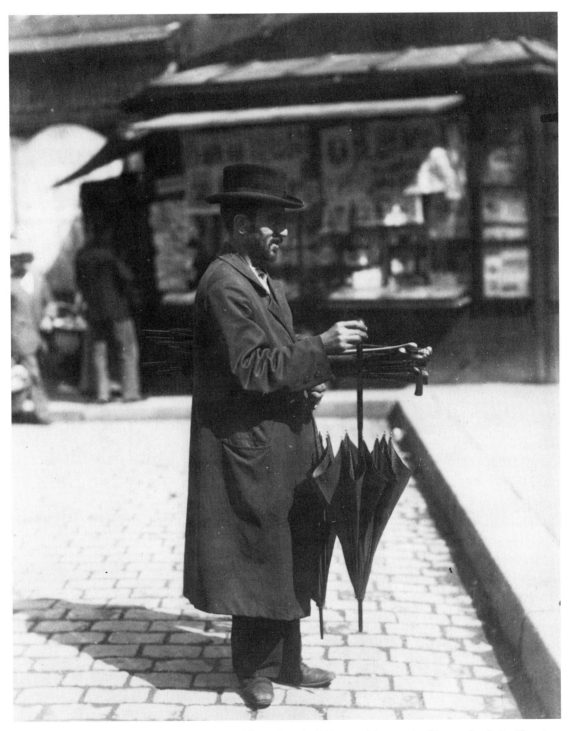

2—Eugène Atget photographed this umbrella peddler in Paris in 1910, one of thousands of images he shot with a view camera. For almost thirty years he focused on whatever appealed to him, from castles to markets to storefronts. From George Eastman House Collection.

6. Photographs that convey an idea, affect emotions, and entertain the eye are likely to be effective.

Increasing Awareness

Not long ago I talked to a class of young photographers who I found were woefully unaware of the masters of photography, including those of the mid-twentieth century. For instance, they had never heard of Eugène Atget, whose work (photo 2) went unrecognized in the early 1900s until his discovery in 1926 by Man Ray and Berenice Abbot. She preserved and printed thousands of Atget's negatives after his death and wrote about him as the classic street photographer he was. These students also didn't know many other trendsetters of the past, nor were they familiar with painters such as Piet Mondrian or designers such as Charles Eames.

The world is so rich in imagery, in sights and sounds, that to be ignorant of so much is to rob the senses. It's like seeing with one eye and hearing with one ear. Get out and haunt the libraries, bookshops, museums, concert halls, and galleries. Through such exposure, visual sensitivity and perception grow; creative batteries are recharged.

The following chapters will introduce photographers and styles and hopefully will kindle experimental urges. Each chapter is a sampler in a category you'll find expanded upon in other books. My goal is to see that you catch the joy of new vision and new feeling—with a camera and in the darkroom. I want the pleasure of photography to be contagious. But first some transitional notes.

Color Versus Black and White

Though we touched briefly on the characteristics of color films and made a few comparisons with black-and-white films in the last chapter, I want to make further distinctions. Most photographers have worked in color, but some have little or no experience black-and-white film, though fast color films often are used in such situations. Black and white gives you the freedom to manipulate contrast, which means controlling detail in highlights and shadows at the time of exposure or when making enlargements. The same may be said of color slides and prints,

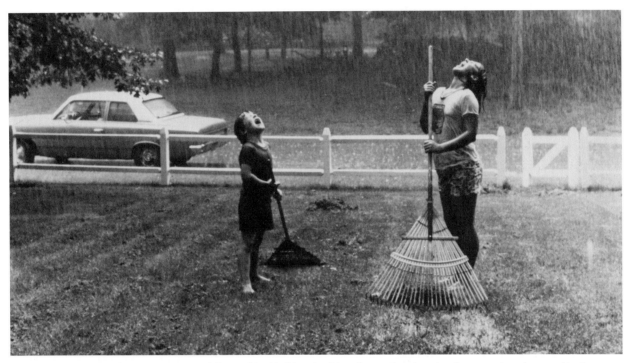

3—Marianne T. Richards won a trip around the world with this refreshing photo taken from her front porch and entered in the Kodak International Newspaper Snapshot Awards. Taken in color, the picture is also effective in black and white.

with black and white, which may be considered "old fashioned" or strictly for fine-art images. Both these views are misconceptions, but wherever your tastes may lie, neither color nor black and white is the answer to every photographic challenge. Both are essential, for each offers a unique, personal satisfaction.

Here are some black-and-white and color points to keep in mind:

• Visualizing and photographing in tones of black, white, and gray are challenges loaded with creative latitude. It's easier to shoot in relatively low light levels with

but more skill, time, and expense are involved.

• Color is more of a sensory experience; whether realistic or manipulative, it quickly relates to the emotions or senses.

• If a subject includes bright colors that may attract *excessive* attention in a print or slide, it might be better translated into black and white. However, the reverse can also be true.

• Though we see in color (a fact which makes the medium more "literal" in the photographic sense), color is also very adaptable to the abstract. Color is integral to

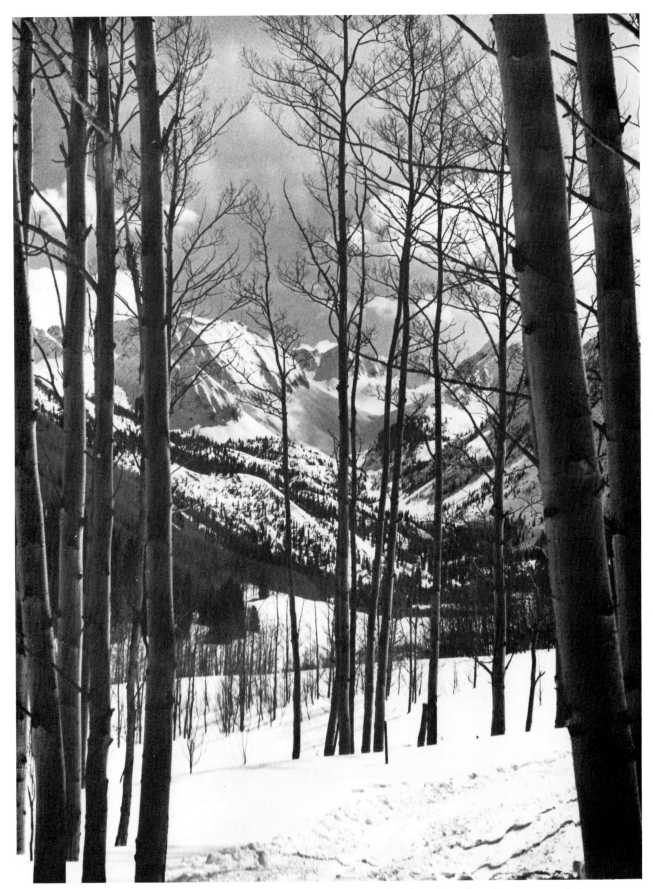

4—Diane Huntress enjoys shooting Colorado in black and white, especially when the subject allows her to communicate personal feelings in an artistic manner.

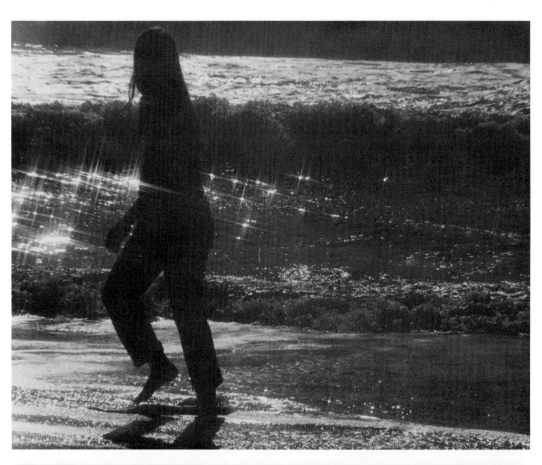

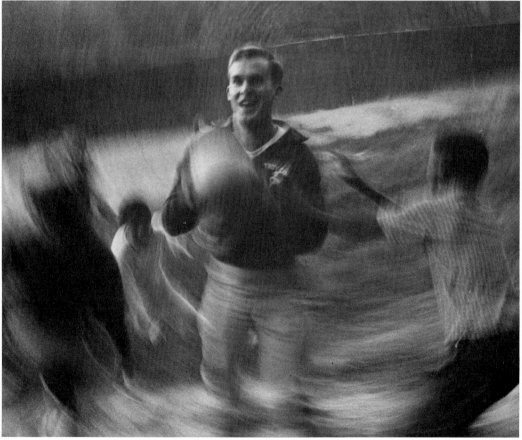

the design of a composition and can give emphasis where black and white cannot.

• It requires experience and imagination to see the many-colored world in the monotone of black and white and to render it effectively in a print. We must be aware of different colors of the *same value* in order to separate them in black and white; a color film does this for us more easily.

• Neither black and white nor color is a more creative medium than the other. Each allows great range for interpretation or reportage. Black and white can be manipulated with more facility because the average viewer, who is convinced he or she can recognize "true" color, will accept black-and-white photographs with a less-than-realistic look of the world as part of a personal statement.

• Color is seductive. There's a temptation to feel that an image is successful merely because the colors are brilliant, harmonious, shocking, or otherwise distinctive, but picture content and ideas must prevail over "pretty" or "exciting" colors.

Add your own arguments for and against color or black and white. Explore both mediums and use each according to the demands of the situation. Even though you may have only one camera to work with, go ahead and think in terms of color or black and white anyway, no matter what type of film it's loaded with. If you shot portraits or landscapes in color the last time out, switch to black and white the next time. Some subjects, such as landscapes and seascapes, cry out for

color, but the black-and-white images of Edward Weston, Ansel Adams, or Paul Strand demonstrate that they can be handled effectively in either medium.

Go on kicks, shooting either color or black and white for periods of time that suit you. And remember, you can always rewind one kind of film into its 35mm cartridge, leaving the leader out and marking the frame number last exposed. Then load another type of film and shoot some more. When you reload the first roll, advance it one frame beyond where you stopped to avoid any overlap.

A final note: black-and-white prints can be made from color negative stock, but the image quality in this situation isn't as good as it is when a black-and-white negative is used. Nevertheless, a skilled printer can work very well with color negs.

Now let's explore the many ways photography can be fulfilling.

Chapter Checklist

1. Analyze your present priorities based on the six-point summary and try to anticipate whether or not they'll change, and if so, how.

2. Eugène Atget was a street photographer who often took pictures from which artists could draw and paint.

3. While studying the black-and-white photographs in this chapter, envision them in color. Which do you think would be improved in color?

4. Think of a picture you have taken that you like very much, then try to decide if it reflects the style of another photographer, living or dead.

5. If you own just one 35mm camera, remember that you can rewind the film in mid-roll (without winding the film leader into the cartridge) and thus switch to another type of film.

5 (opposite top)—Nancy McBride used a star filter for this memorable picture—one way of experimenting in the move toward visual growth.

6 (opposite bottom)—On an assignment where he could not show the faces of handicapped kids, Tom Carroll photographed a basketball game using the instructor as the center of interest as he twisted his 35mm camera during a ⅛-second exposure for an impressionistic image.

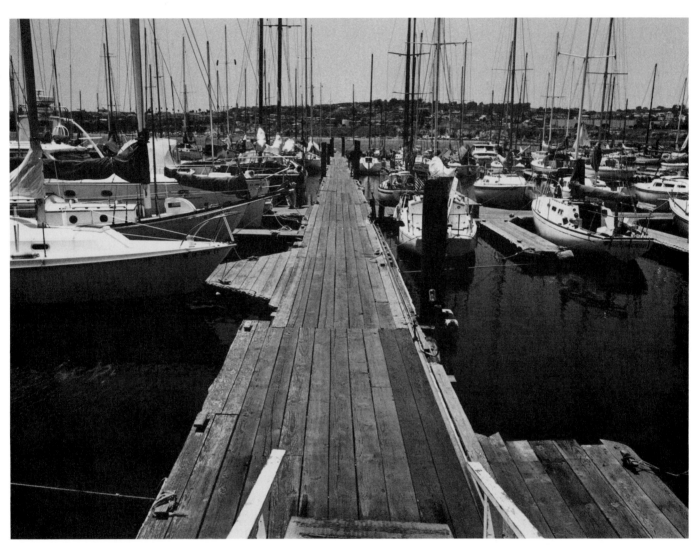

1—A somewhat confusing jumble of boats plus an empty dock is reminiscent of the snapshot style, but it's a modern imitation. The scene was snapped quickly with a 35mm lens on a 35mm SLR camera.

The Imitation Snapshot 5

If, as I've previously stated, *snapshot* is sometimes a dirty eight-letter word, can an *imitation* snapshot have value as expressive photography? The answer lies in capitalizing on the guileless technique all snapshots have in common. Exploit the quality of spontaneity, and with a little sophisticated know-how, the imitation snapshot becomes an effective style in itself:

1. Picture content is meaningful and has specific impact.

2. Action or expression are appealing enough to supersede the need for orderly composition or other more conventional characteristics.

3. The picture has the appearance of being casual in design or concept but may in fact have been carefully planned or resulted from instinct.

The lowly snapshot has been elevated in status by the work of Emmet Gowin and Bill Owens, two photographers who shoot revealing slices of life and catch the joy of living with verve and insight. There are also imitation snapshots which at best are empty images, and at worst, frauds.

Winging It

A few years ago I rediscovered the fact that snapshooting is a delightful activity. I began carrying a twelve-ounce 35mm compact rangefinder camera to places where I didn't care to take heavier, more elaborate equipment. These cameras have 38mm or 40mm lenses and offer automatic exposure; more versatile models also include manual override if automation isn't appropriate for a situation. Some models have built-in electronic flash, and all but a few are priced under $200.

In relatively bright light (with a short focal length lens focus set for a predetermined depth of field), it's easy to wing it or make grab shots with minimum preparation. When a subject is between seven and twenty feet away, for instance, and you know it will be in focus, merely lift the camera to your eye and snap. What these pictures may lack in careful composition, they make up for in spontaneity. I often find myself snapshooting with a certain abandon and enjoying it. I feel a thaw in my conditioning about more careful planning, but at the same time I make a point to distinguish between being unorthodox and careless.

Recently, I came across a book called *The Snapshot*, edited by Jonathan Green and published by Aperture, Inc. Its contributors include some well-known photographers; here are a few of their comments:

Lisette Model: "Snapshots can be made with any camera. . . . Innocence is the quintessence of the snapshot. . . . We should

remember that much of the power of snapshots comes from their centering on basic everyday experience. . . . Pictures have an apparent disorder and imperfection, which is their appeal and style."

Tod Papageorge: "For me, the word *snapshot* is tied in meaning to family album . . . 'happy accidents' do happen, and probably in direct proportion to the chances the photographer takes."

John A. Kouwenhoven: "Snapshots are predominately photographs taken quickly with a minimum of deliberate selectivity on the part of the people represented and with a minimum of deliberate selectivity on the part of the photographer so far as vantage point and the framing or cropping of the image are concerned." (Copyright © 1974 by Aperture, Inc. Reprinted by permission.)

The provocative images in Mr. Green's book demonstrate the many ways in which the snapshot can be interpreted. Mr. Kouwenhoven's definition is the one we think of first. However, it's entirely possible to assume a casual or playful attitude and still create a meaningful *imitation* snapshot, which is different from the naive efforts of a simple camera enthusiast because of its sense of design, timing, and pictorial content. Photos 1, 3, 4, 13, and 14 demonstrate what I have in mind. While the point-and-shoot photo fan knows or cares little about lines, space, or other elements of good design, the serious photographer is aware of these concepts and uses them with an immediacy that can make a snapshot a work of art.

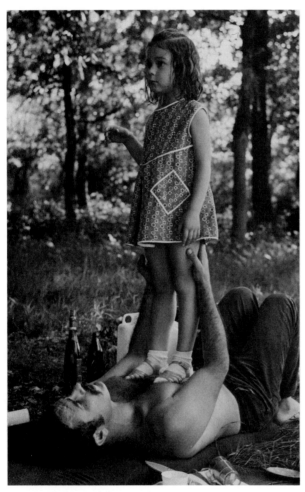

2—Helen Miljakovich casually photographed a father and daughter during a picnic in Yugoslavia. Helen is a professional photographer, and her sophisticated approach resulted in a warm impression with lasting appeal.

3—Meaningful moments captured with an agile camera combine good reporting with the snapshot style. A compact 35mm rangefinder camera was used here.

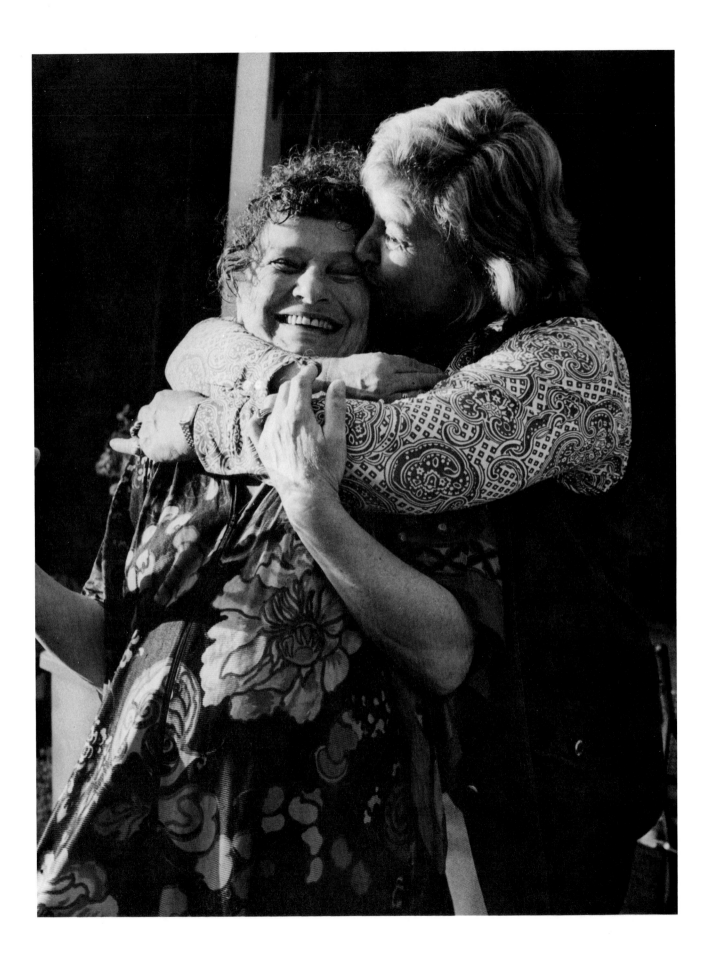

Courting Chance

Many of us learn to take pictures in a rather deliberate manner, and it may not be easy to shake off disciplines and dilute inhibitions. But sophisticated snapshooting means not always waiting for the "right" light, an ideal camera angle, or an uncluttered background. Good habits can still be practiced as you "think" through the viewfinder. Train yourself to work more quickly in order to capture lively moments like those illustrated in photos 3 and 4. Chance played a role in these pictures, which, along with their faults, have a spontaneous spirit. The background in photo 4, especially, is a mess, but it's overpowered by the dynamic figure of the child. Sensitivity to how a composition *should* look contributes to success when you wing it, because you're instinctively more selective while being quick and casual.

Photo 5 represents the "apparent disorder" mentioned above by Lisette Model, but despite the confusion behind the man crossing a Mexican street, there's a sense of atmosphere and reality. I made the shot with a single-lens reflex, and though I wasn't quite ready to shoot as he stepped off the curb, I made several exposures as he crossed. The point is this: when poised to take pictures, don't waste time moving closer or maneuvering to improve the background—it might mean missing the situation entirely. Shoot first, and then make further adjustments of camera position, lens focal length, and the like if circumstances allow. You may only get one chance, so grab the moment and squeeze it for all it's worth.

I'm advocating *camera readiness*, which is particularly valuable in street photography (the subject of the next chapter). When photographer and subject are on the move, being alert and as selective as possible

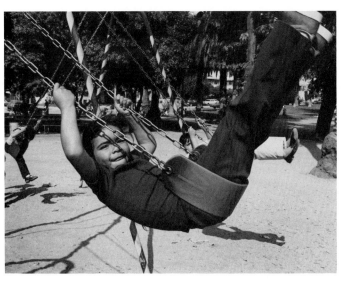

4—Good timing and an instinct for visual selectivity is gained through the experience of shooting many mobile situations.

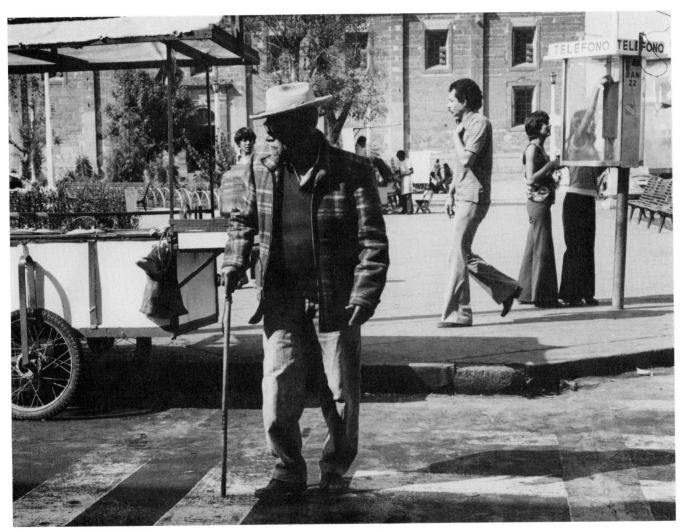

5—When you see picture possibilities, shoot before they disappear and decide later
if the images are worth enlarging or projecting.

requires having the camera ready for immediate use. Here are some pointers:

1. Prefocus to attain a depth of field that covers the subjects and area to be shot. I mentioned doing this with both the compact 35mm rangefinder and the SLR cameras, but it's feasible with any hand-held, adjustable camera that has a depth-of-field scale adjacent to the lens mount. If using a fast film enables you to prefocus and wing it with more confidence, then by all means use it. The faster the film, the greater the depth of field possible because smaller lens openings can be used.

2. It's nice to have plenty of equipment, but when grab-shooting, carry only the essentials. Store lenses and other accessories in a shoulder bag that allows you plenty of mobility. A bag that's too large, or one that must be carried by a handle, is bad news (unless of course you have a strong and willing assistant).

3. If your favorite camera is slightly heavy, and your favorite zoom lens adds to the weight, practice handling them with agility. Some photojournalists can move and shoot with speed and skill even though they're weighed down with two or three cameras and accessories. Trained instinct is an antidote for an excess of gear.

4. Auto winders for 35mm cameras are miniature motor drives which automatically advance film and cock the shutter. They enable the photographer to keep his or her eye in the viewfinder to provide superior camera readiness.

5. For effortless snapshooting—imitation style—try a lightweight 35mm rangefinder model and assume a happy-go-lucky attitude with an excellent piece of equipment that everyone thinks is a toy. This type of camera can be taken places to get images that otherwise might have been missed.

Without Apologies

Random, educated snapshooting is a valid approach to self-expression, and seeming imperfections in prints or slides need not be apologized for as long as they have fresh visual meaning for the photographer. As the basic principles of composition are mastered, the imitation snapshot takes on added significance. There's a feeling of freedom to be enjoyed which brings out the best in a photographer as he or she captures moments in time. No longer will camera shake, or the fear of cropping somebody's head off, or errors of focus interfere with the spontaneous act of snapshooting.

As an example, look at photo 6. It's not often you find a friend who owns a vintage wheelchair that is part of her apartment decor, but I was lucky. During an informal visit I had with me a single-lens reflex and a versatile electronic flash unit. I asked my friend to pretend she was riding in the wheelchair in front of a white wall in her living room, and I bounced the flash off another wall for a strong sidelight, which seemed an appropriate procedure for an unconventional subject. For this picture I mounted a remote sensor in the shoe on top of my camera, and someone held the flash on a long cord off to the right. In a few minutes I shot about fifteen pictures, and this one had the most spirit and strongest impact.

Winging it, therefore, doesn't mean being careless. It does mean trying to keep a composition as simple and uncluttered as possible,

6—Playing photographic games with a cooperative friend, I bounced an electronic flash from a wall and ceiling to stop the action.

while ignoring conventional taboos when expressive photography is the desired effect. In an effort to master the medium, we sometimes become too serious. Take chances when excited about a situation, for there's little to lose in shooting impetuously, using whatever disciplines you've learned as guides.

How does one decide if a quickly made image has any aesthetic merit? The answers are flexible; compare your shots with the examples that follow. Try to accept constructive criticism from those whose opinions you feel are valid, but when chance is an image's allure, enjoy it. Later when you edit your black-and-white contact prints or color slides and can view a photo with the objectivity time and distance provide, you may have second thoughts.

In the Snapshot Style

In recent years there has evolved an approach to serious photography that is related to the snapshot in appearance but which actually is more contrived than it is spontaneous. A number of photographers pretend to be artless in an effort to be arty. Their techniques include shooting from moving cars or making pictures of commonplace subjects that usually are meaningless. Viewers may overestimate the value of such images because the prints are sharp and well exposed.

Imagine a series of black-and-white photographs showing empty parking lots along stretches of a main street in Los Angeles. Such a series has been exhibited and published in a privately printed book. Another individual chose to photograph what a critic called "picture postcard views of

unusually drab and boring Middle Western towns." The images included litter in motel rooms, dull trailer camps, and bland backyards. Insipid pictures such as these, produced with technical skill, have been elevated to the walls of museums and galleries.

Another exhibit, this one of color prints at a prominent museum, featured mundane scenes—snapshots of people doing absolutely nothing, empty rooms and streets, and such inspiring subjects as a bare light bulb with a

8—This imitation snapshot was made to glorify the mundane in the style of some contemporary photographers. It has no special significance, but if it were labeled "an artistic vision of the commonplace," would the phrase give it meaning or make it any more impressive than it really is?

red wall behind it. The catalog introduction for this show was filled with elegant phrases "explaining" why the photographs had artistic merit. I was reminded of a marvelous

7—Amidst a crowd in the Louvre I had to shoot quickly with minimum control, using an educated snapshot approach. Here I was attracted to the guide's extended arm echoing that of the Greek statue.

essay by Tom Wolfe in the April 1975 *Harper's* titled "The Painted Word" (it later became a book). If you're interested in a masterful analysis of art criticism, read Wolfe's thesis.

In a nutshell Tom Wolfe says that modern art (in which photography is included) gains status because paintings and other works "exist only to illustrate the text." By this he

out that such works are often taken seriously only because of the "word-painters."

Beware of scholarly double-talk. An admiring and buying public readily succumbs to pronouncements by "authorities" that certain pictures are chic, but serious photographers must remain aware of possible frauds that are passed off as noble undertakings. However,

9—There's a hint of social comment here, but not much. This photo was snapped to symbolize intentional obscurity. Unfortunately, meaning can be manufactured by clever words.

means that the complex, esoteric verbal comments accompanying art printed in catalogs, for instance, really are more important than the supposedly aesthetic works they describe. Thus, clever gallery owners, museum curators, and critics are able to thrust upon us empty images through the persuasive edicts of literary craftsmanship. The snobbish spotlight of eloquence shines on art that "illustrates the text," and Tom Wolfe points

well-executed nothingness, when it has been certified in print as "luminous," "insightful," or "persuasive," is hard to dismiss as a passing fancy.

Personal taste and judgment lead to controversy, especially where aesthetic values are concerned. But as Robert Routh so thoughtfully pointed out to me, "We're involved in an intellectual process, both literary and visual, and personal likes and dislikes will have little

to do with eventual historical significance when viewed by scholars who see the works later in a total perspective." The question, "What has artistic value?" will produce different answers from different people, depending on the individual's conception of the word *artistic,* but photographs that have

time being suspicious and critical. New insights and discoveries make your own expressions with a camera more vital.

In general the snapshot mode offers a new freedom of expression. The examples that follow illustrate points made previously and investigate new facets of the imitation snap-

10—Do you recognize the style as that of a specific photographer? Does the image move you? Are small details intriguing? This was also taken as an example of the empty snapshot, but I believe it's too interesting to be typical.

retained visual stature throughout the years become criteria for evaluating current images.

Snapshots, Pro and Con

In regard to the imitation snapshot, don't reject images that at first upset your visual sense because they are strange, erotic, or unfamiliar to your experience. You may see some such photos in this book, so it's worthwhile to be open-minded while at the same

shot. Despite distortions and contrivances, the style has been stretched to stimulating new dimensions. An image may be incongruous or have the guise of carelessness and still be fascinating; technique might intentionally be amateurish.

Photo 10. This was taken to illustrate the empty or meaningless style of several photographers you may know by name. Compared

to some of their vacuous images, my shot may fail as a parody because it's *too* interesting! Try to imagine it enlarged to 11 x 14 inches, with a pristine white mount around it, and hung on a gallery wall with a cryptic title like "No Left Turn." In such a setting the average viewer might attempt to discover what the picture has going for it. Why is it worthy of exhibition? Is it an aesthetic photograph because it's large, clear, in sharp focus, or expensively priced? Unfortunately, in dealing with works such as this, it's difficult to determine if the photographer is sincere or not—and none of us appreciates being duped by clever craftsmen.

Photo 11. Suppose you found this imitation snapshot in a catalog that proclaimed it was profound because it portrays "the heaviness of a moment." Would you be convinced? Truthfully, the picture was quickly and carelessly snapped to record a temporary mood; the background is unimportant, and the cropping is awkward. It represents an imitation snapshot style after those seen in books and museums where similar photographs have been lifted to an artificially elevated status.

Photo 12. This rather unconventional composition won David Chien a Kodak/ Scholastic Award in 1975, but it's an atypical winner. Why was the boy's head cut off? Why feature the steps so dominantly? The answers probably have something to do with personal aesthetics. Perhaps the photographer wished to symbolize social pressures. However, there's a welcome simplicity to the image which in color might have been even more memorable.

11—A nondecisive moment may be passed off by pretentious photographers as meaningful because it's ambiguous and somewhat bizarre.

12—David Chien's unusual composition is simple, unconventional, and contemporary in style.

13—There's a mystery to this image similar to others described as having "inner vision," a synthetic mystique based on incongruity and inscrutability, both of which are artificial.

Photo 13. This is also a simple arrangement with all lines leading to the two figures. Do their attitudes and expressions create enough interest or impact within the total composition to make the picture worthy of exhibition? Consider the context in which the image is seen, for it might be consistent with an exhibition theme.

Photo 14. On seeing this scene in the camera finder, I recognized a mixture of mystery and confusion typical of the snapshot idiom. Subject contrast and detail might be interesting at first glance, but is there much lingering visual value to the picture? Is it made "artistic" by the combination of obscurity with sharp focus? I think not, but if I wrote an erudite caption hinting at "hidden meanings," I could indulge in articulate deception.

As a personal project shoot a series of snapshot-style pictures of ordinary subjects in color or black and white. Have prints made (or make them yourself) from the best negatives, or choose a selection of slides to project. Assuming that your craftsmanship is good (however unorthodox the photographs may be), "explain" the mystique which motivated you to create the images, using whatever words you feel viewers will find convincing. Be sure to include shots such as photo 14, which is entirely unworthy of serious attention. When you've made your points and elicited some response, let the audience in on the fact that it was all an experiment to show how word power influences visual perception. Whatever their reactions, you'll find it a valuable exercise.

Photo 15. The imitation snapshot can easily be journalistic and benefit from its reality, as noted in the next chapter. On

14—This was taken specifically to exemplify the worst type of imitation snapshot too often accompanied by articulate explanations of its "depth" or "luminosity."

15—A snapshot taken for fun is pleasant and unpretentious. It's a brand of personal reportage and needs no analytical verbal overlay.

leaving a supermarket I noticed this youngster having fun in the doorway, which opens and closes automatically. As casually as possible I prefocused a 50mm lens on a 35mm SLR and shot a few frames. The boy enjoyed showing off and continued to play with the doors, which he found would not close on him. I concentrated on his antics within an attractive setting where humor also contributed.

New Directions

As a closing note I recommend to you a picture essay in the July 1976 *Modern Photography* titled "U.S.A.: Pushing the Limits," which surveys the search for new boundaries in photographic expression. The pictures shown run the gamut from revealing illusions to provocative portraits to sophisticated surrealism. Julia Scully and Andy Grundberg, who selected the work of twenty-two photographers and wrote the introduction, said in part that some contemporary photographers have "abandoned the tradition of content developed during the century or so of photographic history." They added, "This outline may help reveal photography's new expression not as a chaotic abandonment of tradition and taste, but as a concerted exploration of the medium. We do know this is a time of great ferment and change in American photography."

Indeed, it's a time to forge new directions for yourself within the snapshot style or its derivitives, or through approaches explored in chapters that follow.

Chapter Checklist

1. The word *snapshot* has several connotations, depending on who defines it or what sorts of images are used to depict it.

2. In the hands of a skilled photographer, a relatively simple camera of good quality can be used to make photographs in the snapshot style with a sophisticated twist to give them more impact and meaning.

3. Snapshooting by the aware photographer often is employed with planned carelessness or reduced inhibition about composition and picture content. It's not always necessary to wait for "ideal" conditions. In fact, winging it at moments that seem right but not ideal leads to personal expression of potential merit.

4. Sophisticated snapshots depend on camera readiness—prefocused lens, cocked shutter, and mental agility. An auto winder or motor-drive can also be helpful for fast shooting when the element of chance is expected to play a role.

5. Try snapshooting with flash-on-camera in the news photographer tradition, or hold the flash above the camera for a less conventional look.

6. Some photographers shooting in the snapshot style pretend to be artless in an effort to be arty. Be on the lookout for imitation snapshots in books and exhibitions.

7. A clever, perhaps even artistic photographer is capable—through articulate deception and with outside help from a gallery owner or museum curator—of foisting inferior, sometimes bizarre images on even a wary audience.

8. Examine photo 10 and discuss the questions asked about it with friends or colleagues. Do you agree it's an "empty" snapshot? Are you familiar with the work of any photographers you would describe as representing this style?

9. Healthy controversy about pseudo-artistic photographic images in the snapshot style can stimulate you to explore this mode of expression for yourself.

10. In specific terms, determine for yourself what "tradition of content" in American photography means.

1—The author made this picture across the street from his home in frank (and satiric) imitation of the cover photograph on the book *William Eggleston's Guide* (Museum of Modern Art, 1976).

Street Photography

<div style="text-align: right">**6**</div>

Many photographers searching for visual stimulation find excitement in the streets, which includes parks, shopping areas, and many other outdoor locations. For years I've "hunted" in residential areas, around buildings under construction, down alleyways, or wherever people pass and congregate. I like Sundays and early mornings when shadows are long and just a few people are about, but crowds, such as you find at popular beach areas, are also a welcome challenge.

Street photography tests a photographer's reflexes. It helps to develop a sense of instant composition (touched on in chapter 5) when technique and instinct should merge spontaneously. Street photography keeps one alert to the odd and unexpected as well as the commonplace. I look for unguarded moments, close or incongruous relationships, patterns, action, reflections, and other kinds of contrasts. Whenever photographic lethargy seems imminent, take to the streets.

In the past, street photography was associated with downbeat and documentary images; the focus often was on slums and social problems. More recently, many other subjects—such as Wall Street financiers, pretty girls, and the everyday activities of ordinary people—have been pictured with a photojournalistic approach. Street scenes in foreign countries often are more appealing to the average photographer, because things look so "different." In any case, the most prevalent theme of street pictures is realism.

Photographers known for this style include Henri Cartier-Bresson, Elliot Erwitt, Mary Ellen Mark, André Kertész, Garry Winogrand, and Bill Eggleston. Perhaps you've seen *William Eggleston's Guide*, a book based on his exhibit at the Museum of Modern Art in New York. His color pictures of people and places (not all outdoors) have in common a mundane snapshot style which may intrigue or infuriate you with its pretense. In photo 1 I've imitated Eggleston's photograph on the book's cover for my own amusement. What meaning, if any, does my picture seem to have? Are the forms and tones enough to offer a visual treat? Whatever your feelings of the picture, Eggleston's images should be seen to represent his *own* artistic eccentricity. I've found that being provoked has positive connotations: it motivates me to examine my own concepts of the world through a camera finder. If such pictures aren't a treat, they are at least a treatment.

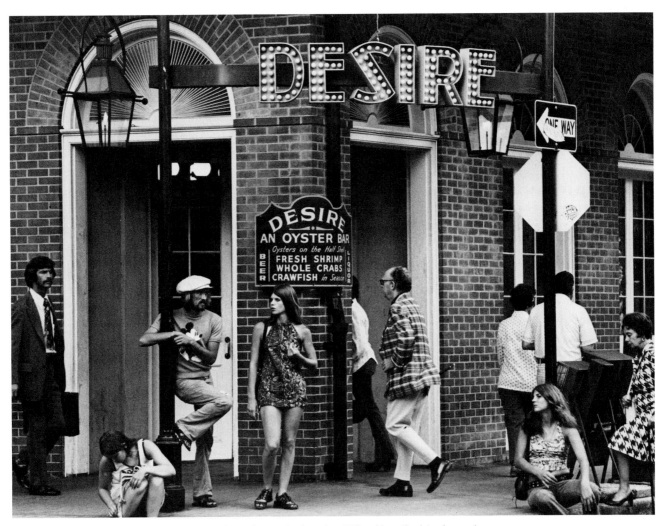

2—The quintessence of fine street photography is the work of Arthur Hiller (described in the text).

The Street Look

In a series of loose-knit categories this chapter presents examples of street photography to activate your imagination. As you explore the world with a camera, you may recall some of these images.

Photo 2. Arthur Hiller, a young Chicago photographer, has made what I consider to be a quintessential street photograph. It reminds me of Cartier-Bresson, who is one of the greatest practitioners of this genre. Arthur told me, "It was taken in the French Quarter of New Orleans with a 200mm lens. Because a thundershower was threatening, people seemed to be scurrying back and forth at this particular corner." Hiller stood across the street and made three careful shots, of which this is his favorite.

There are nine-and-a-half people in Arthur's remarkable pageant, and we are compelled to know more about them, who they are. Are two of the girls sisters? Is it chance that someone is entering at each end of the picture? The composition is busy but dynamic. It's a vivid slice of life which comes off strongly in black and white. Would color have been an asset—or a liability? When analyzing images, the mark of an excellent photograph is the determination that nothing about it should be changed, and such is the case with Hiller's picture: black and white is the perfect medium here.

Photo 3. Hiller's use of a telephoto lens in photo 2 represents one very effective approach to street photography. It allows a photographer to "move in" on a subject without intruding and often without calling attention to him- or herself. With a long-focal-length lens, there's more time to study and compose in comparison to the use of a wide-angle lens, which requires that the

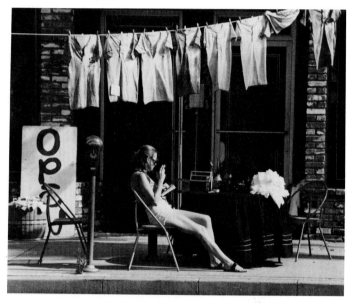

3—Subjects such as this abound in most neighborhoods and are challenges to alert photographers.

photographer be close to the subject (if he or she is to fill the frame) and that it be shot rather abruptly in order to avoid a self-conscious reaction on the part of the subject.

For photo 3 I used a zoom lens (80–200mm, a popular range), an especially versatile tool in such situations. A Sunday sidewalk sale on a business street near my home drew me to look for unusual relationships of people and their

4—Fifth Avenue, New York City. When you visit an unfamiliar place, its imagery may stimulate your urge to be expressive with a camera.

surroundings. This lady relaxed to music, read, and improved her tan while waiting for customers; I shot with the lens set at 200mm. The composition is quickly readable, and in color it might have been even more appealing.

Photo 4. The unfamiliar is always alluring to photographers. New York City is somewhat "foreign" to me, so it's not surprising that Fifth Avenue, complete with snow and bare trees, was an attractive subject. It was easy to carry a compact 35mm rangefinder camera and snap whatever caught my eye in passing. The following year I again did the same using color with equal pleasure.

If you've taken pictures many times in your own neighborhood, try a new location or pretend you're seeing the familiar as a stranger would. Shoot at night or in a season you haven't explored before. Switch to a lens with a new focal length, or vary your technique in any way that provides new stimulation.

Photo 5. The "streets" of Venice, Italy, symbolize the charm of any place, foreign or domestic, that may seem easy to photograph. "Who couldn't find good pictures in Venice or Paris?" you might ask. While it's easier to be visually attuned in Europe or wherever the scene is unlike your own surroundings, it nevertheless is difficult to avoid the cliché and the postcard approach. If you do shoot these types of photographs, try to look beyond them for images that are more personal, unusual, or exciting.

Especially when you travel, and the sky is overcast, take advantage of pastel hues in slides. If you can't wait for bright sun, cloudy days can be luminous, and adverse weather may inspire you to shoot distinctive photographs where others may disdain to shoot at all.

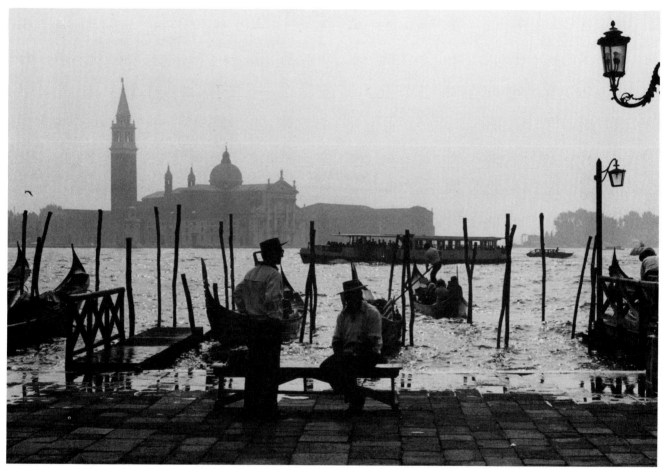

5—An overcast sky in an exciting place such as Venice, Italy, may help you take pictures unlike those found on most postcards. Carry and shoot both black-and-white and color film to exploit more opportunities.

Photo 6. With an extremely long lens like the 600mm used here, streets begin to look unreal because perspective is so compressed. This is the "telephoto look" that Andreas Feininger, for one, has used artfully for views of New York. If you don't own a long-focal-length lens, borrow one for the fun of it. Otherwise use a 2X or 3X extender on your 35mm SLR camera, together with the longest lens available. A 2X extender doubles the focal length of a lens (a 100mm lens becomes 200mm), and a 3X triples it. At the same time, effective aperture of the lens is reduced by a stop or more, which means an f/3.5 lens becomes f/4.5 or f/5. In bright enough light, this doesn't matter, and neither does the fact that an extender tends to reduce the ultimate sharpness of the lens attached. (When using an extender or a telephoto lens, shoot from a tripod for better sharpness, because the slightest camera movement is magnified by the long focal length. It's also easier to compose precisely from a tripod.)

People and Patterns

While people and their animation are good camera targets for street photographers, so are rivers and their bridges, store windows, signs, and many types of incongruity. Sometimes photographers wander along with specific targets in mind (such as pretty girls, à la Garry Winogrand), and at other times they may be open-minded and ready to record, or interpret, whatever comes along. Ordinarily you'll think in terms of a single picture, but keep in mind that one image leads to another, forming a series or sequence (a topic we'll discuss in chapter 11).

Photo 7. With the sea as a background, I was strolling along the palisades in Santa Monica, California, when I saw this attractive lady approaching. Working with a medium-

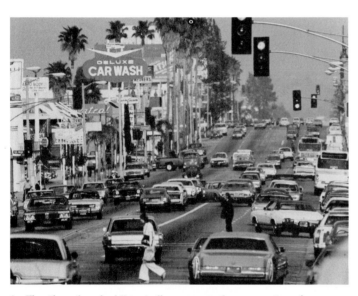

6—The "long-lens look" typically compacts the perspective of a scene and adds flavor to outdoor photographs.

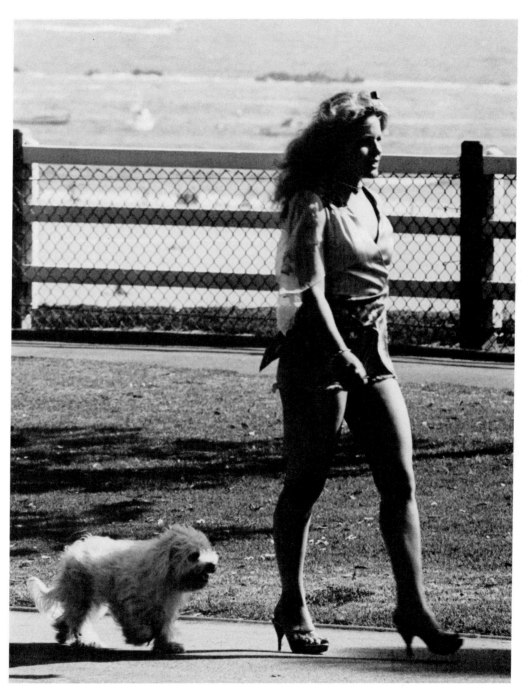

7—Human interest is worth searching for as a means of visual expression.

range zoom lens (75–150mm), I was able to stay out of her vision. When I enlarged the negative I cropped extraneous matter from the horizontal format. This is a situation where color film might have been preferable to contrast the figure with the green grass and blue sea, but I prefer to work with black and white in the darkroom, since color printing takes more time and is a lot more expensive.

Photo 8. A wide-angle lens on a 35mm camera also has its virtues in mobile outdoor situations. On crowded streets when you're fairly close to people, the wide-angle lens is a natural. I was wandering in a park when I caught this youngster with a 35mm lens; I shot quickly without stopping to focus. The picture has interest despite the fact that the child is centered. The blank background allows the viewer to concentrate on his face and gesture.

I mentioned not stopping to focus in reference to a zone of sharp focus that exists between specific distances at given apertures with any lens. The shorter the focal length of a lens, the greater the zone of sharp focus, or depth of field, at any given aperture. For instance, if I focus a 35mm lens at seven feet, I know the zone of sharp focus begins at about four feet and extends to about twenty feet when the lens opening is f/16. Thus, I was able to shoot photo 8 quickly without bothering to focus, because the child was about six or seven feet away. For quick reference use the depth-of-field scale on the lens barrel, and for exact figures check a depth-of-field table for each focal-length lens. Your agility as a street photographer is enhanced by prefocusing and "shooting from the hip."

8—Wandering with a prefocused camera makes it possible to shoot rapidly when you see fleeting images such as the gestures made by this cute youngster.

Photo 9. Still lifes abound along the streets and may be interpreted realistically, which I have done with this beautiful Italian shop window, or abstractly, as illustrated in chapter

9—No one need recommend a subject such as this to the alert photographer. The challenge here is to excerpt artfully and emphasize design along with detail.

9. It's a joy to find a subject combining fascinating detail with a pattern, both of which help to create visual impact. Here I had time to be selective, so I shot several frames with a 50mm lens on my SLR. In color the same subject can add an impressive change of pace to a slide showing, while in black and white it's easier to enlarge a cropped portion of the full negative as an alternate possibility.

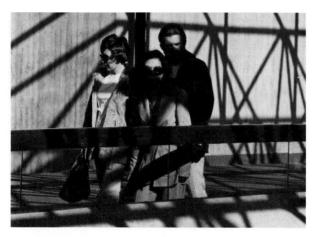

10—Street forms and shadow patterns are intriguing, especially with passing people thrown into the bargain.

Photo 10. Sometimes photographers find —and create—mystery in the streets where facial expressions or actions are unclear and shadow patterns fall strangely from overhead steel beams as they did here. When I first discovered this location I was driving by and had no camera on hand. A week later I returned with a short-range zoom lens to experiment with the unusual shadow effects. In half an hour I shot half a roll each of color and black and white, concentrating on the ambiguity inherent in the light/shadow play. Some of the pictures were too confusing, while others were unexciting. Photo 10 was cropped from a larger scene to eliminate nonessentials and emphasize the people under the shadows.

This brings to mind the "cult of the full negative," whose members insist that the original 35mm format be printed or projected *completely* (without cropping) or not at all. As I'll explain in the next chapter, when I work with a 4 x 5 view camera, or with any format, and the subject is static enough to allow careful, precise framing, I always try to compose tightly to avoid cropping later. This is an important discipline which is bound to make you more visually sensitive when shooting quickly.

However, when a subject is in motion, there's no reason to be rigidly limited to using a full negative or slide. There *are* a number of uncropped 35mm photographs in this book, but they do not represent a personal fetish. Many years ago when I photographed Man Ray I mentioned the cropping dilemma to him, and he exclaimed, "Why should you be restricted? Just because a manufacturer happens to make printing paper 8 x 10 or 11 x 14 inches doesn't mean I must conform to that shape. I crop as I care to." Of course, he was right: we need freedom of format. Often the pictorial content of a photograph dictates its use as a full image or not. By all means, try to shoot in ways that preclude cropping, but don't confine yourself to a format—that should evolve from the subject matter and other circumstances.

Photo 11. In most neighborhoods commonplace subjects can be *seen* as uncommon picture possibilities while the photographer roams the streets in sensitive contemplation. This small-town garage was closed in early morning, but the geometry of its forms reminded me of an Edward Hopper painting. To accent shapes and tones I printed almost the full negative on grade 5 paper for greater contrast.

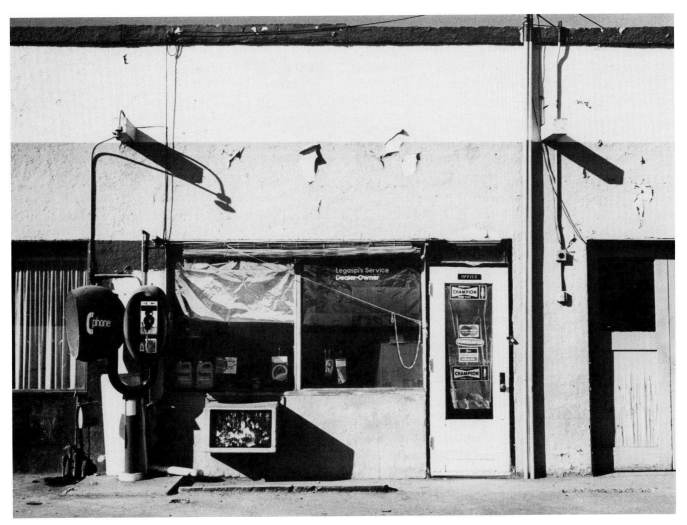

11—Familiarity with painters Edward Hopper and Piet Mondrian influenced the author's choice of subject and camera position.

Influences from both painting and photography are valuable to self-expression with a camera. Hopper is noted for his chiaroscuro and his simplification of realistic scenes. There's also an overlay of influence here from another favorite painter, Piet Mondrian, who emphasized strong horizontal and vertical oppositions in abstract form. Among photographers, Harry Callahan is distinguished in this genre, and decades ago Paul Strand did

12—Ambient humor is difficult to find but worth the exploration.

wonderful things with the lines of a picket fence in front of a simple farmhouse.

The more familiar you become with fine art in various mediums, the more effectively your visual perception responds to subjects that others may ignore. By studying many styles you also learn to distinguish between potentially exciting images and those that are trite or bland.

Humor and Distortions

Street photography is people, places, and things photography. It's a wide-open category, which is one reason I recommend it for combatting boredom. There's much that's humorous in what people do, but intentional distortion often is a useful technique for supplying or creating humor. The alert photographer avoids exploiting others, however, and learns not to depend purely on optical contrivance.

Photo 12. More than one book has been done about funny signs or the amusing juxtapositions found in everyday circumstances. Depicting humor with a camera is difficult, except when people are doing amusing things, but the search for it is challenging. Here I used a wide-angle lens (28mm) in order to show both foreground and background in sharp focus. The picture is not meant to have any lasting significance, but expressive photography need not always be profound or serious to be fulfilling. Visual puns require skill that helps keep the wandering photographer alert.

Photo 13. The camera can distort reality to our pictorial advantage. In this case a 15mm fisheye lens bowed the street and compressed a massive building for a grotesque— and dramatic—effect. Experiment with wide-angle lenses for amusement and whatever benefits evolve from their individual interpretations of perspective. Each focal length, from fisheye to 35mm, will bend and twist form and space in ways that can be exploited.

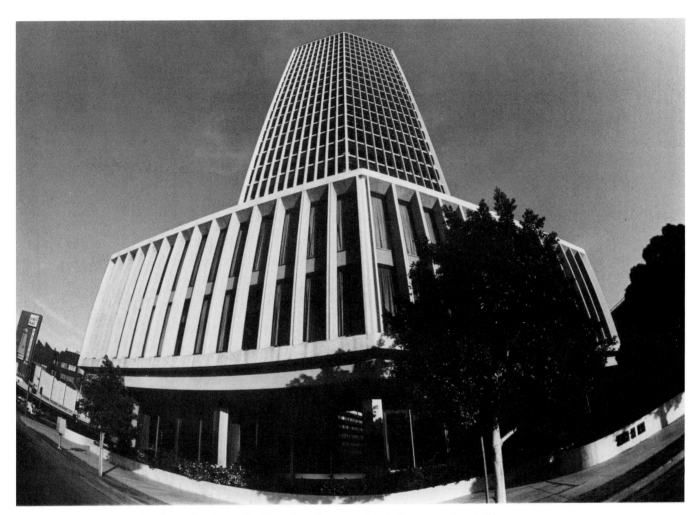

13—Intentional distortion by the choice of lens focal length makes a good topic for an ongoing project.

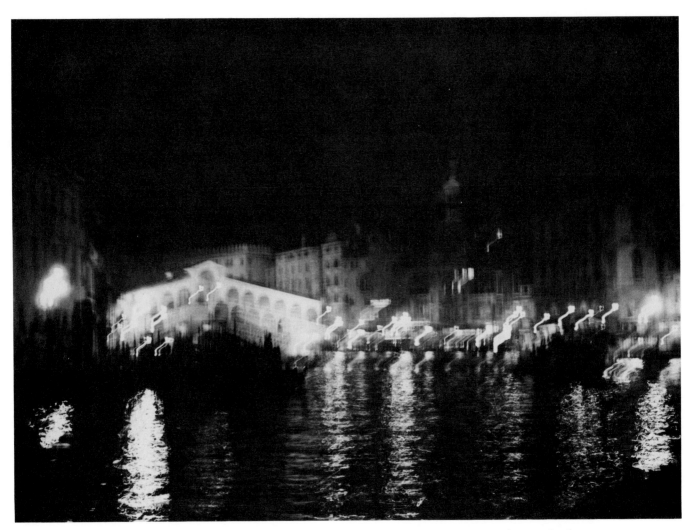

14—Night lights turn into exciting patterns when the camera is moved intentionally during an exposure of a second or longer.

Photo 14. Shooting on the streets after dark is a special adventure, whether you use a tripod, brace the camera, or take advantage of movement. Ordinarily, when a subject is moving, I like the blur that can only partly be anticipated with slow shutter speeds or time exposures. When hand-held exposures are longer than 1/30 second you can expect some camera shake, and the longer the exposure, the greater the role serendipity plays.

Even with my elbows braced on a bridge over the Grand Canal in Venice, Italy, I knew my negatives wouldn't be very sharp, so I deliberately added more camera movement. Half a dozen shots were taken at a series of exposures, including 1/2 second, 1 second, and 2 seconds, with a 100mm f/2.8 lens set at f/4. The film was Plus-X, which isn't ideal for fast shooting at night, but when you wish to play with the possibilities of blur, a medium-speed film is an asset.

Picture Projects

Street photography lends itself to personal picture projects. Proceed as follows:

• Choose a theme that seems promising, beginning with familiar subject matter, and shoot a series of pictures over a period of time.

Sample topics might include "People in a Hurry," "Animal Antics," or "Faces in the Crowd." Work in a variety of locations where your theme motivates you to experiment. Be selective, but don't try to conserve film if it means sacrificing an opportunity that may not repeat itself.

• Once into your project, analyze further possibilities to enlarge the scope of visual expression. Change places, camera positions, or anything that gives you new enthusiasm along with added opportunities. A picture project is a self-assignment—you're in charge. However, you may benefit by discussing your work with knowledgeable friends.

• Allow chance to broaden your photography, but don't depend on it unless you know the odds are in your favor. Plan ahead to be in

15—A photographic project you assign to yourself is a stimulating way to grow and enjoy using a camera. This might be part of a series called ''Through Windows and Doorways,'' which could be both real and surreal when reflections and interior scenes blend. (Should you use such a theme, take care not to invade a person's privacy in an annoying way.)

the right place in the right light, or to be there when something worthwhile is happening.

• Edit your pictures carefully, tossing out duplications and images that don't measure up in quality or content. Eliminate even acceptable pictures that are inconsistent or distracting. Try to include surprise, drama, and mood for effect.

• When it's feasible to do so, reshoot to improve or augment your theme. This is comparable to a writer who revises and polishes his or her prose.

• Consider the project complete when you've exhausted the practical possibilities or when the effort becomes tedious. Make a set of prints and arrange them in logical sequence to show or exhibit, or edit slides for an orderly display. Think about what you've learned and how your vision has grown. Based on these accomplishments, plan a new project.

Many street photographers have turned picture projects into photographic books, an example of which is Garry Winogrand's *Women Are Beautiful.* Visit libraries and bookstores to increase your visual awareness and, perhaps, to gain inspiration from the work of others. Street photography of commonplace subjects is a pleasant and expedient path to self-expression.

Chapter Checklist

1. Street photography is a stimulating challenge, but it's not a cinch—even though the subject matter is available everywhere. Look carefully at pictures by Cartier-Bresson, Elliot Erwitt, or Garry Winogrand, and analyze what makes their work distinguished, if you like it, and what characterizes it, if you dislike it.

2. If possible find a location in your own neighborhood and stand by waiting for a picture situation that might be slightly similar to the New Orleans photograph by Arthur

Hiller. Think of mood, spontaneity, and impact in color or black and white.

3. Visit someplace new, in a rural area or a large town, where your impressions of people and structures along the streets can benefit by your attraction to the unfamiliar.

4. When you travel, take advantage of overcast days or nasty weather, because the typical pictures have been taken in bright sun.

5. Thinking in sequences helps create picture stories that may take place in a few moments or over a period of time.

6. Prefocusing your camera and using an f/stop small enough to provide adequate depth of field are excellent approaches to street photography.

7. Try to emphasize the mystery of a particular locale by making the most of lighting effects and people/structure relationships.

8. Trying to compose in order to print or project a *full* negative is a worthy effort, but when enlarging a picture, cropping often can improve it and shouldn't be ignored.

9. The geometry of painter Piet Mondrian's work has influenced countless photographers, particularly where man-made structures are concerned.

10. Capturing humor on film is often difficult. It shouldn't depend for effect on ridicule or exaggerated distortion at someone's expense, so look for humor that is indigenous to the situation.

11. At night, streets (and canals) are visually exciting for reasons not present by day. Taking chances with time exposures pays off.

12. Choose a picture project and make an informal "script" or list of pictures you hope to take. Don't be hedged in by the list or frustrated if a photographic possibility eludes you too long.

13. Like so many avenues to expressive photography, street photography offers mind-expanding opportunities.

1—Styles in scenic photography vary widely from superrealism to superficial, salon-type images. This marsh at sunset represents aesthetic realism.

Scenics and Studies

There's an aesthetic satisfaction to be had in shooting distant views or details of the landscape, seascape, or cityscape—in realistic or abstract style. For some people, scenic photography is a prime source of self-expression, but the word *scenic* doesn't mean the same to everyone. It can connote images that are sharp and literal, soft and romantic, or merely "pretty." When the literal camera eye was discussed in chapter 2, the distinction was made between painterly soft focus and overall sharp focus, both of which spring from the traditions of the nineteenth century when photography was coming of age.

Unfortunately, pictorialism persisted in the twentieth century, influenced by academic painting as well as photographic "old masters." In what was known as salon photography, scenics were sometimes saccharine, compositions were formally ruled by contrivances such as "S-curves" and "dynamic symmetry," and sepia-toning sought to imitate the look of aging nineteenth-century prints. For years salon photographers' favorite subjects were wagon wheels, puffy clouds, and grizzled old "prospectors," who were really bearded models in hired costumes. There was general confusion about sharpness. Some felt it was a great technical

accomplishment to prettify the subject, while others worshipped diffusion, using textured papers and various devices to soften definition. When 35mm cameras and film were introduced, the new "miniature photography" was thought beneath the concern of serious salonists whose larger cameras provided all that "detail" they managed to divorce from substance.

Realism and Sharpness
In the evolution of photographic style, strongly inspired by artists such as Paul Strand and Edward Weston, picturesque scenics gave way to well-defined, directly conceived images of nature without con-trivance. The old pictorialism attempted to add a veneer to reality, while the new tradition tends to probe beneath surfaces. Photo 2 by Harry Callahan symbolizes what I mean. No salon photographer of the idealizing school would aim a camera at such relics as these ancient windows unless they could in some manner be disguised or beautified. But modern realists are refresh-ingly honest. Harry Callahan used an 8 x 10 view camera on a gray day to picture these windows for their design, textures, and perhaps for their social connotations.

While nineteenth- and early twentieth-century photographers favored conventional —often static—compositions, the newer tradition, influenced by modern painting, is more dynamic and flexible. Arrangements may sometimes be predictable, but rigid formality is out: composition often is dictated by the subject matter and the personal vision of the photographer. The salonist style was shallow, and though sharp-focus realism isn't original and meaningful per se, it's an honest effort to gain strength of image through the

2—Strong, direct, and thought-provoking. This image by Harry Callahan, made with careful view camera vision, makes black and white seem "colorful."

3—Much scenic photography demands a deliberate approach using a camera on a tripod, such as the view camera, with which this rocky California setting was interpreted.

indigenous qualities of the photographic medium.

The Purist Tradition

I've experimented with many photographic styles, and I'm intrigued with the bizarre and the surreal, but I continue to enjoy a straight or "purist" approach to scenics, nature, and people as well. In the sense that Edward Weston, Paul Strand, Walker Evans, and Ansel Adams practiced their art, purist denotes a direct, nonmanipulative use of camera, lens, film, and image presentation. These men (and a few women, such as Imogen Cunningham) enjoy the admiration of a wide variety of people, many of whom are artistically unsophisticated. Their images combine purity and poetry and have lasting aesthetic value.

Another direct approach to natural phenomena is exemplified by the fine color photography of Ernst Haas, which can be found in several of his books such as *The Creation* and *In America.* He shows us the earth and man's influences on it with beauty and occasional surreal vision. Consider also Ernest Braun's marvelous glimpses of nature in his book *Living Water.* These are but a few of the "new masters" stretching the purist tradition within their personal disciplines.

The purist approach often is slow and deliberate and is based on using one's perception to previsualize a composition before viewing it through a camera eyepiece or on a ground-glass finder. This may sound like a chore to anyone accustomed to lifting a 35mm SLR to one eye, focusing, and snapping quickly, but careful photography in this manner has never been outmoded. Many of us learned the basics with a view camera, but with the easy accessibility offered by the 35mm camera, the view camera often is

neglected. Now there are lightweight 4 x 5 models on the market, and no longer do you have to haul a heavy, metal view camera up hills or along trails.

Edward Weston, Wynn Bullock, Harry Callahan, and other realists are known for their use of the 8 x 10 view camera; often they print the complete negative. Photographers following this discipline who prefer 4 x 5 cameras compose the full format and do not crop when enlarging. Working carefully on a tripod and without an eye-level viewfinder affords thorough concentration when dealing with static subjects and may be a relief from photography with hand-held cameras. Film processing and printing are also meticulous procedures here, but time and effort are rewarded with image detail and unmatched tonal range.

Photos 1 and 3, among others, were taken with a 4 x 5 view camera. In some ways they are traditional scenics, but each includes an emphasis on subject matter that goes beyond just being pretty. Photo 1 is most likely to be shot in color by the average person, but Harry Callahan's photo 2 is quite at home in black and white. When I explored California's rugged Alabama Hills (adjacent to the Sierras in the background) for photo 3, I simply looked for compositions that pleased me. I try to have a fairly accurate concept of what I'll see in the ground glass before I bother to set up the 4 x 5 and zero in on a scene. In this respect it's a lot more expedient to use a smaller camera—with a readily accessible finder—as demonstrated in photos 4, 5, and 6.

4—A hand-held 35mm camera makes aesthetic selection more expedient, especially when shooting in city streets.

Small-Format Exploration

Photo 4 is the kind of scenic subject ideally adapted to a 35mm or medium-format camera. It's usually difficult to work with a view camera on city streets, but photos 4, 5, and 6 (and many others in the book) demonstrate that sharpness and a deliberate approach to composition aren't exclusive to large, slow cameras. Photo 4 was taken with a 24mm lens and Plus-X film, which has beautiful contrast and relatively fine grain. Buildings and architecture in general offer many possibilities beyond recording mere shape and size. Even the Taj Mahal needs an imaginative approach to become more than what is seen in the average slide for sale by nearby souvenir vendors. That's why early morning and late afternoon are favorites of professionals and smart amateurs; the light helps to dramatize form, and color is soft and warm.

When you can't relate a structure to its surroundings in a way that satisfies your aesthetic needs, try shooting a portion of it (as illustrated in photos 11 and 12). In photo 5 photographer Aaron Siskind shot an excerpt with a medium-format Rollei SL66. Here he printed the full negative of a tree on Martha's Vineyard, where he's been doing a continuing series of the same tree. Siskind is noted for his images of walls, signs, peeling paint, and rocks seen in elegant compositions that are sometimes abstract designs. He isolates a minute section of the world so we can see its beauty uncluttered. In the manner of other fine photographers such as Clarence John Laughlin and Eliot Porter (to name but a few), Siskind never emphasizes style at the expense of subject matter.

There are a number of medium-format cameras to chose from, among them models made by Rolleiflex, Pentax, Kowa, Mamiya, Bronica, and Hasselblad. Some are fairly

5—''The Tree'' in Martha's Vineyard, 1972, photographed by Aaron Siskind with a Rollei SL66 camera. Noted for his isolated designs of walls or peeling paint, Siskind has made studies of this tree in many lighting conditions and seasons.

heavy, but all may be hand-held, and on a tripod they offer superior sharpness not possible from 35mm enlargements beyond 8 x 10 or 11 x 14.

Including People

Some scenics are improved by the presence of people, and in some studies where nature or man-made objects form the background, the human figure is the dominant element of the composition. Beautiful landscapes or seascapes can of course be shot without people, but sometimes a scene seems empty without a person in it. There are no rules here, so individual taste must decide. The following are examples of situations where people are assets.

Photo 6 was taken on an abandoned movie set situated in what is now a state park. On my first visit I was alone and wishing I had a model, though I did find water patterns and a few abstract designs of interest. On my second visit I brought along a friend who hadn't modeled previously. I told her to relax, and that I wasn't really taking pictures of *her* but instead was making compositions of which she would be an important part. I also told her to improvise, and that sometimes her presence would give the picture an ambiguity I sought. Without her, some of the settings would have been dull and worthless.

She followed directions well, and her austere expression in photo 6 provided just the right note within the surroundings. I worked with a 4 x 5 Ikeda view camera but could have used a smaller-format camera, preferably on a tripod.

Photo 7 is of an authentic Norman farmer and his marvelously textured home—which I also shot from a slightly greater distance

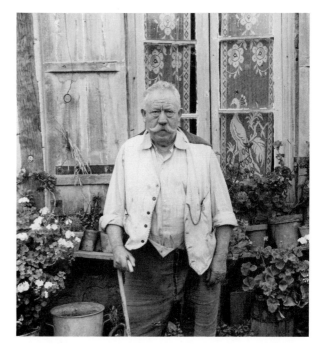

7—In the Normandy section of France a farmer, in front of his quaint little house, stood for his portrait, after I gave the man a Polaroid snap of himself.

6—An abandoned movie set becomes a fine pictorial subject because the model is there to provide an air of mystery.

without the gentleman. I asked the farmer to pose in front of his house and garden because I wanted a portrait and study of an individual and his own environment. Since my French is only fair, I caught the man's fancy by photographing him first with a Polaroid

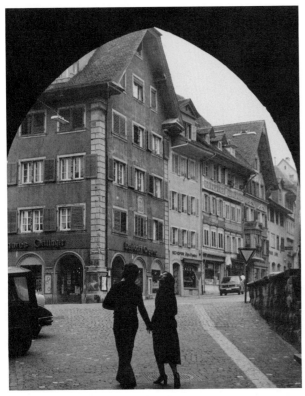

8—Instinct can be improved if you practice slow composition on a tripod and become more alert to changing situations as exemplified in this small Swiss town.

camera. When I handed him a print moments after I exposed it, he was amazed and charmed. Though he looks rather stern, his attitude was hospitable.

Scenic photography is satisfying anywhere, anytime. It's good practice to occasionally make deliberate compositions with any type of camera on a tripod. In being meticulous, intuitions about the relationships of forms in the camera finder become more acute. This

builds the confidence needed to shoot quickly in changeable situations such as the one I faced in photo 8. On reaching this archway in a small Swiss town, I realized it looked empty, but in a minute a couple came by. In my first shot both their faces were turned away, so I shot again as the lady looked around. My instinct has been sharpened through exercises with a camera on a tripod, and by composing slowly, my mind and eyes have become more agile for fast decision making.

In photo 9 Henry Lansford created a situation scenic as he was "poking around" one afternoon with his young son somewhere in Colorado. Lansford, who used a 2¼ x 2¼ camera, is a professional writer whose photography augments his work, but primarily he takes pictures for pleasure. He shared with me a few thoughts I think worth noting here:

"I've probably learned more by experimenting than any other way," he wrote. "I'm never stingy with film, and I've tried a lot of things that haven't worked, but I've broken some rules and gotten away with it. For example, late in the afternoon when I'm working without a tripod, I've learned to hand-hold my camera at slow shutter speeds such as 1/30 and 1/15 second. It doesn't bother me to throw away mistakes if they teach me enough to get a few shots that I'm really satisfied with.

"I've also learned by looking at photographs in magazines, exhibitions, and other places. I try to figure out how certain effects I like were achieved, and then I experiment with the same approach myself. I've also picked the brains of good photographers I meet.

"A lot of my best pictures were made by having a camera along and keeping my eyes open for combinations of form and light that came together to make a picture. For me, the primary ingredients of photography are first

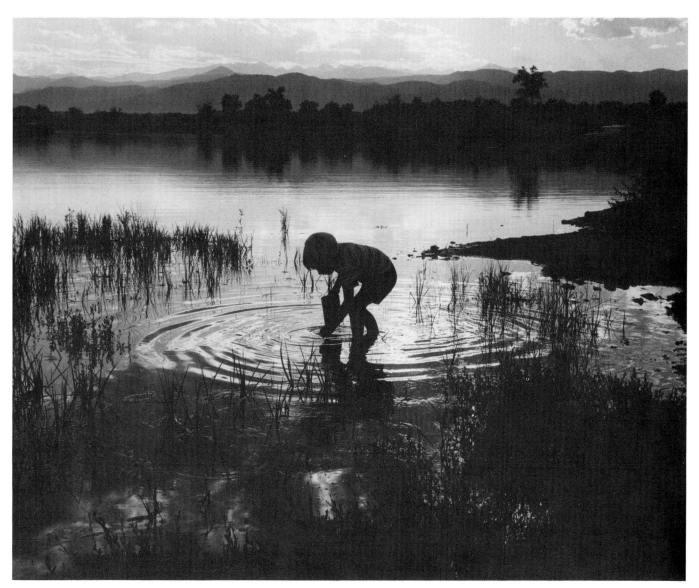

9—Henry Lansford explored a portion of rural Colorado and discovered the joys of dusk as his son collected tiny water creatures.

to master the technical fundamentals of getting the image on film, and then to practice learning to see pictures that are worth taking."

Henry Lansford's observations are astute and apply not only to scenics but to most of the categories in this book as well.

Excerpting Reality

A landscape or seascape is a rather wide view of nature taken from some distance. To me, a scenic picture that concentrates on a portion of a landscape, for instance, is a study or *excerpt* with a visual validity of its own. Details discovered in a large scene gain new identity as excerpts, and occasionally they become abstractions.

For instance, photo 10 is an area about twenty-five feet wide which is part of a marsh that possessed little aesthetic potential in its entirety. But here the play of light on strangely textured water and the peculiar shadow that lay across highlighted foam became a design in the camera finder. I had a vantage point above the marsh and took my time shifting image size and content with a 65–135mm zoom lens on a SLR camera. In perhaps ten minutes I made only three exposures, so most of my time was spent eliminating possibilities. This takes patience and a willingness to reject, or even walk away from, unattractive options. When in doubt, shoot, but once you've gained the experience that comes with second-guessing yourself while editing slides or contact prints, being particular comes easy.

Photo 11 is an excerpt that became an abstraction with recognizable features in it. My aim wasn't to show the inside of a vintage

10—Careful selection through a zoom lens resulted in an excerpt of a marsh that had little photographic merit as a whole.

11—Reality that lends itself to abstract design is exemplified in this image of an antiquated automobile door, which looks a little like a hard-edge painting in color.

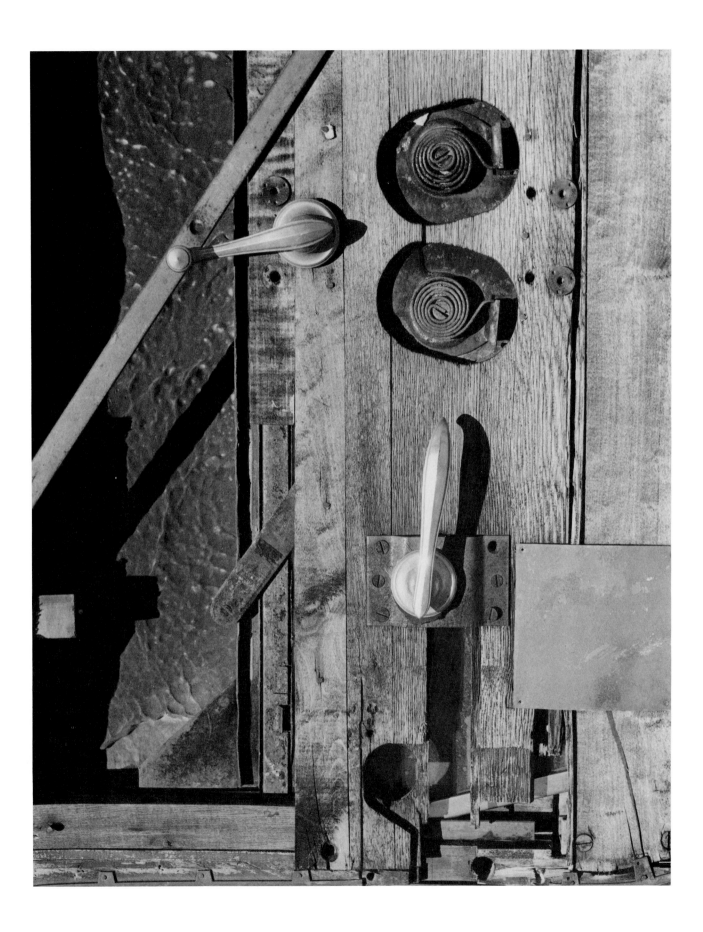

12—An old relic of a hotel, like junk and other ruins, is visually exciting subject matter. I liked this excerpt better than the entire facade.

automobile door, but to capture on film an arrangement of those parts that pleased my sense of design. I liked the essential verticality of the whole interrupted with circles, rectangles, and a strong diagonal. The hardware was conceived as shapes and textures which are also able to tell a story about their own existence. Photographers expect to go through a visual struggle in such a situation, but the artistic rewards make the effort worthwhile.

This is a good opportunity to make a personal pitch about the merits of junk and ruins as prime photographic subjects. When nature weathers man-made materials and structures, literal appearance fades and is replaced with new combinations of form, color, texture, and meaning. Peeling paint and broken glass, for example, create patterns within which a critical eye can find pictures. Age does things to materials that makes them beautiful, and people do things to their structures to give us an endless supply of picture possibilities.

Consider the visual treasure time has created on the facade of a decrepit hotel on the outskirts of Paris (photo 12). In the first several shots I included the street and three floors. I then changed lenses in order to show just a portion, or excerpt, of the total. My senses responded to this lovely relic as a visual treat, but later, on viewing the print at leisure, I could ponder the human equivalents suggested in the character of the old building. Whether one photographs to capture meaning or sees form, color, and texture through the camera finder, there's a great deal of satisfaction to be gained in this expressive medium.

Still Lifes and Close-ups
Painters have always found aesthetic challenge in still lifes. (Paul Cézanne comes

to mind as among the greatest of the still-life painters.) However, many photographers ignore the possibilities of still life or think it's "corny." It's often equated with "tabletop" photography, which involves the arranging of miniature objects to simulate a real scene. Tabletop pictures usually have an obviously synthetic look, but a carefully crafted still life can be a means of expressing a personal style.

Consider photo 13 by teenager Thomas Balla, who became intrigued with food photography while watching a professional

13—Thomas Balla finds a challenge in food photography, which is a type of still life that offers excellent opportunities for lighting practice and training in composition.

demonstrate his skills at a photography convention. For the original shot (in color), Balla patiently stacked crackers as a backdrop for the cheese and lighted the arrangement simply with one floodlight from the top right

14—Close-up photography makes possible selective focus to create soft backgrounds for detailed foreground subjects.

plus a small reflected light to fill the shadows. Balla used a 4 x 5 view camera to create this Kodak/Scholastic Award winner, but it could have been taken with any size or format.

The most important aspects of still lifes are composition and lighting. When experimenting, remember that daylight entering from a window or doorway also has beautiful potential and that white cardboard or a foil reflector can be used to illuminate shadows. Still life offers one of the best means for lighting practice with floods, electronic flash, or daylight, and what you learn applies as well to portraiture.

Close-ups

Shooting close-ups with a reflex camera or view camera moves one into a new world of photographic expression. Here a photographer can record detail hard to see with the naked eye and can interpret, through extreme close-ups, to create abstractions of aesthetic distinction. Wynn Bullock spent a number of years experimenting with tiny reflecting objects photographed an inch or less from the lens of a 35mm SLR. His color abstractions have been exhibited but never published, and I mention them as another means of motivating the neophyte to search for new approaches in the close-up field.

The most useful close-up tool is a single-lens reflex, to which any one of the following may be attached:

• A macro lens designed especially for close-up work, though it may also be used for general photography. With the average macro lens you can expect to shoot an object life-size, or 1:1, and half life-size, which is 1:2.

• Close-up attachment lenses available in sets of two or three, which provide a magnified image and can be used with the taking lens individually or in pairs.

• Close-up rings mounted to the camera body, which extend the lens mounted to them for close focusing.

• A reverse adapter, which allows the photographer to mount a normal lens to a camera in reversed position, providing better close-up capability.

• A macro-zoom lens, available in many focal-length ranges, which can be used for general photography but also provides an average 1:2 close-up image. Some models allow you to zoom at close range, and others include a macro mode at one focal length only.

The closer a photographer focuses to a subject, the less depth of field any lens produces. For this reason close-up photography is more efficient from a tripod, but the selective focus capability of close-up equipment can be used to creative advantage with a hand-held camera as well. Photo 14 was shot with an 80–200mm zoom lens, which produces a 1:2 image and usually ensures an out-of-focus background, even at f/16, the aperture used for this picture. In color, background hues blend pleasingly and become anonymous, as did the leaves behind the flower in photo 14.

Depth of field in close-up photography is measured in fractions of an inch. Knowing that a limited plane in your picture will be sharp and that the rest will be soft-focus is an asset of the macro, or close-up, world worth exploiting. You can isolate tiny details and adjust the lens opening for selective focus in ways that are visually exciting.

Photo 15 is a close-up excerpt of finely eroded tree bark, the texture of which is enhanced by overhead sunlight. A macro lens or close-up attachment might have been useful in this circumstance, but because the normal 50mm lens of an SLR will focus to about eighteen inches, it was all I needed.

15—Tree bark photographed with a normal 50mm lens focused about eighteen inches away. With a macro lens or close-up attachments, it's possible to work within a few inches of a subject.

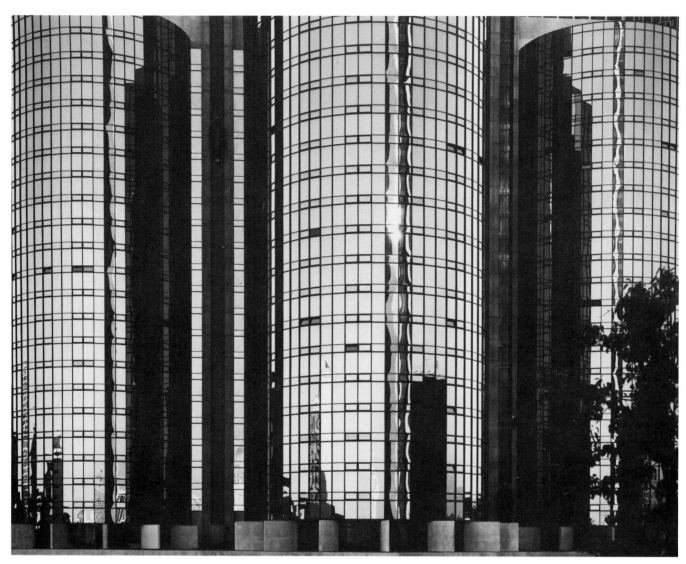

16—A modern hotel with glass-and-steel facades becomes an exciting play of forms, lines, and shadows in this view camera study.

Shorter focal-length lenses, such as a 35mm lens, focus even closer than the 50mm without attachments, so experiment with equipment on hand if special close-up accessories aren't available.

Think about planning a personal project of intriguing macro-style images, which may be literal or abstract. Subject matter is unlimited and may include seashells, bread crust, shag carpeting, leaves, wood grain, or anything that appears with enough definition in very close focus. Such a project can test your imagination and skill as well.

Chapter Checklist

1. Nineteenth-century pictorialism was characterized by technique as well as choice of subject matter. Unfortunately, some static tendencies of the less mobile nineteenth century carried over to the technically astute twentieth century, particularly where scenic photography is concerned.

2. Realism, sharpness, and the purist tradition are all related. Consider what these words mean to you in terms of photographs you've seen or would like to take.

3. The inherent sharpness and potential beauty of a black-and-white contact print make it distinguishable from an excellent enlargement of the same size from a smaller negative.

4. Harry Callahan is one photographer whose work shows his exploration of styles and approaches, all presumably evolved from personal growth.

5. Extracting strong images from nature or from man-made objects is typical of the work by Edward Weston, Aaron Siskind, and Clarence John Laughlin.

6. There are many ways of including people in scenics and studies. Sometimes the human figure is incidental to a composition and other times it is dominant.

7. Learning to direct people, professional models or otherwise, is one of the accomplishments behind successful photographic expression.

8. "It doesn't bother me to throw away mistakes if they teach me enough to get a few shots that I'm really satisfied with" is a useful bit of guidance from a potential professional photographer.

9. Learning to see a part of the whole is called excerpting.

10. An abstraction is an excerpt of reality that has lost its primary identity and may appear to be pure pattern or at least is unrecognizable. Ruins and junk in general are appropriate subjects for abstractions.

11. Many photographers avoid still life—perhaps because it seems contrived—but making setups for the camera can be valuable exercises in opening creative doors.

12. Close-up photography is a means of examining ordinary subjects in detail to find visual excitement that might otherwise be overlooked.

13. In the past few years many zoom lenses with close-up capability have become useful tools for the photographer. When used on a tripod, a zoom affords great close-up versatility.

14. There's a lot more challenge in scenics and studies beyond the pretty postcard or the static pictorial with a nice, "safe" composition.

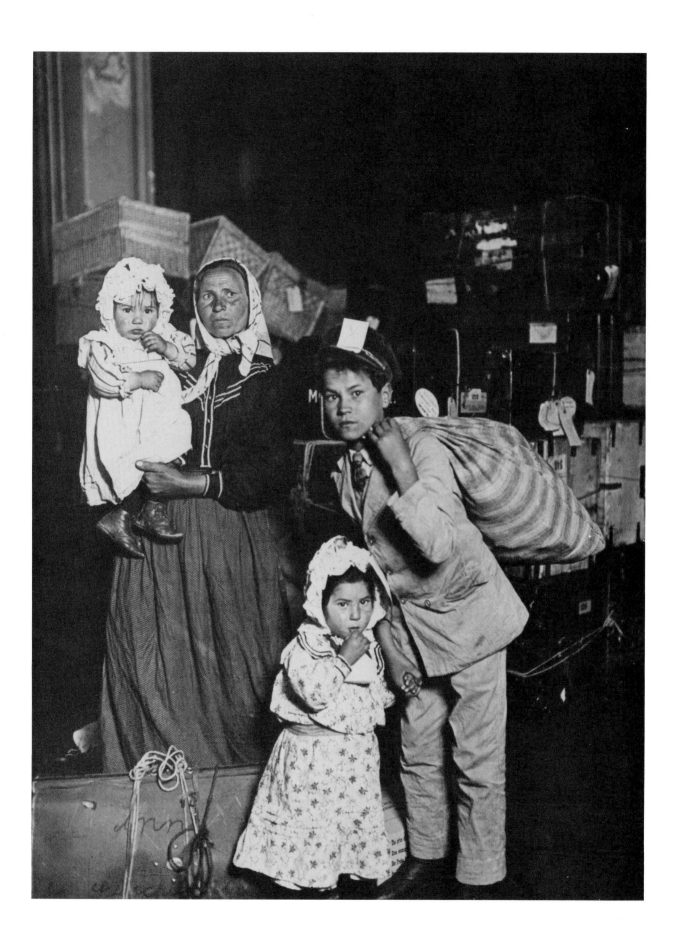

Social Comment and Reportage

8

While discussing photographic purposes and styles in chapters 1 and 2, I mentioned news pictures and reportage in connection with the popular picture magazines and I pointed out the importance of the Farm Security Administration (FSA) work, which itself was influenced by documentary photographers like Lewis Hine and Jacob Riis. There's more about documentary photography in this chapter; it's part of a tradition which may help expand your own personal expression.

The documentary approach seeks to convey social comment through reportage. It's usually practiced by dedicated professionals trying to sway the minds of viewers or undertaking crusades for justice. Does that sound pretentious? What has this to do with the use of a camera for creative recreation? The answer lies in the individual's degree of involvement with the issue being reported or championed. On the one hand, reportage can be a serious expression of strong convictions which the photographer may communicate through slides and prints. On the other hand, reportage can be a casual, though challeng-

1 —Lewis Hine photographed this Italian family just as they arrived at Ellis Island in 1905. Hine, who was a pioneer in documentary photography, influenced social consciousness in his own time and, indirectly, through Roy Stryker and the FSA later in the 1930s. From George Eastman House Collection.

ing, medium with no special aim to "say something."

Life and *Look* published hundreds of picture stories meant to inform rather than persuade. In your own way, with your own resources, you too can examine human events with a

2—Happenings everywhere are targets for personal reportage. These dancers, entertaining students on a high school campus, were photographed with a medium-range zoom lens on a 35mm SLR camera.

camera. Eliminating inaccessible topics such as wars, disasters, celebrity capers, or underwater treasure hunting, subjects such as these could be typical to your experience:

- A high school graduation ceremony and its significance for a teenager, your own or one you know well.
- A day at the zoo, including pictures of funny animals and amusing spectators.

- The effects of tourists on a nearby forest, beach, desert, or wherever you feel there's a story to tell.
- Poetry or prose illustrated, either something you have written or a favorite author's work.
- Your city's skyline and how it's changing, especially when there's construction you can follow routinely.

I'm certain you can devise worthy picture projects of your own that test your prowess as a reporter on significant or frothy subjects. Some of the material that follows may seem rather "heavy" in relation to the incidental nature of the themes you choose, but absorb it for its subliminal value. You never can tell when you'll be inclined to shoot a situation reminiscent of an FSA picture implanted in your memory.

Documentary Photography

The direct documentary style involves showing things as they are, without contrivance, and occasionally with an axe to grind for a cause. A lot of photo propaganda has been disguised as documentary, so the viewer must analyze pictures (and words) to discover their truths according to his or her own subjectivity. Matthew Brady and his dauntless crew photographed the Civil War to create an honest document, and the positive power of the camera has been recognized ever since. Jacob Riis was a newspaper reporter who took up the camera in the late nineteenth century to communicate the misery of New York slums. After him, Lewis Hine unmasked the terrible working conditions for children in the eastern United States. Hine, a trained sociologist, claimed he wanted to "show things that had to be corrected . . . and things that had to be appreciated." This quote is from *Lewis W. Hine* (Viking, 1974), one of a series of

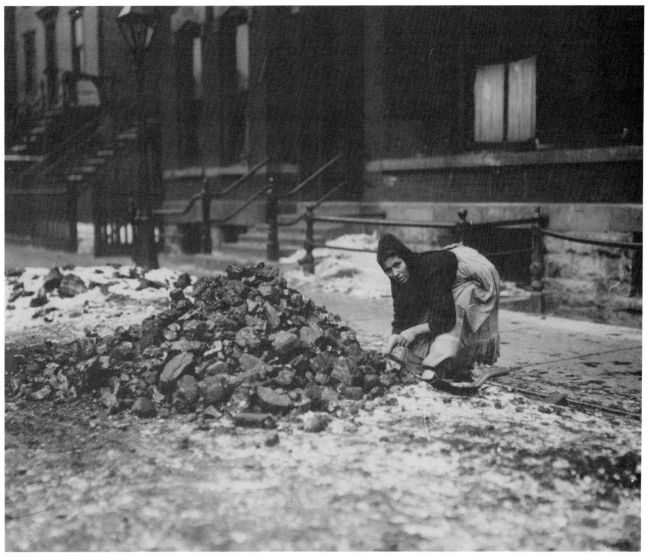

3—Another moving image by Lewis Hine titled "Tenement Dweller Carrying in County Coal, Chicago, 1910." His skill at capturing real-life situations so early in the century is still impressive considering his primitive equipment and films. From George Eastman House Collection.

4—Walker Evans was interested in both social documentation and aesthetic expression during his association with the FSA. Evans photographed this boarding house in Birmingham, Alabama, in 1936.

books motivated by the International Fund for Concerned Photography that also includes neat paperback volumes on other concerned photographers like Robert Capa, David Seymour, and Werner Bischof. Working in the early twentieth century Lewis Hine used, by our standards, primitive equipment and films. But he thought of himself as a teacher, and his feelings filtered through to others by the compelling character of the images he made.

It's interesting that Hine's last large photographic project was to record the construction of the Empire State Building, which began in 1930. In the 1920s and '30s, he was also a strong influence on Roy Stryker, the man who organized the FSA effort, which itself has made a profound impression on the world of reportage photography. Study the pictures of Dorothea Lange, Arthur Rothstein, or Walker Evans in *A Vision Shared* and *In This Proud Land*. They're the forerunners of modern photojournalism as practiced by many important men and women such as W. Eugene Smith, Margaret Bourke-White, and David Douglas Duncan.

Since Brady, Hine, and the FSA, there's hardly a subject that hasn't been touched by the objective camera. Stirring the mass social conscience has become an honorable tradition. Though I'm hardly urging photographic rabble-rousing, there's no reason why you can't attempt to reflect the issues and conditions of our times with a direct, documentary approach if the effort is satisfying.

Social Comment

Today "concerned photographers" seek to reveal the events and problems of the world through exhibitions or publication of their work in books or magazines. At the more serious end of the scale, man's inhumanity to man will always be an emotionally moving topic, and an aspect of this is the state of our environment. Photo 5 might have been taken to help expose pollution in a public park. I was first attracted to this scene by the interwoven

5—Comments on your own environment can be effectively stated with a searching camera.

pattern of debris glistening in the backlight. Later I realized how the image, shot with a 50mm lens on Plus-X film in an SLR, comments on city people who foul their own nests. You might very well undertake a similar picture project related to improving the state of the land, air, and water in your neighborhood.

In a more frivolous vein of social comment, the everyday events of life often are targets for

personal photojournalism. A subject doesn't have to be heavy or ponderous to be worthy of photographing. The things we do for fun are also real, such as a lighthearted ride in an amusement park where people let themselves go. For photo 6 I stood on a low bridge under which the boat would pass and made several shots as it approached using a short-range zoom lens. While such picture situations usually are personal records, they're a type of dramatic social comment, too. Perhaps our civilization will be better remembered for its amusement parks than for its stock markets.

A revealing genre of social observation comes from Bill Owens, a former newspaper photographer in Livermore, California, who evolved a style of recording people in their homes and yards or at their jobs. His first book, *Suburbia*, shows the life-styles of, you guessed it, suburbia, and his second, *Our Kind of People*, illustrates their numerous group activities. In a third book (*Working: I Only Do It for the Money*), Owens examines where and how his neighbors are employed.

Bill Owens' style of photography is unpretentious but penetrating. He looks at people in the manner of a news photographer, often using a Pentax 6 x 7 and a bare flash tube instead of the conventional electronic flash within a reflector. Note the relative softness of light in photo 7 (by Owens); the bare flash tube scatters its rays in all directions. It's not a technique we can all use, but it typifies a personal approach worth examining.

In his individual way, Bill Owens is making a record of our times, which according to one reviewer is both "loving and scathing." Without trying to duplicate Owens' themes, think about close-to-home subjects and how you might envision them with a camera. It's

6—Snapshot or reportage? The answer lies in the photographer's intentions when shooting and how well the picture communicates these intentions when it's presented.

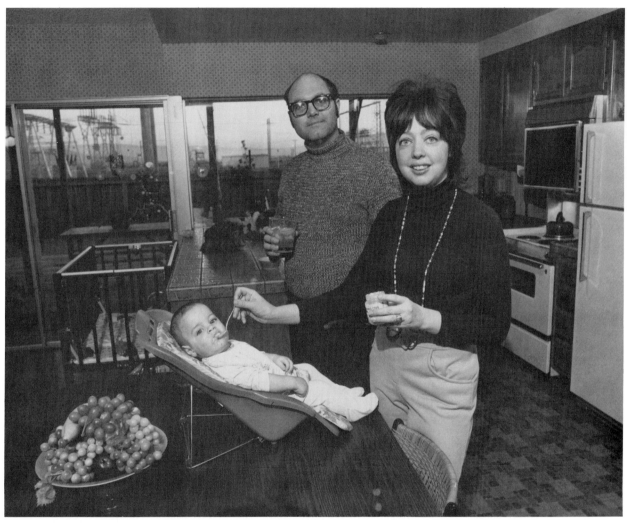

7—In his book *Suburbia*, Bill Owens captioned this as follows: "We're really happy. Our kids are healthy, we eat good food and we have a really nice home." Owens uses a distinctive and ingenuous approach to social comment.

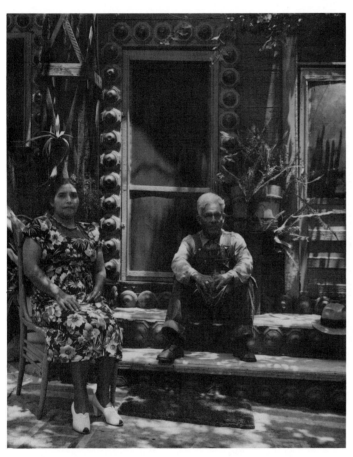

8—A couple and their modest home photographed about 1951. The house has since disappeared, swept away by "progress" to become a photographic memory only the camera can create.

the personal point of view applied to people, places, and things that stimulates the mind and emotions and results in really expressive photography.

Years ago I took pictures of a couple (seen in photo 8) which might have been part of a project with a theme such as, "And this too shall pass away." The man and his wife posed with dignity on the porch of their Mexican-style home in the Chavez Ravine section of Los Angeles. The home is gone and a baseball stadium now fills the area. I photographed, not for posterity, but because I knew change was on the way. We record with a camera to serve memory, which is certainly a valid facet of reportage.

Meaning and Message

When you photograph in documentary style expect to find several levels of meaning in your pictures. For example, a basic level of meaning is sentimentality—recording to remember that which is near or dear. Snapshot albums are, unwittingly, graphic social documents of the future.

The most effective images somehow catch moments in time that have universal appeal, and they often imply more than appears on the surface. In photo 9, a bride and groom greet friends in a reception line after a rather elaborate wedding. Among the guests were a few black people at a time (1960) when the civil rights movement was more prominent than it is today. Therefore the picture might be viewed as propaganda for the democratic process, or, in the wrong hands, it might be angled to malign the subjects in one way or another. My purpose was straight reportage for the young couple, and I had no axe to grind. Photo 9, then, serves to illustrate that an implied "message" can be misleading or superficial.

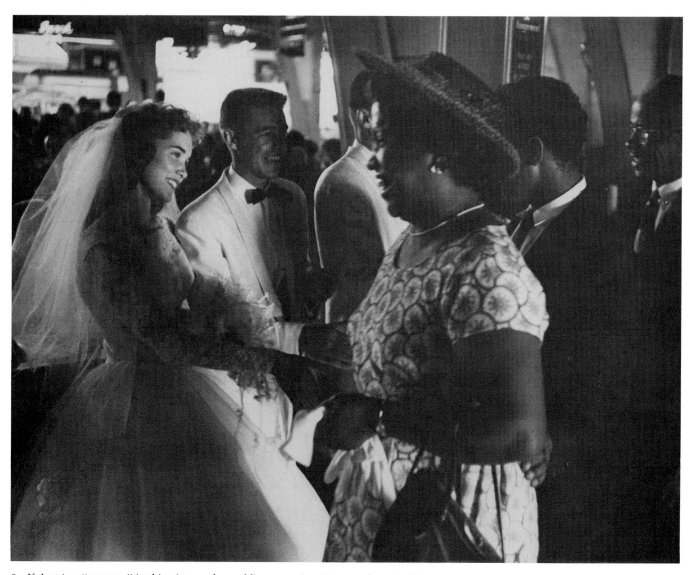

9—If there's a "message" in this picture of a wedding reception, it's one of good will.

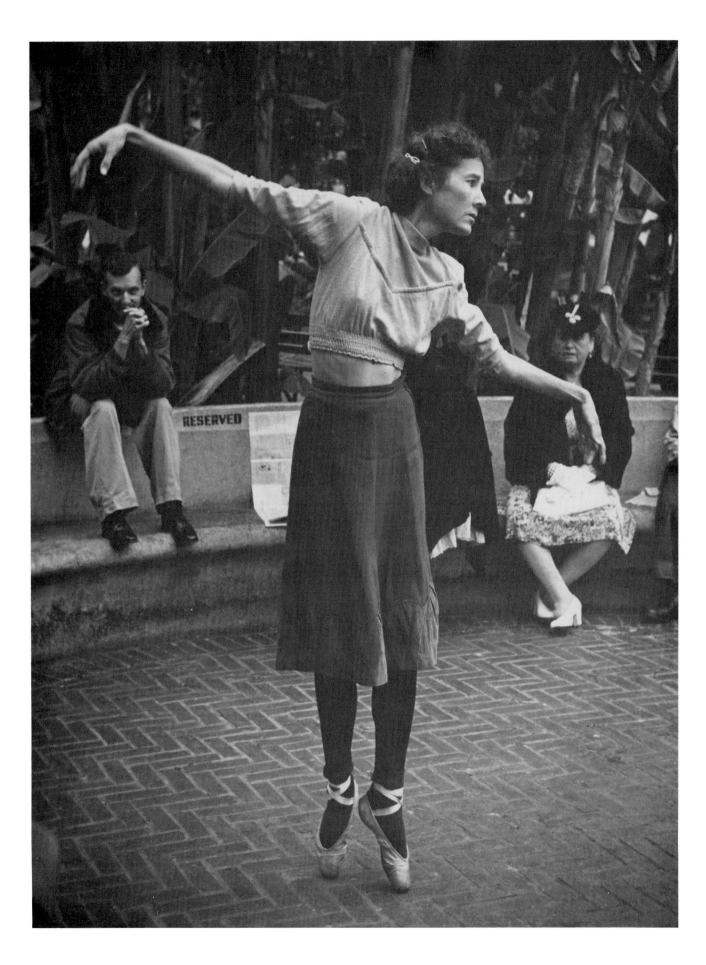

When emotionally involved with or moved by a subject, it's possible to feel deeper planes of meaning than actually can be seen in a given situation. The photographer has the power to sway viewers with pictures of people or situations taken out of context. An awkward camera angle can elicit unsympathetic reaction toward a portrait resulting in possible viewer dislike of the subject. Bias in favor of something must also be handled with discretion—unless of course partisanship is the photographer's objective.

Message in a photograph should be treated with subtlety or it will be obvious and perhaps self-conscious. Photo 10 includes non-judgmental social comment about groups of offbeat people who once hung out in the old Pershing Square in downtown Los Angeles. My picture shows a pathetic young woman demonstrating ballet steps for an audience that is either indifferent, or offers silent empathy. The woman's perception of reality was slim, and the message of the image might have been negative and harmful had it been published out of context. I could have been making fun of the indigent, though I was actually shooting a human-interest story which emphasized free speech and open places for public performances. It so happens that the magazine layout didn't include this picture, which I have long valued for its pathos.

The Law and Self-Expression
Reporting with a camera without worrying about the message or specific meanings can also be stimulating. If you follow strong urges and interpret or record honestly, your motives shouldn't be questioned—and they won't be until your work is exhibited or published. Then repercussions may occur that weren't anticipated, despite the fact that your intentions in taking and showing the images were honorable.

The law says you may photograph just about anything, anywhere, anytime without interference as long as you're not invading private property, or specific individuals do not object. However, your right to have a picture published or exhibited is governed by many circumstances, such as how it's used, who's involved, and whether or not you have signed model releases from the people involved. News pictures and photographs of celebrities are usually publishable without problems, but how soon after the event the picture is used can make a difference.

In addition to the above concerns there are the unwritten laws of good taste and propriety to take into account: don't embarrass yourself or others with tasteless images. Legal considerations are necessary evils in the worlds of publishing and exhibiting and must be included among the pleasures—and responsibilities—of self-expression. For guidance on matters of privacy, libel, publication, model releases, and more, refer to *Photography and the Law* by George Chernoff and Hershel Sarbin (Amphoto, 1977) and *Photography: What's the Law?* by Robert M. Cavallo and Stuart Kahan (Crown Publishers, 1976). Knowing your rights and being prepared for the legal aspects of photography helps in avoiding sticky situations and potential

10—Photographs taken in public places may be published for nonadvertising purposes without model releases if no one is ridiculed and if privacy isn't invaded. Thirty years ago when this was taken, it wasn't included in a picture story because there was no release. Today it has become a visual recollection of historic significance.

headaches. In some cases (for instance, if you're sued), you may need to consult a knowledgeable attorney. Find one familiar with publication and copyright law—you may need a specialist.

Reportage

Terms such as *reportage*, *documentary*, and *photojournalism* may overlap in definition as well as styles they connote. While looking at the pictures in this chapter try to decide what labels best describe them and answer these questions: What are the characteristics of

11—Reporting on your family's outings and including a bit of local color while in the process produces visually exciting photographs for exhibit or personal enjoyment.

effective journalistic images? How does a documentary picture tell its story? Why are some photographs more believable or persuasive than others? Is there a documentary state of mind?

Personal Reporting

On the streets, around the home, or when traveling, it's natural to become a reporter with a camera. Personal reporting for fun is similar in many respects to professional news or feature photography for profit. One basic quality that most reportorial images have in common is what Henri Cartier-Bresson called "the decisive moment." It's the instant when a hand is raised, a face is most expressive, or an action is at its peak. It's the split second that alert photographers anticipate with excitement. A sense of humor, a strong curiosity, and a feeling for visual adventure are also integral aspects of personal reporting.

The traveling photographer is a reporter who tries to show through the camera eye what he or she is seeing. Alert travelers shoot some situations "because they're there" and seek opportunities for personal interpretation in others. Shooting predictable images should be kept to a minimum, since they result in dull pictures or slide shows that may as well have been assembled from packaged slides bought from street vendors.

Take visual chances—in the rain, at night, or when conventional circumstances don't prevail. Photo 12 is an example of this shot in London during a drizzle. Shutter speed was 1/60 second, which allowed the passing bus to blur along with the moving pedestrian at left. There's an ambience I like in this type of personal reporting, and in color it would be even more striking.

Traveling tips. Here are some guidelines for effective reportage on a trip or around the home:

• Carry two cameras, if possible, and mount a different focal-length lens on each. To get about more comfortably and not feel like a trail mule, pack your shoulder bag with essential equipment only.

12—Traveling photographers become good reporters when they can shoot instant impressions that are authentic and interesting.

• Be familiar with your camera, lenses, and accessories: familiarity breeds attempt.

• Don't take for granted the extra camera and lenses. As an exercise in discipline during a whole day, restrict yourself to one camera and one lens. Stretch this minimum of equipment to new visual limits. It's an austere

13—Action and sports are good pathways to personal expression requiring precise timing and a knowledge of the sport or activity. Courtesy Oregon Department of Transportation.

approach which pays off in greater self-confidence.

• Set your sights on a theme or two that you haven't tried often enough. Exotic patterns, unusual or commonplace relationships between people, and wide-angle views of places you've shot before with a normal lens are challenging alternatives.

• Shoot black and white where color might be expected, and color where you may have been reluctant to previously, such as on

overcast days or in dim light when moving objects will blur. A change of pace keeps the mental batteries charged.

• Include people wherever you go and don't be afraid to set up picture situations with friends or strangers. "I need someone in my picture right here," I'm apt to tell a passerby, and since most people are flattered to be singled out, I usually get cooperation.

• Switch camera angles as often as possible: shoot from near the ground or look for higher perches to get elevation. Don't be satisfied with obvious camera positions, and you won't have to settle for routine images.

Photo 13. Shooting sports pictures is also a brand of personal reportage. Normally you'll do your best work when you're familiar with the games or activities being shot and know what to expect in the way of action. A telephoto or zoom lens is very helpful for most sports photography, since you'll usually be stationed far away from where the competition is taking place. This skiing shot, taken by a photographer for the Oregon Department of Transportation to publicize winter sports, summarizes *peak action*, the decisive moment in sports we all want to capture on film. It was taken with a 120-size camera on color negative film and required more preparation than is apparent.

Photo 14. When you're a captive on a tour bus and are allowed to disembark only at prescribed spots, distinctive personal reporting requires good reflexes and imagination. Everything seems to rush by or is too far away, or there are fences and barriers coming between you and a composition. However, if you have one or two cameras with separate

14—Shooting from a tour bus is frustrating, but it challenges your ability as a reporter. This scene appeared momentarily at an intersection of the Universal Studios Tour.

focal-length lenses at the ready, you're prepared for the unexpected—as I was here when facing two large mirrors with a van passing behind them on the Universal Studios Tour. There's a nice surrealism in this unmanipulated photograph, a quality which is found when your senses are sharpened.

Photo 15. There are several ways of incorporating aesthetic values into a documentary photograph: through lighting, camera angle, or general design. I was excited to find this antique house standing alone against the sky, and I photographed it with a 35mm lens on a 35mm SLR. Of the several angles shot, I like the head-on view best, probably because of my Mondrian geometric conditioning. Someday I hope to go back and shoot the house with a view camera (perhaps in color) and bridge the gap between reportage and art.

Photo 16. Personal reporting also means portraits shot in a style that is frank and uncontrived. My friend Helen Miljakovich took this of her friends Joan Delany and Stu Pappe in their Santa Fe, New Mexico, shop. Helen had known Joan as an actress and Stu as a film editor before they married and departed Hollywood. Visiting them later, Helen recalls, "Their shop sold old clothes and antiques, which accounts for the setting. Joan was decidedly happier here than working as an actress, and their lives had become relaxed." Helen's impressions seem well translated as environmental portraiture, which is discussed further in chapter 13. Friends, relatives, or strangers all may be candidates for your investigative camera.

15—This old home, reminiscent of Walker Evans' boarding house (photo 4), lent itself to various interpretations in terms of design and social value.

16—An informal environmental portrait by Helen Miljakovich of her friends Joan Delany and Stu Pappe in their Santa Fe, New Mexico, shop.

17—News situations usually are unsuitable for personal projects, because it's too easy to interfere with lawmen or fire fighters, and there's always the possibility of danger. This fire-control exercise was taken by Tom Carroll.

Photo 17. News photography per se isn't a topic that gets much attention in this book; it's a profession, a way of making a living and not primarily aimed at personal expression. Newsworthy events draw the press, the police, and crowds of people who shouldn't be there. If you do intend to take these types of pictures, keep your distance with a telephoto lens unless you're in a tight spot and need a wide-angle lens. Tom Carroll shot this refinery fire-control exercise with a 200mm lens on a 35mm camera. As a pro, he knows how to work quickly and safely. Good judgment and experience keep the professional from becoming a nuisance or an accident casualty.

Photo 18. This last image may belong in the next chapter, but my original intent was to document the charred roof of our home after a fire. At the same time I found intriguing patterns such as this, which includes my own foot and shadow. Taken with a 28mm lens, this picture presents another example of the positive qualities of junk and ruins for personal interpretation with a camera. (The kitchen seen through a hole in the roof became a rather bizarre setting for some nudes you'll see in chapter 12.)

The word *communication* is used sparingly in this chapter, though often it's related to social comment and photodocumentation. It's true that a photojournalist tries to communicate the look and feel of a given situation or subject to viewers not present at the time of exposure. Communication may also connote a partisan message or a sense of mystery or beauty. The term has many applications, and as such it's too ambiguous for my purposes.

18—My shadow can be seen as I record the burned roof of our home, where I found the pattern of ruins to be intriguing design.

Reality, on the other hand, is at the core of many aspects of expressive photography. See things honestly but in your own way. There's sometimes a fine line between the shallow and the significant. Search for the differences, for projects to believe in that may inspire your own photodocuments. Mix imagination with objectivity and create pictures of value for now and for the future.

Chapter Checklist

1. One of the strongest influences on American documentary photography was the Farm Security Administration (FSA), whose photographers examined Middle America during the Great Depression and afterwards in a concentrated way that has yet to be equaled as a collective social document.

2. *Life* and *Look* began publication about the time the FSA began probing the surface of American life-styles, before television and motion pictures reflected reality as they do now.

3. Review the samples of outstanding documentary photography and try to determine what these pictures and photographers had in common. Do they evince a sincere involvement with social issues, or are they simply examples of sharp reportage?

4. Being a "concerned" photographer today is a valid means of stimulating self-expression with a camera.

5. Social comment and reportage need not be serious or "heavy" all the time, as evidenced by the visual insights of Bill Owens in his several books.

6. Think of a situation that might be photographed in both a "straight" and a "slanted" way to demonstrate how the photographer's viewpoint can be used to influence, or prejudice, the viewer.

7. You may legally photograph just about anyone, anywhere, anytime, but you may *not* exhibit or publish many of your pictures without permission from the people involved or owners of certain property. Knowledge of your rights and obligations regarding the use of model releases can save a lot of embarrassment and legal hassles.

8. Mastering the techniques of personal reporting can make your family pictures more meaningful and can also come in handy when traveling. Reportage can be casual and direct at the same time.

9. As a photoreporter, always try to include people in your shots and don't be afraid to ask strangers to model for you when you need someone in a given situation.

10. Action may seem like one of the easier things to capture on film, but it takes a polished sense of timing to shoot *peak* action at the decisive moment.

11. Social comment and reportage are related to visual communication. What does the word *communication* mean to you when used in reference to the camera?

19—Susan King made a personal document when she photographed children in Dubrovnik, Yugoslavia, using a 35mm lens on a 35mm camera with color slide film. Her portfolio including this image won Susan a 1978 Kodak/Scholastic Award.

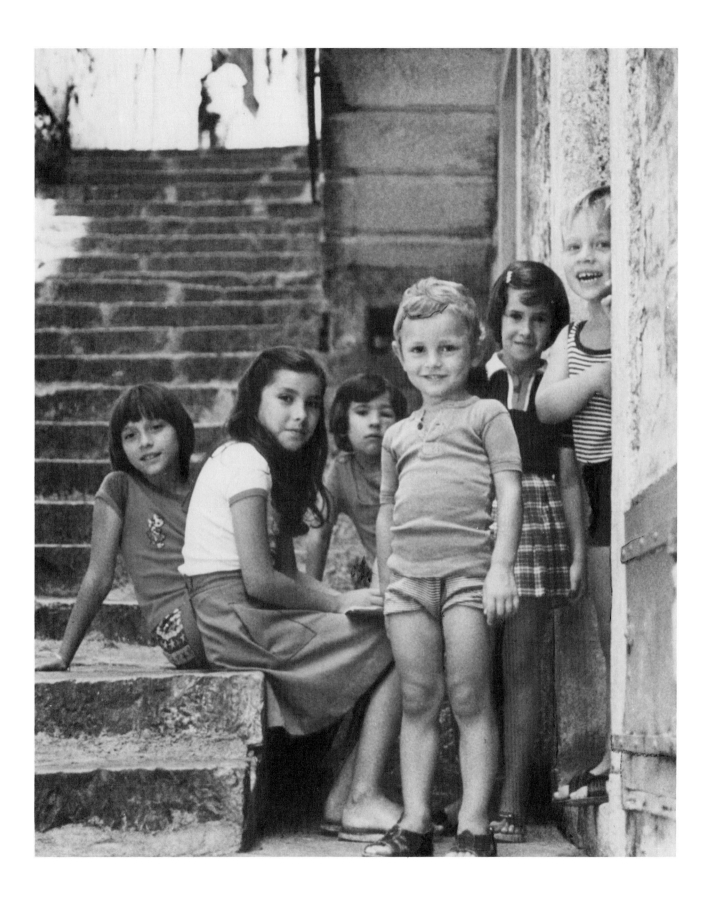

1—Optical illusions are prevalent in reflections, such as the one seen in this show window of a company that customizes cars.

Optical Illusions, Patterns, and Abstractions

9

Photography for personal fulfillment must be imbued with a sense of adventure and, hopefully, a sense of ingenuous joy. When you first see your contact prints or slides, "it's like being given 36 presents," as photographer Lilo Raymond once described the experience in a *Popular Photography* interview (July 1977).

Some pictures that turn us on are very recognizable: a Fourth of July parade, a sandlot softball game, or a lovely friend in a softly lit setting. But other situations are generated by imagination. We may see optical illusions, patterns, or abstractions without being consciously aware of them, or we can create and anticipate the unseen on film, as demonstrated in photos 1 and 11. Adventure comes from being open and receptive. While painters bend reality into artistic abstractions, photographers can do it with a lens and camera or in the darkroom. Photographers can capture unique and unreal scenes via techniques unavailable to painters. We have our own means of distorting space and form or recording illusions—often in an exciting fraction of a second.

Optical Illusions

Reflections are the most common phenomena in this category. They come in an infinite number of shapes and sizes and are often enigmatical, as exemplified by one of my favorites, the bumper sculpture in photo 1, chapter 1.

Many years ago a design professor named Robert Lepper suggested a pictorial problem to me. "In photography," he said, "show me how two or more images can occupy the same plane at the same time." This was an invitation to experiment with reflections. Lepper pointed out that cubist painters in particular made an art of overlapping lines and forms. One famous optical illusion is Marcel Duchamps' "Nude Descending a Staircase," which predates repetitive-image action photography by fast-firing electronic flash. Since reflections are everywhere, I readily accepted Mr. Lepper's challenge.

Photo 1 combines real and reflected elements in a pleasing manner. It was taken into a display window of a shop that customizes cars. The reflected scene includes a faint landscape and a friend of mine. The blend of images "occupying" the plane of my negative and print is intriguing and well worth the search for aesthetic combinations of lines, forms, colors, or textures.

Metallic surfaces, glass, and highly polished objects large enough to reflect images should be examined carefully. Mirror reflections often are more literal than those seen in windows or hubcaps, and we'll discuss self-portraits in

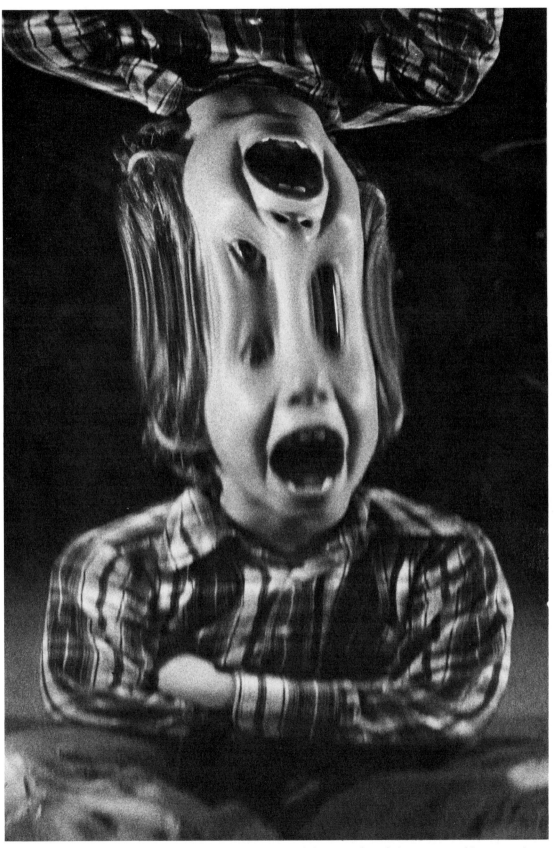

2—Maurice Manson played with reflections in a trick mirror and shot a number of pictures to get this provocative image that also works upside down.

mirrors in chapter 13. In a class by themselves are trick mirrors such as Maurice Manson found in an amusement park (photo 2). He stood to one side and out of the way while the youngster played and postured. Turn the picture upside down for another eerie effect.

For a personal project, arrange several mirrors opposite each other. They may be small hand mirrors or larger. Choose a few objects to be reflected for the illusions they may offer. Change camera angles and adjust the lighting if you wish, because what you see in the camera finder can be altered quickly and easily. Possibilities are almost endless as you move from one location to another and replace objects.

A polarizing filter which fits over the lens of a single-lens reflex is also useful in photographing reflections. By revolving the filter you can reduce some of the reflections from surfaces like water or metal. The most effective angle for a polarizer is about thirty degrees, but experiment to find out where it works best for you. The polarizer doesn't alter color but can, for instance, deepen the blue of skies when you're shooting landscapes instead of reflections.

Lens Illusions

Odd, strange, and curious optical deceptions are created by very short and very long focal-length lenses, particularly on 35mm SLR cameras, for which there's a vast assortment of optical accessories available. For instance, a fisheye lens in the 15–18mm range bows straight lines in ways that can be annoying or amusing, as in photo 3. This is a typical street in Guadalajara, Mexico, as seen through a 16mm fisheye lens. Such effects should be exploited when there's no special concern for reality. For architectural pictures in which you want straight lines to remain straight, there's

3—A fisheye lens bends a real street in Guadalajara, Mexico, to create an illusion that entertains the eye.

also a rectilinear-type of super-wide-angle or fisheye lens. Few nonprofessionals use such lenses, however, because they cost a fortune and take the visual fun out of playing with a fisheye.

Extremely short or long focal lengths alter dimensional world can be subjected to personal interpretation. Alternate methods are seen in photos 5 and 6.

A wide-angle lens makes objects close to it disproportionately large compared to objects farther away. In fact, space relationships can

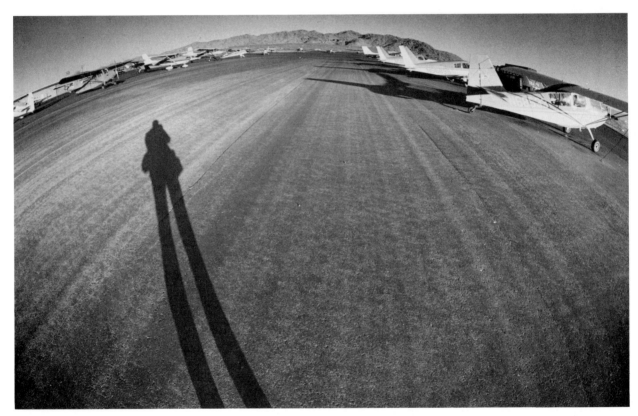

4—Another fisheye lens seems to add space to a rural airport and stilts to the photographer.

space and perspective, as the next three photographs demonstrate. Photo 4 was taken with a 15mm fisheye lens at a rural airport just after sunrise. My shadow here gives the illusion of a man on stilts. At the same location I positioned the 15mm lens close to the tail of a small plane to make it loom gigantically in the foreground. The body of the aircraft tapers quickly toward wings that seem too tiny to fly. This is only one of the ways the three-

be dynamically modified simply by changing lenses. To illustrate this I shot photos 5 and 6. Photo 5 was taken with a 28mm lens on a 35mm SLR from a distance of about twelve feet in front of this abstract sculpture. I might have backed away even more, but I liked the dark line running out of the top of the frame.

For photo 6, I did move back slightly in order to include the entire sculpture with a 135mm lens. Though the camera location was

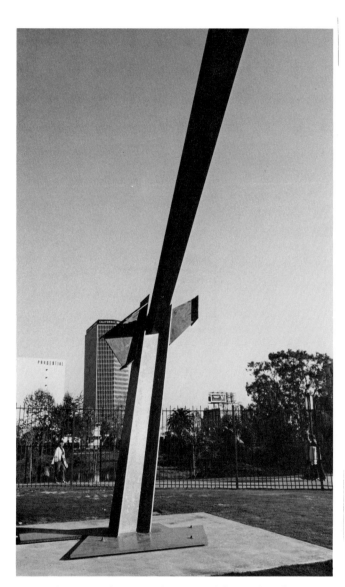

5—An abstract steel sculpture looms much larger than the office building in the background when photographed with a 28mm lens on a 35mm camera.

6—The same steel sculpture photographed with a 135mm lens is now dwarfed by the building, demonstrating how spacial relationships can be controlled to create illusions.

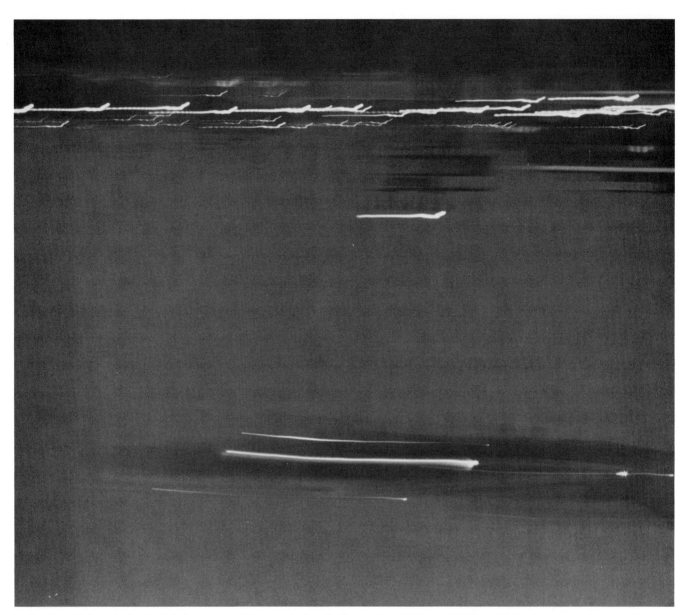

7—Streaking lights of a landing airplane create an impressionistic feeling as the camera is panned at a slow shutter speed.

altered by only a few feet, the building in the background seems hundreds of yards closer. A wide-angle lens spreads the distance from foreground to background in photo 5, while the telescopic characteristics of a longer focal length compress perspective in photo 6. Which picture is an optical illusion? Both are, really, for neither is a true representation of the way we might see the relationship of sculpture and building with the naked eye.

Shoot similar pairs of pictures to experiment with the optical options of changing lens focal length. Distortion can be attractive or freaky. If you venture into the bizarre in search of the aesthetic, you need only please yourself. In expressive photography, inhibition is a dirty word.

The Beauty of Blur

There are several sensible ways to deliberately avoid shooting sharp images. You can shake the camera intentionally, as I did for photo 14 of chapter 6, or you can plant the camera firmly and allow passing subjects to blur on film. You may also zoom a lens during exposure. All of these techniques offer the magic of movement, and here are a few case histories.

Photo 7. Photographing moving traffic at night with camera on tripod produces white and colored light streaks on film, and if there are enough of them, they dominate the picture. Photo 7 is a variation on this theme where I panned or turned the tripod-mounted camera in the direction of an incoming aircraft, which blurred artistically during a one-second exposure. Light streaks from buildings along the runway indicate that the camera was jiggled slightly during the movement and add to the impressionistic effect. I shot half a dozen passing planes to

ensure at least one or two useful images in an unpredictable situation. Had I been using a camera with an electronic shutter that automatically times exposures longer than one second, I might have tried for a longer streak at two seconds or more.

Photo 8. Indoors, light levels are often low enough to allow proper exposures at slow shutter speeds and provide plenty of

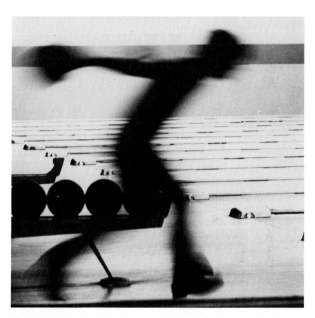

8—James Thacker shot from a tripod at a half second to blur a bowler in action.

opportunities for blur. Teenager James Thacker made a ½-second exposure from a tripod in a bowling alley to capture this decorative figure in action. He shot at various stages of a bowling sequence because he wasn't sure what he would get. He won a Kodak/Scholastic Award for his efforts.

Blurred movement can be anticipated and precisely planned. People in motion and moving lights become soft-edged or streaks in prints and slides, depending on how fast they move and the shutter speed you choose. Exposures for blur may vary from ½ second to

many seconds, again according to the film speed and lens aperture. A starting exposure can be found by meter and subsequently can be adjusted by guess or estimate. A few

Boulevard, where celebrities were passing in vintage cars. He panned the 35mm SLR camera during ½- and 1-second exposures, allowing streaked highlights to dominate

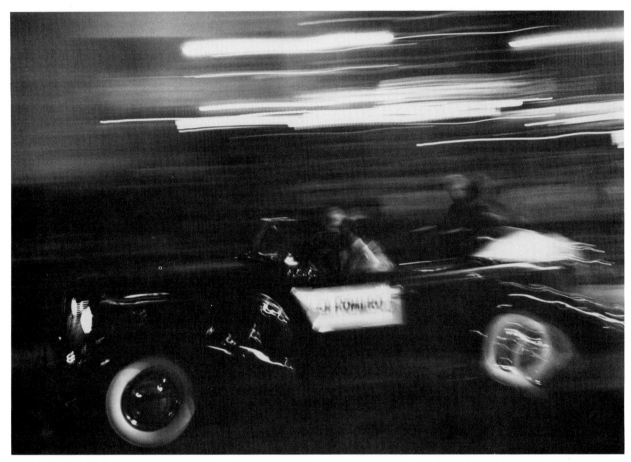

9—Barry Jacobs panned an SLR camera at one-second exposure to follow the moving car and blur the background lights.

seconds more or less at night aren't as critical as a fraction of a second can be in bright sunlight.

Photo 9. You won't always have a tripod handy, so camera shake will become a factor during long exposures. Take advantage of this handicap and get decorative results. My son Barry faced such a situation one night while watching a parade along Hollywood

when not much else would show up on the negatives. Some of the things he found on film were interesting, such as the sharply focused front wheel and double-image back wheel in photo 9. Blur and serendipity obviously work hand in hand.

Photo 10. Everything is in motion here, including the camera. When I came across this amusement park ride decorated with rows of

lights, I set my 35mm lens at about f/4 and gently swung the camera through several slow arcs for a few seconds as the ride revolved. The shutter was open on B, and the limit of most lenses for 35mm cameras. Therefore, when you plan to shoot for blurred effects, choose a slow film like Kodachrome 25 or Pantomic-X. In some levels of illumination,

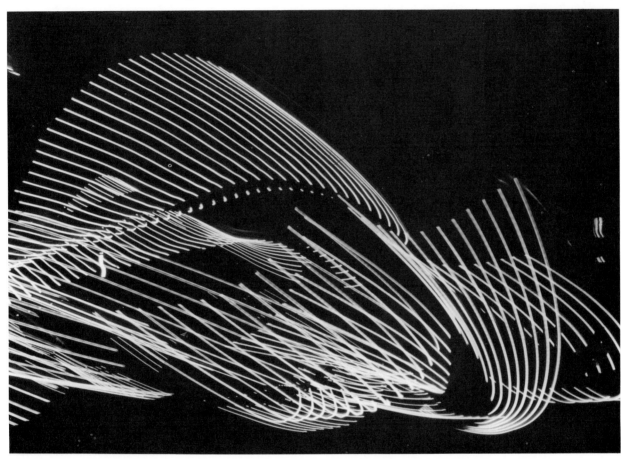

10—Lights on a rotating amusement park ride traced curved lines on the film during three overlapping exposures.

film was Tri-X rated at its normal ASA 400. Photo 10 actually is the result of three exposures made by holding my hand over the lens without closing the shutter. Separate streak patterns overlapped to create a lot of confusion on some of the negatives but worthwhile patterns on others.

Blurred images in daylight, or any bright light, are impossible to obtain with fast film—even at f/16, which is the stop-down a medium-speed film such as Plus-X or Ektachrome 64 will also do well. The trick is to shoot at relatively long shutter speeds and be able to use a small enough lens opening to match. And remember, you can always place a neutral density filter over the lens to reduce effective film speed without altering color or image quality. A neutral density filter is also very helpful when zooming a lens during exposure.

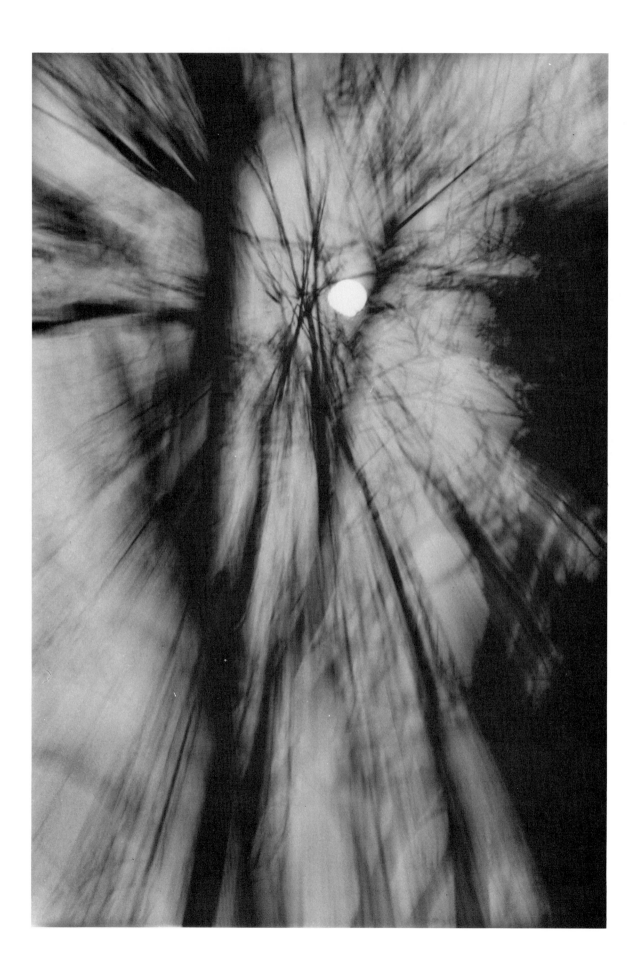

Zoom Techniques

The first zoom photographs I ever saw mystified me—until I realized that by continuously changing the focal length of a zoom lens while the shutter is open, the photographer records an image in a sequence of sizes that becomes a zoom blur. Objects and colors overlap unpredictably, making this technique a visual adventure. I'll explain how two pictures were made using zoom. Experiment on your own and keep notes so you can repeat effects you like best.

Photo 11. With a 65–135mm zoom lens on an SLR camera mounted on a tripod, I aimed at the moon through bare branches on a gray winter morning. I began at ½ second and shot at a second as well, varying between f/8 and f/11. Starting at the short or long end of the zoom range is a matter of preference. Experiment both ways. In some cases you won't be able to determine at which end of the range you began. Zoom as smoothly as possible because jerky movements will show up in the blur lines and may be annoying. Whenever it's possible, shoot plenty of film: even when a subject is still you can't be sure of what you're going to get. At its best, zooming produces decorative and mysterious images.

Photo 12. Zooming during exposure with the subject in motion adds another item of unpredictability to the procedure. Take the risk anyway and trust to serendipity. My model for this picture was outdoors on an overcast day. I attached a 4X neutral density filter to my 65–135mm zoom lens, so I could expose—and zoom—for a full second at about

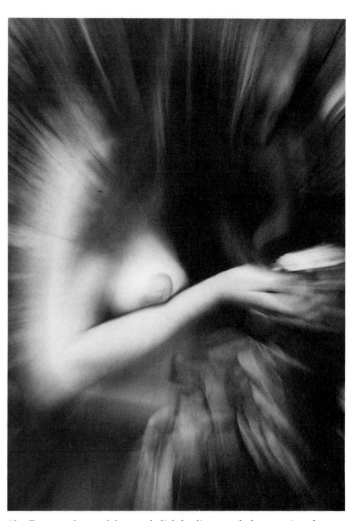

12—Because the model moved slightly, lines made by zooming the lens during exposure are irregular in places.

11—The moon was photographed through softened tree branches by zooming a 65–135mm lens during a half-second exposure.

f/16. At my signal she moved her body slightly, which accounts for the irregularity of lines along the right side. In comparison, look again at photo 5 in chapter 2. Here the model stood still, and the exposure was only a half

13—An abstract composition—until you realize these are air-conditioning ducts stacked to resemble a modern painting.

second. The zoom-blur lines aren't only straighter, but shorter.

When light is dim enough to allow slow exposures and your camera is on a tripod (though I've seen hand-held zoom exposures at ½ second that were okay), take the time to shoot zoom exposures in a series. No two are likely to be the same because the manner in which you zoom the lens won't be uniform. Try both color and black-and-white films and varying subjects and be prepared for welcome surprises.

Abstracting Reality

In chapter 7 I discussed excerpting reality, a practice in which the photographer zeros in on a portion of a scene or subject to achieve a satisfying composition. Directly related to this is the search for abstract patterns or segments of something that can be photographed with a minimum sense of reality—or what painters term "nonassociative" images. Creating an illusion in an abstract composition further aids to disguise the subject or fool the eye.

Among photographers, Aaron Siskind, Minor White, Clarence John Laughlin, Brett Weston, Robert Heinecken, Lucas Samaras, and Paul Caponigro have produced fascinating abstract images. It's also helpful to be aware of the subjective paintings by Georges Braque, Pablo Picasso, Fernand Léger, or Stuart Davis. Their imaginative pictorial visions may help inspire your seeing through a camera finder.

Photo 13 is an abstraction of air-conditioning ducts awaiting installation. At the time of exposure (using a 35mm SLR camera with a 50mm lens), I had it in mind that the forms shouldn't be immediately recognizable. Even as I explored the shops under construction, I consciously thought of the modern paintings I had seen and felt a relationship between this subject and a Braque composition. When you're familiar enough with modern painting, make a personal project of finding non-associative designs in the midst of reality. It takes concentration and perception, but the payoff is unique images.

In photo 14 reality has been "fractured" handsomely by William Buckley, who placed a textured plastic sheet (from a fluorescent lighting fixture) in front of a model who was lighted by two electronic flash units, one on each side. Mr. Buckley, who is a senior photographer for the Polaroid Corporation,

14—William Buckley shot this fractured image of a model through a textured plastic sheet. The original was made on Polacolor 108 film.

told me he experimented with the model at several distances from the textured grid and shot a number of pictures to capture changing patterns and tones as she moved. The original images were made on Polacolor 108 film using an adapter in a 4 x 5 view camera. However, similar effects can be created with any adjustable camera using daylight, flash, or floodlights.

Close-ups and Other Patterns

In addition to the discussion of close-up photography in chapter 7, I might add that taking pictures in the macro mode is another way of creating abstractions. Photo 15 is the surface texture of a pineapple enlarged for its repetitive pattern, which gives it a fresh visual identity. At close range, a tiny group of pebbles may resemble the surface of Mars, and the veins of a leaf can be enlarged to look like an aerial view of a river and its tributaries. When reality is viewed out of scale, it can be an optical illusion or an abstraction worth careful composition.

Natural and man-made patterns can be found everywhere, but it's not that easy to extract what you want to see in a photograph. Images that are successful or most effective exhibit a basic simplicity. Repetitive shapes may produce ho-hum effects and, often, terribly confusing pictures. For instance, anyone can take a picture of trees, but if you try to segregate an interesting portion of the forest that entertains the eye on a slide or print, you might come up with something similar to photo 16. It *literally* reads as tree trunks, while at the same time the strong play of shadows and highlights suggest more.

Look around and beyond the literal and filter forms through your visual perception. If it gives you pleasure to seek the abstract in the midst of reality or to discover illusion in the commonplace, feel free to proceed, for these too are stimulating paths to expressive

15—Textures and small details enlarged beyond life-size become abstract patterns, much like this pineapple skin.

photography. Push your creative urges to the limit, for in this manner are uncommon images produced.

Chapter Checklist

1. Expressive photography is adventurous photography.

2. Two or more images may occupy the same plane simultaneously with a synergistic effect.

3. A valuable self-assignment could be to shoot as many kinds of reflections as possible by varying materials, surfaces, and camera angles.

4. An optical illusion created by a specific lens focal length may be an intentional distortion, but "distortion" need not be a negative concept. Picasso distorted reality quite effectively.

5. Consider the graphic differences that can be created through the use of several different lens focal lengths from the same camera position. In this manner, photographers are better able to alter the sense of perspective available to the human eye.

6. Serendipity pervades the creative use of blur, but it's still important to make a number of exposures at night or anytime light levels are low.

7. Shooting subjects on the move and creating blur by zooming a lens during exposure are adventurous means of optical illusions requiring *control*. Luck of course plays a great part in situations like these, but anticipation removes the total dependency on chance.

8. It's possible to zoom a lens during a one-second exposure with camera in hand, but the stability of a tripod often is preferable.

9. When a repetitive pattern dominates a photograph, it can be a treat to the eye—providing it's not monotonous.

10. Look around and beyond the obvious for personal photographic excitement.

16—Choosing specific trees to shoot within the forest is a form of artistic selection, especially when looking for patterns and abstract designs.

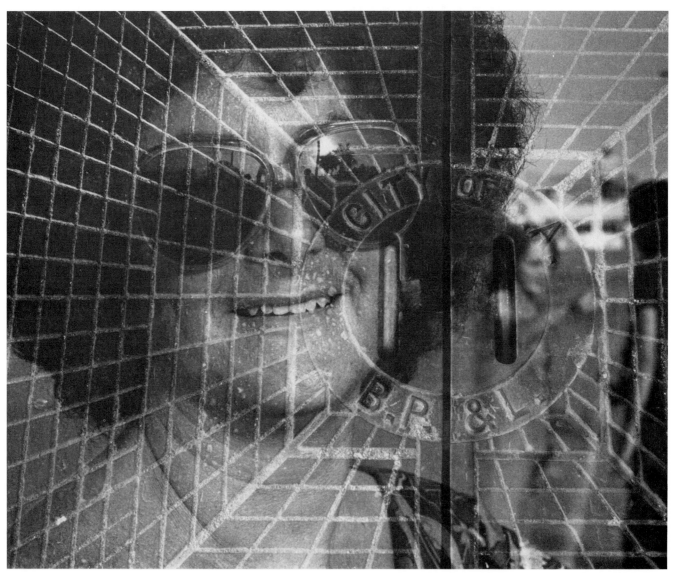

1—Is this multiple image an exercise in intentional obscurity, or does it possess some symbolism not easily recognized? It's an exercise, but answers about some pictures depend on the motives of the photographer.

Fantasy, Symbolism, and the Bizarre

10

Trying to categorize styles in photography is a tricky business fraught with benefits, hazards, and limits. For instance, there's no clear-cut boundary between optical illusions and fantasies, and other descriptive labels tend to similarly overlap. However, we classify in order to clarify. Each of us has a personal system of relating what we see to the images we create, but we also want to grasp the meanings of photographs made by others.

As an adjunct to this chapter, as well as to the appreciation and understanding of the aesthetics of photography, I recommend the book *Looking at Photographs* by John Szarkowski (Museum of Modern Art, 1973). In his eloquent short essays, Mr. Szarkowski combines history, visual concepts, social questions, and a lot of entertaining ramblings about what certain images signify. Apropos to fantasy, symbolism, and the bizarre, he discusses the "ephemera of appearances" and comments on the "richly ambiguous phrases" sensed in some images. Mr. Szarkowski's references are widely eclectic, and the book is an education in visual perception—from the real to the surreal.

I've been reading through *Looking at Photographs* again to strengthen what might be called the connective tissue of visual expression. In many ways the contents of this chapter are subjective, fanciful, or offbeat. I

hope you can *feel* a translation in your own consciousness as well as see it in the pictures. I want to avoid interpretations disguised in heavy prose.

Fantasy

In my dictionary *fantasy* is defined as "imagination, especially extravagant and unrestrained," or "the formation of grotesque mental images." Fantasy also connotes daydreams, hallucinations, and visionary ideas and may indicate "that we are about to indulge in an esthetic experience that has an edge of forbiddenness combined with a leavening of humor," as *Los Angeles Times* art critic William Wilson wrote in a review of Charles Doyle's nineteenth-century drawings. Mr. Wilson underlines fantasy as a pleasurable, self-indulgent form of visual expression by suggesting that sometimes what "we really want from contemporary fantasy [is] the chance for a good cathartic wallow in pure childlike magic. . . . In fantasy art the recognizable world remains basically intact, it's just that funny things happen."

An artist equipped with paint or pen can draw people with tiny heads or flowers taller than trees. Does that mean that photographers, who deal with a literal medium, are somehow hemmed in? Not at all. Photo 2, one of my favorite images by Harry Callahan,

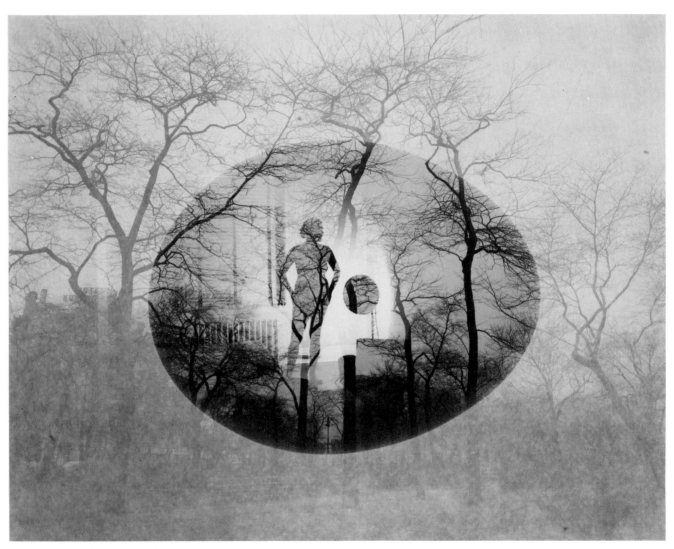

2—This imaginative fantasy by Harry Callahan is a challenge to artists in other mediums.

demonstrates with visual eloquence the unrestrained nature of photography. Callahan stretches the imagination; his graceful fantasy may not be extravagant, but it stimulates the viewer as much as the conceptualizing of the image must have excited the artist. Unwind your mind and move from what is to what could be.

Forms of Fantasy

Multiple images (discussed at length in chapter 14) are an effective and sometimes poetic means of fantasy. In the camera or in the darkroom, film and paper "see" what the eye cannot, but what the mind can envision. Duane Michals and Jerry Uelsmann are two outstanding artists in this genre. Says Michals: "Emotional facts are as valid as 'real' facts." His images often are droll, enigmatic, provocative, playful, or ominous, and his imagination helps him convert *what could be* into images on film. Michals also is involved with the spell of death. He's fond of exploiting the uncertain, and he admits to sticking out his neck and, on occasion, making mistakes. I call it courting serendipity. You can learn more about Duane Michals in *The Photographic Illusion* by Ronald Bailey (Alskog, 1975), for which I wrote the technical section.

Photo 3 is related to Duane Michals' kind of fantasy and might have been expanded into a series—for which he is also noted. Planning in terms of a story situation helps one along the path to fantasy. How far the photographer travels on this path depends on his or her creative impetus and freedom of imagination. I shot photo 3 from a tripod with a Konica Autoreflex NT3, which includes a multiple-exposure lever (also found on other SLR and medium-format cameras). The standing figure was planned against a dark background where it would emerge with greater contrast.

Jerry Uelsmann is also a master of fantasy. Have you ever seen a hamburger floating in the sky or a tree with a rose as its roots? You will by leafing through *Silver Meditations* (Morgan & Morgan, 1975), in which Jerry's fertile imagination comes to life via startling images skillfully combined in the darkroom. Some of Uelsmann's techniques are discussed in chapter 14.

Sometimes a setting itself will suggest ways of departing from reality. On a visit to the new Art Center College of Design Building in Pasadena, California, I was intrigued with the sun-and-shadow pattern, so I asked a passerby to walk along this geometric set several times (photo 4). The stripes in her blouse increased the linear effect, which I further emphasized by printing the negative on high-contrast #5 paper.

John Szarkowski says in *Looking at Photographs* that photographers "collaborate with luck. Luck is in the long run impartial; it will degrade many photographs by allowing small graceless errors in drawing or composition, but it will as often contribute an unforeseen detail or rendering that blesses the picture with the felicity of happy surprise." This thought underlines my own advocacy of serendipity, from which photo 4 (along with several others in the book) benefits. Szarkowski goes on to point out that luck, "whether good or bad . . . is the attentive photographer's best teacher, for it defines what might be anticipated next time."

Symbolism
A photograph is only a representation of what the photographer sees and the film records; it is not always symbolic. However, symbolism can be employed on various levels. Begin by looking at photo 5. What has happened to the young lady and how is her position related to

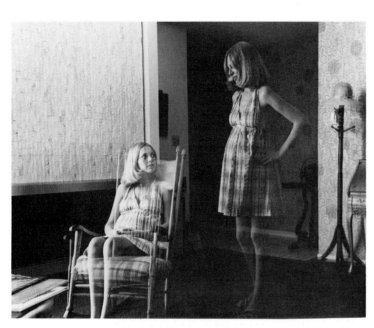

3—"A Lady in Waiting" confronts herself in a dialog created by making two exposures in the camera on the same frame of film.

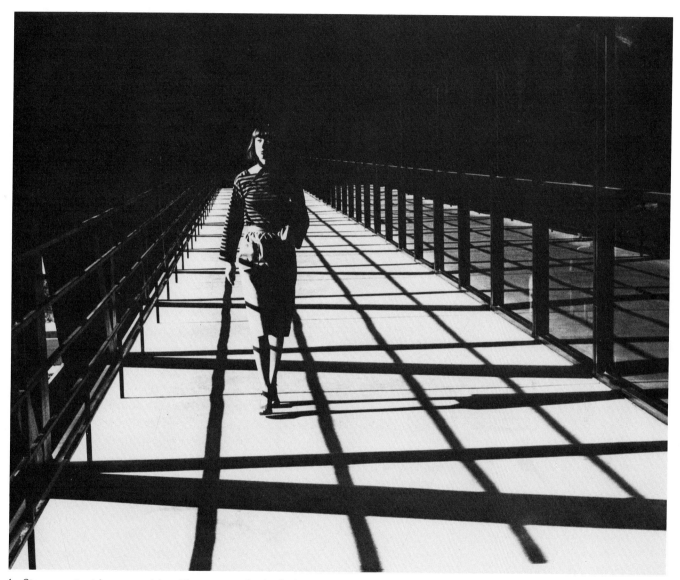

4—Strong contrast in a geometric setting was emphasized when the print was made on #5 paper to eliminate halftones.

5—The implications in this situation allow one to wonder what has happened. Apply your own imagination to the scenario.

the forbidding fence? Is she resting or merely exhausted from trying to climb over the barbed wire? Does the picture have a definite meaning or story? This photo has no title and thus lends itself to individual interpretation. A title may be a clue to a picture's content, but as often as not it misleads the viewer. Photo 5 was taken as a visual exercise and was inspired by the unusual setting. Its "symbolism" is what the viewer chooses it to be.

Any discussion of photographic symbolism brings to mind the work and philosophy of Minor White. As a young poet he was influenced by the photographs of Alfred Stieglitz, Edward Weston, and Ansel Adams. White began making straight, unmanipulated images with sharp detail in fine black-and-white prints, but he brought his own sense of awareness to natural phenomena by creating the photograph as metaphor.

The dictionary defines *metaphor* as "the application of a word or phrase to an object or concept which it does not literally connote, in order to suggest comparison with another object or concept." When Minor White showed us a subject, or a surface, in his pictures, he wanted us to wonder, "What else is there? What else is indicated?" He was concerned with the intangible and its relation to the concrete. When he said, "The photographer must free himself of tyranny of the visual facts," he meant that the essence of an image may lie beneath the appearances that meet the eye.

Photos 6 and 7 typify Minor White's personal approach to the photograph as

6—By Minor White, titled "Window Sill, Daydreaming." The image invites metaphorical musing, which was the photographer's intention. Courtesy of The Minor White Archive, Princeton University.

7—By Minor White, titled "Rehabilitation." One wonders what else is indicated in addition to the obvious. Courtesy of The Minor White Archive, Princeton University.

metaphor. Photo 6, titled "Window Sill, Daydreaming," has an ethereal and poetic mood typifying White's sense of *equivalence*. Photo 7, titled "Rehabilitation," was taken in Boston in 1974 and is a design that invokes introspection, moving the viewer beneath the literal scene into the beauty of the moment.

In *Looking at Photographs* John Szarkowski discusses an elegant Minor White picture that isn't easy to decipher but nevertheless can be immediately appreciated for its harmony of forms and tones. We cannot be sure what's in the picture, says Szarkowski, nor are we certain of our own vantage point, which is how I feel about photo 8. The subject is soft, floating algae blended with cloud and tree reflections. As a whole, it became for me a metaphor for Claude Monet's huge painting of water lilies hanging in Paris' Musée du Jeu de Paume. When taking this picture I remembered reading a quote from Monet: "Try to forget what objects you have before you. Think instead of the shapes and colors, until you have your own naive impression of the scene." (From *The Artist in His Studio* by Alexander Liberman, republished by the Viking Press in 1974, a book well worth your attention.)

8—This combination of water and algae became a metaphor to the author when it recalled a Claude Monet painting of water lilies seen in Paris.

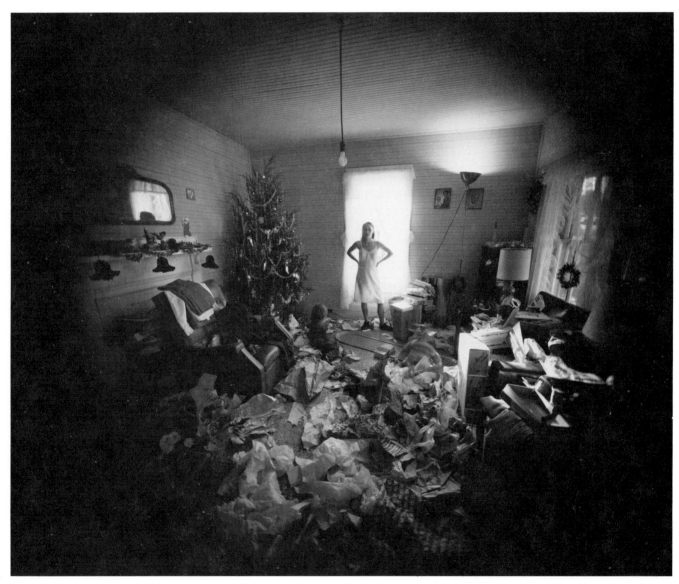

9—A fantasy impression at Christmas, taken by Emmet Gowin on an 8 x 10 view camera with a short focal length lens that produced a circular image.

Photo 9. Here's an example of documentary symbolism by Emmet Gowin, whose admirable taste is evident in offbeat images of the everyday world that often include his wife, Edith. This is titled "Edith, Christmas, Danville, Virginia, 1971." It evolved from a typical family scene: the opening of presents on Christmas morning, after which Gowin placed a floodlight against the back wall, set his 8 x 10 camera on a tripod, and exposed this through a lens of such short focal length that the corners darkened. Gowin often has made circular images in this manner, starting accidentally and continuing when he recognized a graphic visual format. His is a truly expressive photography—with quirks that have wide appeal.

A final note on titles: as mentioned above, titles can be symbolic or matter-of-fact and possess little or no connection to picture content. Titles may also hint at mysterious levels of meaning within an image, all of which may be genuine or contrived. I'm gratified when a title augments a photograph, and I prefer some bizarre images to be untitled. Arbitrary or capricious titles are irritating; they lead the viewer to suspect literary fraud rather than useful metaphor.

Consider titles that are relevant to your own experience and to the work itself. Be literal, outrageous, or tongue-in-cheek, as I was in titling photo 10 "The Four of Diamonds." The model and I worked in an empty house where light from both sides of one room was soft and even. I stood on a low ladder with a 28mm lens on my SLR camera and placed the playing card on the model because it just happened to be found nearby. The title resulted from these circumstances and has no hidden meaning. I feel it's humorous.

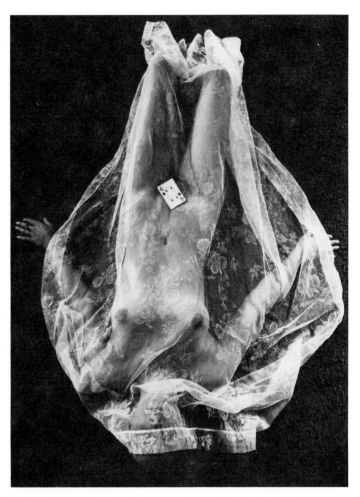

10—Fantasy created by the four of diamonds evolved when the card was found in an empty, carpeted room which became an improvised set.

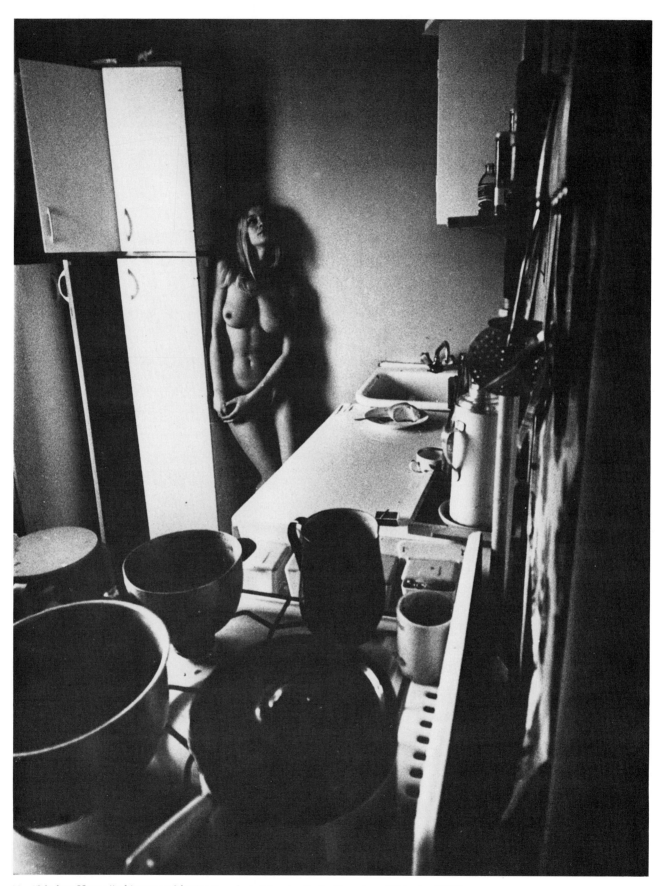

11—''Modern Home,'' a bizarre and fascinating photo taken by Peeter Tooming of Estonia, USSR.

The Bizarre

When the content, approach to, and style of a photograph are especially offbeat, it may be termed *bizarre,* which my dictionary defines as "markedly unusual in appearance, style, or general character; whimsically strange; odd." With a camera or in the developing/printing process, the photographer can stretch that definition to the edges of surrealism or visual shock. Bizarre is "kinky" in today's descriptive language, and it may also be related to any one of the following adjectives: unorthodox, erotic, exotic, eccentric, provocative, freaky, abnormal, or distorted. Like beauty, the bizarre often is in the eye of the beholder.

During the last few years I have become more appreciative of odd, strange, and curious photographic images. I see them published or exhibited, and they stimulate my senses and creativity. At one time I felt that the work of such photographers as Les Krims was merely irritating, because I didn't enjoy having my leg pulled. Now I enjoy Krims' work for its pacesetting imagination. Ralph Gibson is another photographer whose pictures are unconventional but memorable. Even Wynn Bullock was capable of juxtaposing people and things in settings with bizarre artistry. Finally, Helmut Newton leaves a strong impression with his nudes via direct eroticism and tension-evoking images.

In this idiom, when a photograph is lighthearted rather than pretentiously serious, it's easier to make and to enjoy. As an example, photo 11 by Peeter Tooming of Estonia, USSR, came to me as part of a portfolio. Peeter titled this whimsical situation "Modern Home," allowing the viewer to decide upon its social and humorous connotations.

Inspired by Tooming, I made some experiments with a model in the burned-out kitchen

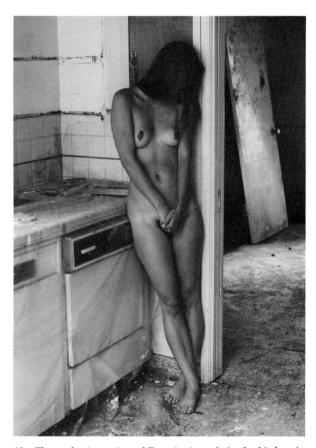

12—The author's version of Tooming's nude in the kitchen is untitled and invites its own interpretations.

of our home, which became an incongruous set. Half the ceiling was open to the sky. In the afternoon the light was indirect, lending a soft illumination to photo 12, my version of Tooming's shot which I could call "Ruined Home." There's a stark contrast and wide-

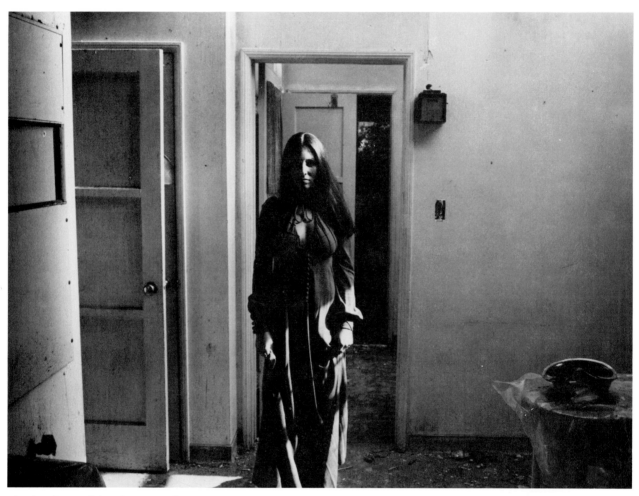

13—Another model in the semiroofless kitchen appears out of place in expression and dress. The bizarre aspects of the situation stimulated the author.

angle perspective in photo 11, and it's a lot more dramatic than my version. However, photo 12 does illustrate how train of thought works to the photographer's advantage when he or she is turned on by picture possibilities anywhere.

Photo 13 was also shot in the kitchen setting, but this time with a different model and a revised ambience. The sunlight filtering through the roof guided my positioning of the beautiful woman, but the suggestion of resigned anger in her expression is her own. Perhaps, if I were doing a series, I could call this "Aftermath," but I prefer the picture without a title. The juxtaposition of the elegant dress and face with the dirty, empty kitchen was my impetus in exploring the bizarre for personal pleasure.

The Intentionally Obscure
The problem in trying to identify the intentionally obscure photograph is that only rarely will a photographer admit to practicing obscurity for its own sake. In my examples I try to convey a message, mood, or atmosphere, though I purposely avoid detailed explanations when literary allusions should be subordinate to the visual impact of the images.

John Szarkowski states it beautifully in *Looking at Photographs* while discussing a picture by Lee Friedlander. "When Lee Friedlander made the photograph reproduced here he was playing a kind of game. The game is of undetermined social utility, and might on the surface seem almost frivolous. The rules of the game are so tentative that they are automatically (though subtly) amended each time the game is successfully played. The chief arbiter of the game is Tradition, which

records in a haphazard fashion the results of all previous games, in order to make sure that no play that won before will be allowed to win again . . .''

The Friedlander picture referred to is a store-window reflection and street scene that is only mildly obscure, if at all. However, I find Mr. Szarkowski's explanation of the continually changing "game" on-target, because, in essence, we make our own rules

14—De Ann Jennings created a situation meant to be obscure to symbolize the phobias of our civilization.

when practicing obscurity. For instance, take a look at photo 14 by De Ann Jennings. It's part of her effort to interpret phobias (her own or those of other people) related to machinery, electricity, and, more vaguely, the threat of rape. What you see is what you get—but what *do* we see?

The direct meaning is *obscure*, and was meant to be provocative and perhaps even upsetting. De Ann often builds simple sets, as she did here to symbolize a maze. A screen

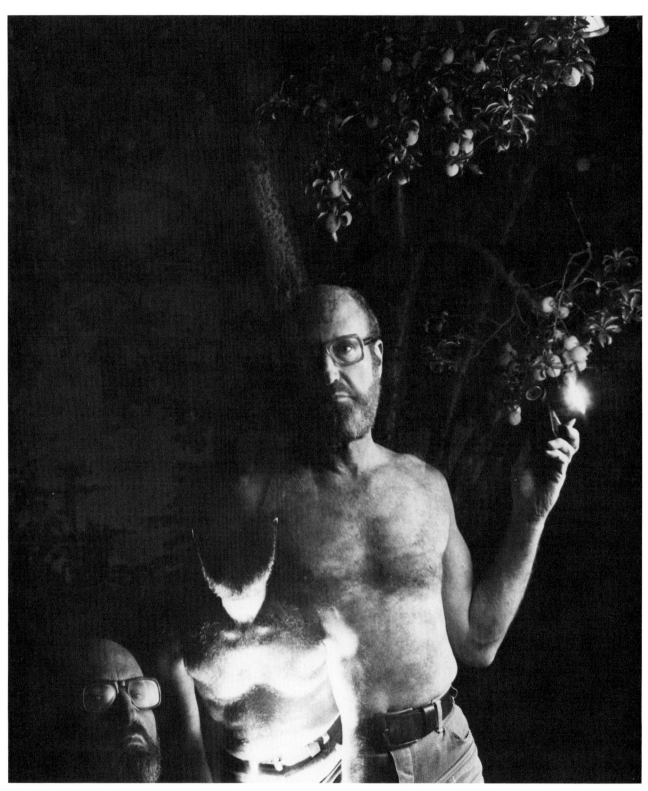

15—Self-portrait by the author, using three images on one frame of film. The light came from the electronic flash unit he is holding.

and a couple of bulletin boards placed out-doors on a paved driveway, plus a model in improvised helmet and fetal position, add up to her personal, creative picture story. Off the camera to the right she placed one electronic flash unit to produce the angled shadows.

Of photo 14, De Ann told me, "It's like a one-act play, an instance in time with psychological overtones of fear, which phobias engender." Does that explain it for you? No? Well, at least we know her purpose, and if your own photo projects are as well defined, you need not fear misinterpretation. However, let's look at a picture in which obscurity itself seems to be the *only* goal.

Photo 15 is a preview of chapter 13, because it's a self-portrait. Tradition says there should be a recognizable point of view when a photographer stands in front of a camera to take his or her own picture with a self-timer or with the shutter set on B, as is the case here. But in the obscurity game, what has happened before is either outlawed or is at least guaranteed to be boring. The rules of the game are tentative, so why not make them up as you go along?

What I'm really suggesting is flexibility of purpose. For photo 15 I placed my SLR camera on a tripod at night, situated myself in three different positions, and made a triple-image exposure by flashing the electronic unit in my hand either against an adjoining wall or, in the case of the center "portrait," from below my waist. There's a mysterious, even ominous, relationship between the three exposures, but it wasn't meticulously plotted. I courted the gods of serendipity purely for

fun, and I'm not inclined to claim that photo 15 is coated with mysticism. I simply wish to help expand your own consciousness. Experiment with obscurity as a means of stimulating self-expression.

The Empty Image

While I urge you to try your hand at being different, I realize it's not always easy to be graphic, literate, or artistic—especially when your goal is pictures nobody is supposed to understand—but go ahead and give it a whirl anyway. At the same time, try to avoid making drab, exaggerated images. *Empty* pictures strain the imaginations of viewers trying to assess their visual purpose.

Take, for instance, photo 16, which is called "Incognito"—hardly an enlightening title. This is my example of a manufactured, empty image, and it's better than some I've seen in contemporary shows and books. The picture is supposed to be perplexing. Is it a joke, the viewer might ask, or is the model really a disturbed person?

It seems that some photographers try to hoodwink the public with visual inventions that may *appear* to have substance but draw our interest only because we expect a lot more than we see. While there should be no limits on photography, try not to delude yourself into thinking your images are "significant" or "meaningful" when you know they are the products of nebulous intentions sprung from the pleasure of using a camera.

I realize this is shaky ground, for I'm objecting to a "bogeyman" without being able to clearly characterize him. I *can* state that the controversy over the bizarre, the obscure, or

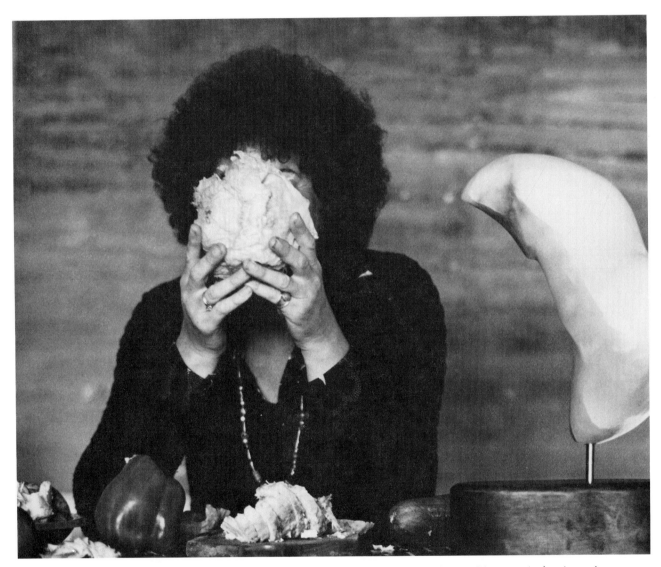

16—In an experiment to perplex the viewer, a friend of the author's covered her face with lettuce. It's a meaningless image in any context.

the empty image is valuable to individual growth. Start a discussion about any of these categories within a class or among friends and note how opinions often are prejudices, labels are accusations, and partisanship is intertwined with personality. The questions and the arguments are as important as the answers, because you can't please all of the people all of the time.

There's an inherent joy in visual games, because the "rules" can be bent regularly. There are also many paths to photographic illusion. Draw your own lines to define the sincere and the fraudulent. You'll be indulging in the pleasures of photography by exploring and discovering your own potentials —as a viewer and as an image-maker.

Chapter Checklist

1. Differences in photographic styles aren't always clear cut. In fact, some styles, such as optical illusion and fantasy, overlap.

2. John Szarkowski's *Looking at Photographs* includes many thought-provoking commentaries on about 100 photographs spanning more than a century.

3. Depicting fantasy with a camera may be a bit of a problem, because photography tends to be a literal medium. However, as your sensitivity increases and your risks begin paying dividends, your grasp of fantasy will improve.

4. In studying the work of Duane Michals, one starts to think in strange storytelling sequences, which may be humorous or eerie.

5. John Szarkowski says photographers should "collaborate with luck," a thesis expressed in earlier chapters. After you compound the effects of luck, fortunate or otherwise, you'll be better prepared for what may happen the next time you shoot similar situations.

6. Symbolism is a stimulating aspect of photography, because it allows personal interpretation through a number of techniques.

7. Minor White quietly and forcefully expounded "the photograph as metaphor," his mode of symbolic statement. Alfred Stieglitz called his own approach to a long series of cloud pictures "equivalents."

8. Study the images of Emmet Gowin as seen in a book of his work and think about how you might apply his approach to your own situations.

9. There are many words related to *bizarre*, including kinky, unorthodox, eccentric, or abnormal. Is the bizarre usually shocking, erotic, or banal?

10. In regard to the photographs of Lee Friedlander, John Szarkowski suggested that being intentionally obscure was like "playing a kind of a game." With skilled direction, you can make obscurity an asset!

11. It's not as easy as it sounds to shoot an empty image that will nevertheless attract attention from viewers, but perhaps you'll learn from the attempt.

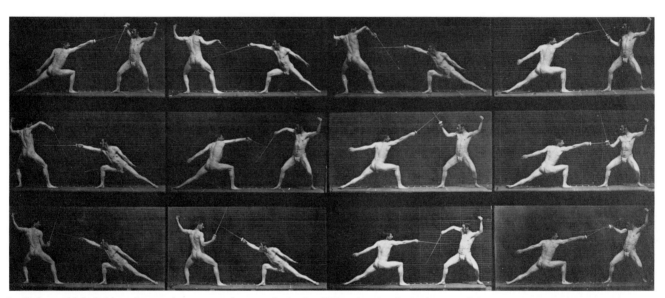

1—Eadweard Muybridge pioneered sequence photography in the 1880s when he devised ways of shooting action to show what he called "locomotion." From George Eastman House Collection.

Sequences

11

A sequence is a series of pictures related to one another in a sort of cinematic style. Perhaps you haven't given much thought to sequences, either because you don't use a motor-driven camera or because this form of personal expression just hasn't occurred to you.

Luckily, a motorized camera isn't necessary to shoot sequences; many subjects lend themselves to fast operation of a manual camera. The main characteristic of a sequence is that something happens to connect one image to the next. A photographer might be thinking in terms of single pictures and abruptly switch to a sequence concept because "form follows function," and a series often will work better than an individual photograph. It's also possible to discover sequences later as slides and contact prints are edited.

Often a picture series is like a short story: it may show an activity with a logical conclusion, or it may have a humorous twist, or perhaps even an unexpected ending. A valid sequence should also combine interdependent pictures. Otherwise, one picture in the group might dominate on its own merits and relegate the rest to your files.

Sports
The pioneer of sequence photography was Eadweard Muybridge, who in 1872 set up a series of large cameras to prove that a horse lifts all four feet off the ground simultaneously while running. Wet plates of the time were too slow to capture the action adequately, so Muybridge ingeniously devised a method using twelve cameras with shutter wires tripped by a passing horse. He went on to shoot innumerable other sequential photographs of human and animal "locomotion," as he called it. Photo 1, dated 1887, is typical of action Muybridge set up to study the human anatomy as it strained and maneuvered through various activities. There are several books of his work, including one entitled *Muybridge: Man in Motion*, by Robert Haas (University of California Press, 1975).

In the twentieth century we often associate sequence photography with sporting events, because where there's fast action, there's also the opportunity to depict it in motion-picture fashion with stills. Sports and news photographers almost always use motorized cameras in order not to miss important action taking place during those moments when one cocks the shutter and advances the film

manually. We've all seen exciting football or track sequences that could only have been made with a motorized camera, which is capable of exposing three or more frames per second. Such cameras are expensive

auto-winder operates like a motor-drive to advance the film and cock the shutter—as fast or faster than the photographer can press the shutter release, depending on the mode set and the brand. However, a winder is much

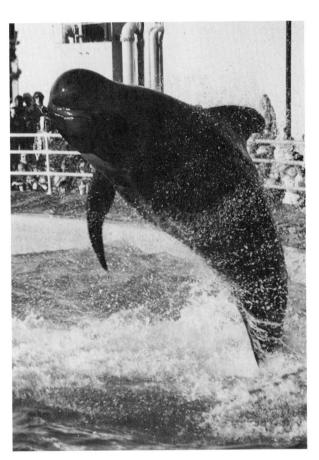

2 through 5—A motorized SLR camera makes fast action easy to capture in a series of pictures, such as these of a leaping pilot whale. Heavier, more expensive motors are being replaced by compact, affordable auto-winders, which are now available for a number of SLR models.

necessities to the working photographer but may represent status symbols or even fetishes for those who rarely use them.

In recent years the average photographer has been blessed with mini-motors called auto-winders or power-winders, which are available for numerous SLR cameras. An

lighter in weight and less expensive than a motor-drive. Either type of unit can also be a delight for shooting portraits, when the photographer can capture fleeting expressions by not having to stop and wind the film by hand.

Over the years I've occasionally used a motorized camera, sometimes in the pursuit of a living but more often for self-expression and fun, as demonstrated in photos 2 through 5. A performing pilot whale at Marineland of the Pacific was an ideal target, and for this

I used an Olympus OM-1 camera with motor-drive attachment, which I had set in the manual mode. On automatic sequence, film runs through the camera so quickly and differences between frames may be so

illusion may be more impressive. However, some subjects may come off better at a slower pace. Think about getting an auto-winder if you don't already own one, but remember, these aren't the primary tools of creativity.

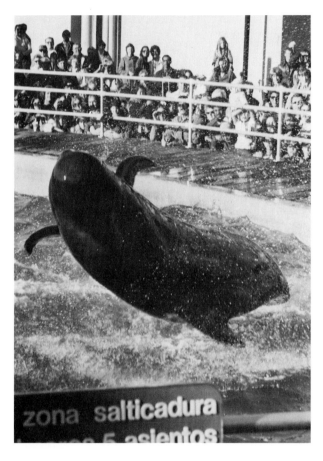

minimal, that I'm more comfortable with manual operation—and an auto-winder is great for that. For the whale shots I also used a 75–150mm zoom lens, which accounts for the change of image to include the sign. Even if I had been interested in only one peak-action picture, use of a motor-drive or auto-winder would have been indicated to ensure more good shots from which to choose.

When you show slides of an action sequence, experiment with pacing. If you pause only briefly at each frame, the cinematic

Stories

To tell a story in photography you don't need a motorized camera, nor must you conceptualize in a sequence—unless of course you wish to. For instance, at a child's birthday party you may shoot the children arriving, the progressing activities, games, food, and farewells, one at a time. Later you can present the slides or prints in chronological order as a picture story, and within the selection there could be a separate sequence taken in quick succession, such as a birthday cake being

presented, cut, and served. Using ambient light or electronic flash it's possible to take five or six shots in ten or twelve seconds by efficiently advancing the film and being close enough to provide fast recycling in a thyristor-circuit electronic flash unit.

There are as many types of stories to tell in sequences as people relate in activities or conversation. A six-shot example is illustrated in photos 6 through 11. The setting was the den of our home during the time it was being remodeled after the above-mentioned fire. Daylight entered via a large sliding-glass door at the right. The SLR camera was mounted on a tripod, because the exposure for Plus-X film had to be 1/8 second at f/4 with a 50mm lens. Though I included four people in each of the dozen pictures taken over a period of perhaps ninety seconds, I felt the amusing ambiguity was best served by opening with only two individuals and expanding to everyone in photo 8. Whatever interpretation you care to put on the interaction is fine, just as long as you understand that the sequence was made in a playful manner evolving from a casual, unplanned situation.

At first I printed ten of the twelve pictures and then I later eliminated four of them, because they held up rather than advanced the progressive feeling of the series. In addition, several shots included excessive blur which didn't seem in keeping with the rest, though I like the blur seen in some frames. It's symbolic of the inherent frolic. To me the sequence is tied together through the woman in the dark blouse, around whom the action pivots.

Obscurity and Guile
In chapter 10 I mentioned the fantasy sequences of Duane Michals, who creates

6—The beginning of a six-picture series, culled from a dozen frames shot in about ninety seconds. The smiling woman in the dark blouse is the visual center of the sequence.

7—She turns to communicate with a new member of the group.

8—Now we see the foursome, of which the woman in the dark blouse is still the central figure.

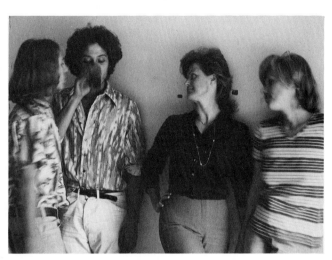

9—Refreshments are quietly shared.

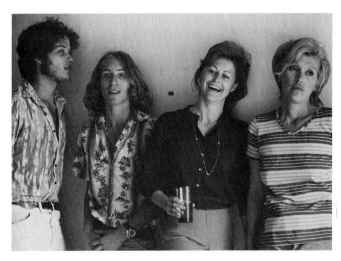

10—A pause that refreshes.

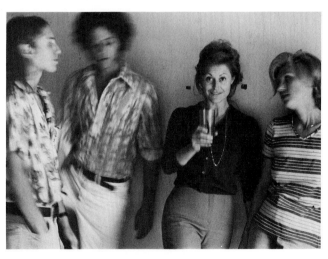

11—The photographer is urged to imbibe.

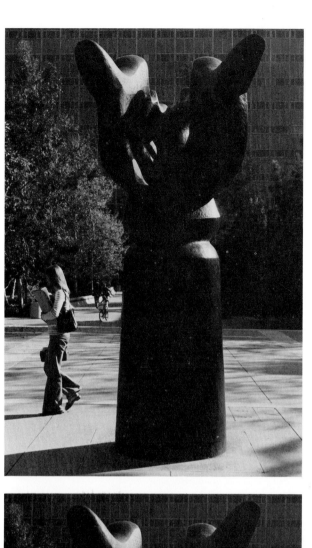
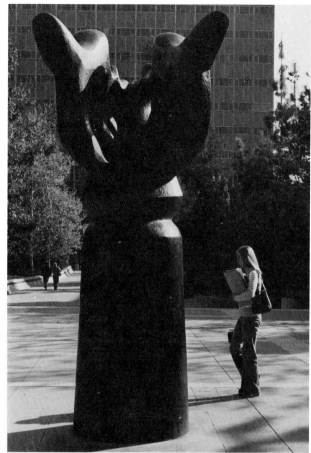
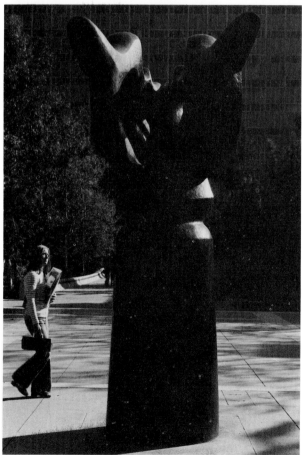
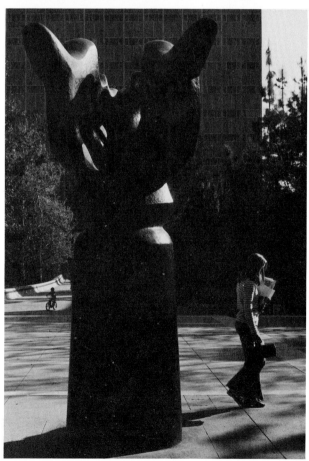

fascinating illusions by telling a story in a series meant to mystify. In books, magazines, and exhibitions, you'll come across other series of images created to conjure up dreams, represent hallucinations, or stimulate poetic fancy. Many of these include ghost figures or situation switches intended to make the viewer wonder what's happening without ever providing an "answer"—because there isn't any. Meaningless effects aren't so easy to spot, so remember to ask yourself this question: Is this a technically competent series with a valid point or cerebral vision translated to film, or is the series a hoax? Consider the possibility of articulate deception. Be on your guard as you evaluate the work you see, and even if you're "fooled," you'll be more cognizant of the possibilities the next time around.

To demonstrate this point, suppose you came upon photos 12 through 15 mounted in left-to-right sequence in a gallery, without a title or with something as ambiguous as "Passing Vision" appended to the mount. Would you decide the series was difficult to take seriously? Suppose there were some solemn words accompanying the set alluding to time, space, mysticism, or symbolism? Would the series be more intellectually appealing? Would it seem more significant?

Single, multiple, and sequential images are exhibited and printed today and presented as "art," though they're primarily tricks. In my case, photos 12 through 15 are an exercise to illustrate a point. I asked the young lady to walk back and forth by the sculpture, while I aimed the camera from a specific position. I did so to elicit curiosity and stimulate awareness. Try such a sequence yourself. Choose or devise a subject, shoot it skillfully, and don't worry about whether it has mean-

ing or not. In fact, set out to be superficial, to perpetrate a fraud for fun, and to make that point with your peers. I don't advocate joining the ranks of the obscure and haughty in the name of art—or art without substance—and yet, I realize that many photographers are capable of legitimate and moving visual expression, the meaning of which may not be easily identified. Learning to distinguish the difference in your own work and that of other people is one of the objects of this book.

Plan more sequences, or edit them from pictures that seem to fall into place and tell stories. Look for the unusual and expand it in cinematic fashion. Remember, people enjoy being hooked by an O. Henry ending.

Chapter Checklist

1. A sequence of photographs may have taken place in a few minutes or over a longer time span. It might happen naturally, as in a basketball game, or it can be contrived to tell a story.

2. Professional news and sports photographers who cannot afford to miss fast-breaking action frequently use an auto-winder or motor-drive with a 35mm camera.

3. Try projecting a series of slides in a cinematic manner. Those taken with an auto-winder or motor-drive will best lend themselves to such an activity.

4. A picture story on a personal theme can be scripted before shooting or taken in logical sequence as you go along. There's a close relationship in this kind of reportage to the way photojournalists work.

5. Just for fun, shoot a picture sequence to make viewers wonder what is happening. This is a worthwhile exercise in the persuasive power of photography to portray guile and obscurity.

12 through 15 (view counterclockwise from upper right)—This is an exercise in synthetic sequential symbolism.

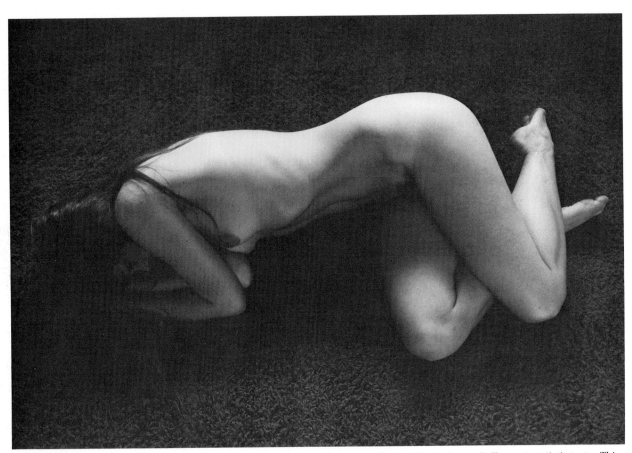

1—In the past and present, the nude has been a favorite subject of photographers and remains a challenge to artistic taste. This is an impersonal approach emphasizing form.

The Nude

<div style="text-align: right">

12

</div>

In the history of art, the nude figure and the landscape have been the foremost subjects of painters and other artists. The classic nude in painting and sculpture was entwined in mythology or idealized to avoid sexuality. Early photographers found ways to observe similar bounds of modesty through soft focus, veils, and impersonal poses. As moral values changed, the nude was photographed more frankly, but hypocrisy and social ambivalence continued until the 1960s, when it finally became legal to mail slides, prints, and publications in which pubic hair could be seen. Previously, slide processors were obliged to hold such "offensive" images and notify photographers that they would be destroyed! In books or magazines, nude figures looked very strange indeed as pubic areas were retouched, thus calling attention to that which was legally forbidden. Photographs exposing male genitals simply weren't published at all.

Fortunately, many fine photographers weren't deterred from shooting nudes in a straightforward, aesthetically erotic manner —even while those ridiculous conditions were in effect. Today we're free to take or mail whatever pictures we wish, and nude models work without stigma. Though this has spawned excesses labeled "obscene" or "pornographic," these words are subjective and loosely used. Here it's enough to say that the significance of nude photography usually is in the eye of the beholder. Vulgar, degrading, exploitive pictures are widely published, but censorship is far more objectionable than the questionable images themselves, which we're *not* forced to view.

In the context of this book the connotations of nudity are recognized as being personal. The nude is an accepted photographic subject in our times, and standards of good taste are well established without being rigid. If you haven't yet photographed the nude, perhaps inhibition, your own or that of prospective models, has held you back from experimenting. No matter. Let's explore some of the psychological and practical problems of the nude that can be solved by the average reader.

The Problems
I've sought to encourage you to see and photograph in new and challenging ways, and however sensitive the nude may be as a

topic, it's worthy of our attention. Serious photographers who have been reluctant to try taking pictures of a nude subject often are restrained by public confusion regarding nudity and sexuality. There's an outdated maxim that "nude is lewd," which really reflects a threat felt by many people who can't handle their own sexuality and are quite willing to suppress visual freedom. Nevertheless, photographers *do* have the right to photograph nude individuals in private or suitable settings, and models have the right to pose in the nude, criticized as they may be. As a result we can enjoy pictures we take ourselves, or by others, that stimulate the aesthetic and sensual senses at the same time. Even a controversy over "good taste" can be healthy to the serious photographer.

Finding subjects willing to model in the nude isn't a simple matter, but it's easier now because the photographic nude is more or less taken for granted. Wives, husbands, lovers, relatives, friends, or professional models may happily cooperate with explorative photographers. You need not show slides or prints to an audience if it will embarrass the models, and of course, you should *never* submit a recognizable nude to a publication without a signed model release.

While some good subjects prefer all pictures of themselves to remain under wraps, there are people relaxed enough to maintain self-esteem as models and allow you to show the pictures without false modesty or undue threat. There are also professional models who pose for an hourly rate. Their experience can make the encounter easier and more satisfying, especially if you're not familiar with nude photography. To find such models, ask friends or inquire at an art school. It's an honorable profession, even for amateurs, when practiced with dignity.

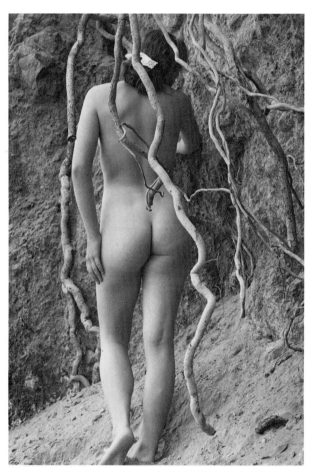

2—Because finding models can be difficult, you can offer to protect their identity in various ways that won't detract from the quality of your images.

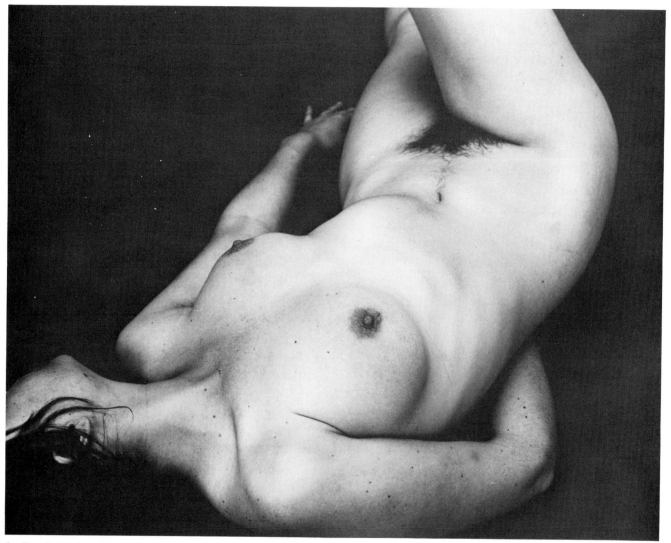

3—Framing only a portion of the figure is a technique that keeps the viewer from confronting the model's facial expression, which sometimes may be confusing.

Finding locations to shoot can also be sticky, because they need to be isolated and private. Look for lonely stretches of beach, woods, lakeshore, desert, mountainside, or even an enclosed yard where you and a model can be comfortable and unobserved. Scout for locations ahead of time and make some mental notes about lighting conditions in the process.

Don't forget indoor settings near windows or in any room where artificial and natural light are sufficient and suitable for the occasion. As illustrated in chapter 10, the offbeat atmosphere of my burned-out kitchen served as a fine background for several pictures, and I've also used the yards of friends with and without pools. Indoors or out, you can create plain backgrounds with wide, seamless paper, which is available from photographic and art supply stores. That's what I used in the shade of my patio to shoot photo 3. A dark-colored paper was chosen to contrast with the model's skin. The camera was a 2¼ x 2¼ Bronica loaded with Plus-X film and operated from a tripod.

You might also use the outdoors as a private set, as did Derald Martin with photo 4. This was taken in a dry desert lake bed far enough from the road to be undisturbed but close enough to reach by car. Martin plans his storytelling pictures before hiring a model and gathering props.

Visual Solutions

Nude photography becomes a welcome challenge, not a problem, for imaginative and resourceful photographers. Through the 1950s attitudes and conditions were far more restrictive, and yet masters such as Edward Weston managed to find ways and means to work with models. Weston often used the female figure as an element of design within a setting that was anonymous, as I did in photo 3. He also made situation nudes, such as the slim young woman lying on her back in a pool of water on page 241 of *Edward Weston: Fifty Years* by Ben Maddow (Aperture, 1974). From Weston I received the concept of directness, which means not being coy in approaching the nude or allowing your model to project self-consciousness. Weston had what one critic called "rigorous standards of visual clarity," and he applied them to fit the human form as well as inanimate objects.

While you acquaint yourself with Weston's nudes, here's a brief list of other photographers whose work can be found in many books:

• Wynn Bullock, to whom the setting was as important as the figure, and who dealt in imagery with classic sexual metaphors.

• Imogen Cunningham, who pictured the nude with a kind of innocence, and who photographed the male nude before many other quality photographers did so.

• Bill Brandt, whose book *Perspective of Nudes* (Amphoto, 1961) depicts the strange architecture of the human body because he used a tiny aperture and a very-wide-angle lens to distort the figure.

• J. Fred Smith, whose approach is sensuality with class. His work is contained in a Masters of Contemporary Photography series book (Alskog, 1975).

4—Derald Martin created this imaginative storytelling image in which the nude is invested with visual symbolism. Martin chose a desert location and used a wide-angle lens on his RB-67 camera.

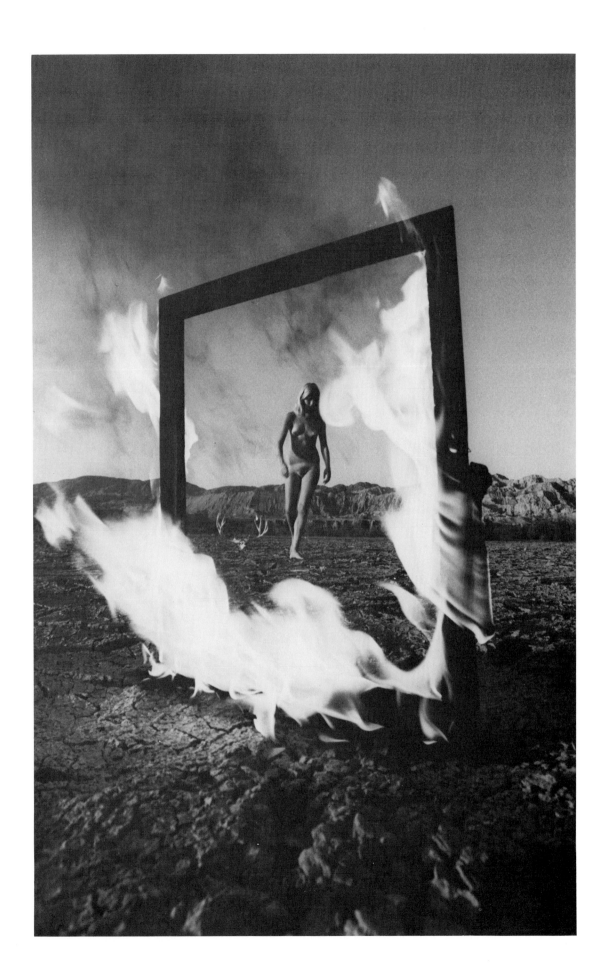

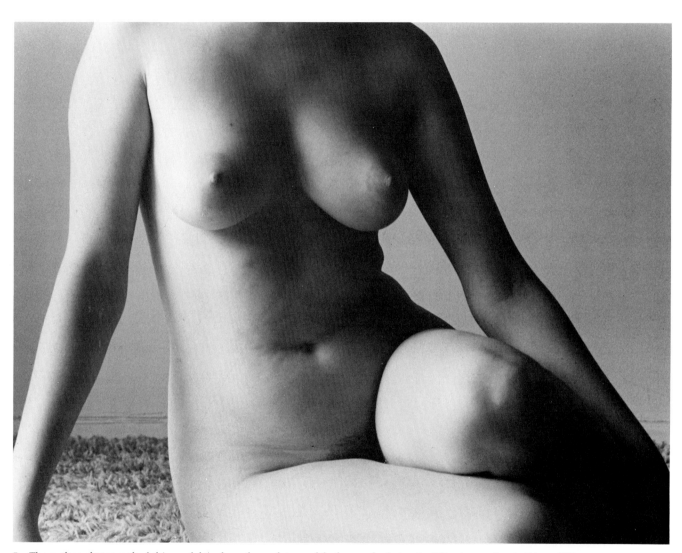

5—The author photographed this model to show the sculpture of the human body in a tradition he ascribes to Edward Weston.

Psychological Connections

The Nude in Photography by Arthur Goldsmith (Ridge Press/Playboy Press, 1975) is an excellent survey, carefully and comprehensively written with a collection of pictures which includes some hard-to-find images.

Photography of the nude should be exciting on several levels. In his book, Arthur Goldsmith emphasizes that many successful nude photographs stimulate aesthetic senses and sexual appetites at the same time. This seems natural and logical, because the mere image of a nude person usually has sexual connotations to the average viewer. In dealing with this reality, the photographer needs to examine his or her motivations. What kind of pictures do you want to take, and why? What's your attitude toward the model? How does the model feel about being photographed? To whom will you show the *best* of your pictures? Are you really being devious, or do you appreciate the beautiful possibilities offered by the nude and enjoyed by painters since the Renaissance?

When sexual values are involved, there can be only limited guidelines acceptable to a wide audience. You'll find that the conflict between objectivity and subjectivity really is based on individual judgments, so aim to please your own tastes, which hopefully are socially and artistically informed and sophisticated.

Photos 5 through 8 represent a point-counterpoint look at the nude, exaggerated to illustrate how intentional distortion may be comic and still not objectionable. Photo 5 is "straight" in the Weston tradition, emphasizing the sculptural design of the figure. It was taken in an empty apartment by window light, and if I were to do it over again, I would use seamless background paper to eliminate the carpeting and floor line behind the model.

Photos 6, 7, and 8 were taken with a 21mm wide-angle lens to show pictorial impact in a choice of angles and options. Photo 6 resembles the Bill Brandt style of feet first, while photo 7 is a head-first version. (Keep photos 5 and 7 in mind as you read further about the personal/impersonal approaches to the nude.)

Generally, the nude is photographed in an impersonal manner. The identity of the model is incidental to the image itself and may be disguised by a turned head or by framing only a portion of the figure as I did in photos 3, 5, and 9. The impersonal nude may be beautiful or sensual, but it's never intentionally suggestive.

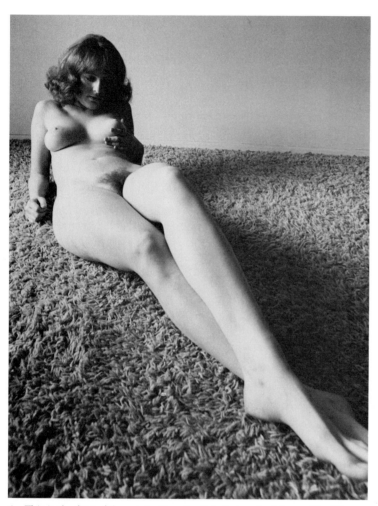

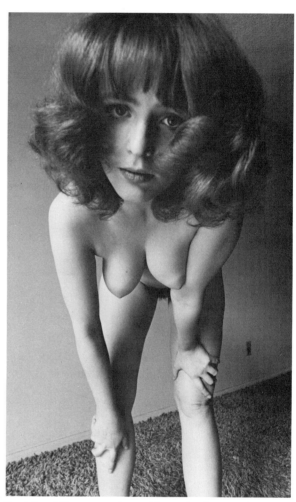

6—This is the first of three intentionally distorted nudes taken with a 21mm lens on a single-lens reflex camera and influenced by Bill Brandt.

7—A head-first approach to wide-angle photography.

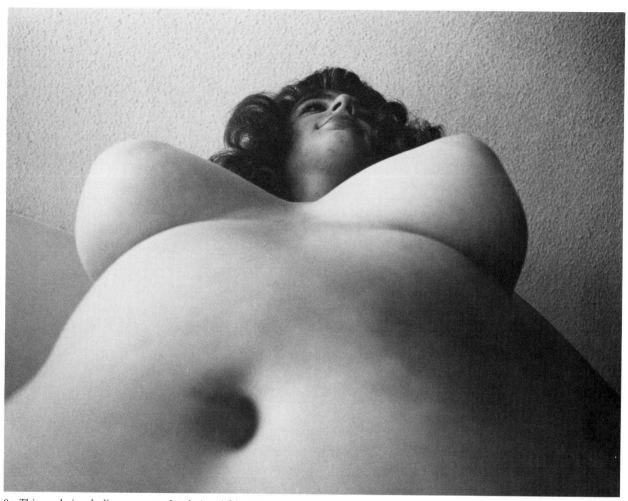

8—This angle is a ludicrous example of pictorial impact as an exercise.

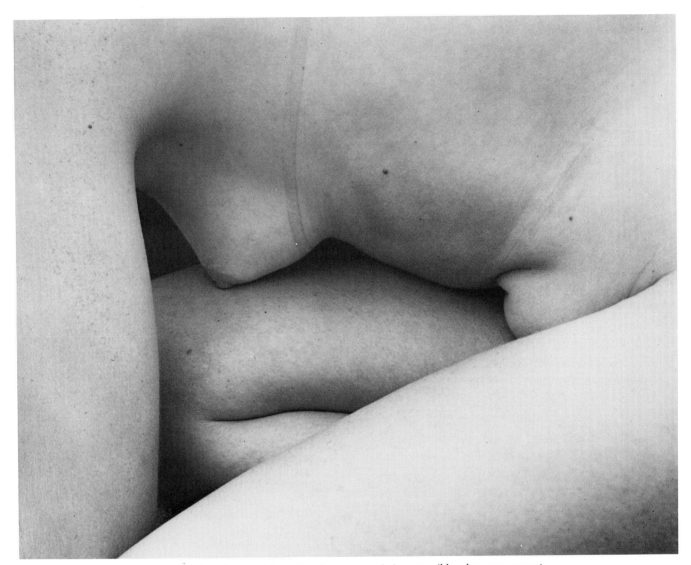

9—There's an abstract quality to the figure here which typifies the many variations possible when you excerpt as well as use the whole form.

If the model's eyes are directed toward the camera lens, there's more possibility of sexual provocation, but the facial expression has a lot to do with this, too. The pleading look in photo 7 is much more likely to inspire pity than lust. Your intentions usually will be apparent, and if your goal is "sexy" pictures, you'll direct the model accordingly. Sometimes this attitude can emanate from the model and will have to be soft-pedaled when it doesn't suit your aesthetic ideas.

There are few criteria about the effects of pose, expression, or camera angle on the potential viewer. Good intentions may be mistaken for exploitation by narrow-minded individuals. One may also be frankly erotic —without being vulgar—or sensational in the style of Helmut Newton in his book *White Women*. Called "phantasmagorical" by one critic, Newton's openly and sexually exciting nudes are nevertheless handled with undeniable class.

Keep in mind that a partially clothed female model may appear to be teasing the viewer, and that an intended impersonal attitude might be seen as simply sexual. There's an ancient tradition of "cheesecake" photography which exploits the seminude figure. This style offers limited artistic opportunity, since, in my opinion, it's another form of product photography.

Whether a figure is animated or in repose may influence the erotic sense of a picture. A leaping nude at the beach isn't necessarily sexy, nor is a model lying quietly supine, as shown in photo 10. Softness of light and grace of form were the stimuli for taking this picture, though I suppose it can be viewed as suggestive. To me it's not, for the model isn't staring at the lens with a smile, she isn't making any gestures, and the pose is not blatant. Sexual stimulation, therefore, isn't the main

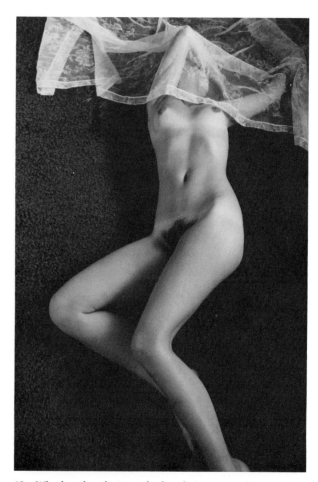

10—Whether the photographed nude is provocative or not begins with the photographer's intentions and includes the values of each viewer.

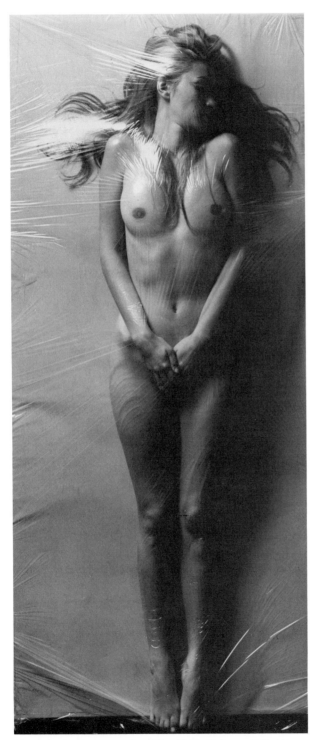

11—A fascinating example of Derald Martin's creativity, in which situation concepts guide him to shoot distinctive images. (For those who may wonder, there was a breathing space for the model hidden in the shadow of her face.)

purpose of the image. You can make distinctions such as these as you shoot and later upon examining the results.

Telling a story or intimating literary aspects within a nude-model situation is also an effective means of self-expression. Derald Martin has done this wonderfully well in

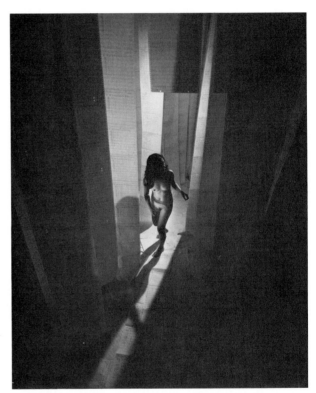

12—Derald Martin constructed a special set in his living room to illustrate his feelings about our computerized world.

photo 4, and his symbolic ideas are demonstrated further in the following pictures.

Photo 11 is one of a series in which Martin actually wrapped a model in Pliofilm to satirize the packaging of individuals in the manner of industrial products. The title for this image is "Human Being, 1973 Model, One Unit, Complete."

In photo 12 Martin again contrasts the mechanical world with the vulnerable, universally appealing nude form. In his own

high-ceilinged living room he hung streamers of computer readouts (which he lit with floods) and carefully directed his model to risk the uncertainty of her fate in Computerland.

Interpreting photo 13 seems easy enough until the viewer begins listing the reasons why the young lady is boxed in. Is she hiding or merely expressing fear of the unknown? Is her sanity secure? Does she symbolize a threat to "civilization"? Martin skillfully allows us to draw our own conclusions and make our own conjectures. His storytelling pictures are somewhat related to those of Duane Michals, who often shoots a series with an ironic twist at the end.

Working with Models

When you have workable ideas about photographing the nude and have found a setting, the problem may then be to locate a model. Some options were mentioned earlier, but assuming you don't wish to pay for a professional—or none are available—consider people with whom you have some rapport. Anatomical beauty is desirable, but it's subject to many interpretations and thus is not a prerequisite. Don't be rigidly uncompromising on the matter of a model's figure if he or she is relaxed enough to take direction comfortably. Explain that "naked" and "nude" are not the same. Show the person outstanding examples of nude photography in books or magazines and discuss your pictorial viewpoints. If you can create trust and understanding about your intentions, reluctant models may come around and be cooperative. At any rate, that has been my experience. I also promise an amateur model that she has the right to veto pictures we both

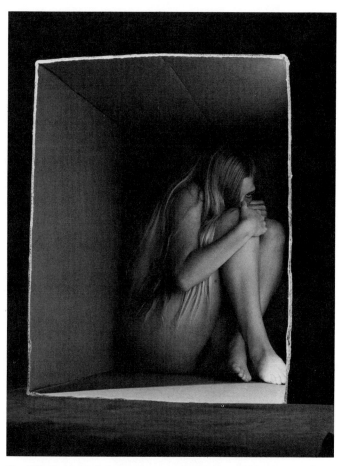

13—Whether he is being serious or playful, Derald Martin provokes viewers into asking why. This concept may be somewhat contrived, but it's very direct and personally expressive.

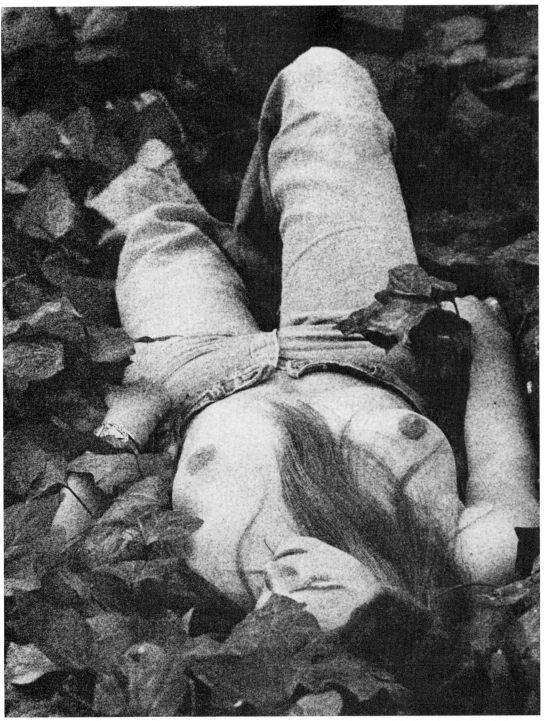

14—Addition of a texture screen during the enlarging process makes this moody seminude softer, more poetic, and slightly mysterious.

agree could be objectionable or cause embarrassment. If recognition is an issue, I explain how the nude can be depicted anonymously.

A model's suggestions for poses are also valuable. The longer you work together, the more freely you respond to each other's ideas and movements. Verbalize what you see in the finder, because when a model can share in your delight as you work, it's even more vital than friendly patter is to portraiture.

My experience in photographing male nudes is limited, but I've discovered that many women of varying ages with reasonably pleasant faces and figures are flattered to pose nude in favorable circumstances. A person's body is strongly connected with ego, and many of us try to take care of our exteriors for reasons of vanity as well as health. Wanting to photograph a particular person in the nude may generate pride in that individual as well as feelings of sexuality.

When the rationalizing and pussyfooting are over and you have the privacy and the model, you'll discover just how deeply personal and challenging photography of the nude can be. It's related to taking portraits but much more intimate. It's a kind of indirect self-portraiture. Though the photographer doesn't appear in the pictures, his or her motives and creative instincts are clearly represented. This pertains to women photographers as well as men. We may all envision ourselves and each other as ''lens objects'' in a favorable and positive way.

Chapter Checklist

1. The nude has always been a popular subject in art and photography, though Victorian hypocrisy made most pictures of the nude figure taboo for decades.

2. If you haven't yet photographed a nude person in what you consider an aesthetic manner, try to analyze the restraints you have placed on yourself.

3. The maxim ''nude is lewd'' reflects a threat felt by many people who misinterpret sexuality and who may attempt to restrict others because of their own inhibitions.

4. Finding suitable models who will pose nude isn't easy, even in this permissive day and age. You'll do your best work with someone you already trust and understand, such as a close friend or relative.

5. Improvise locations for nude photography, trying places such as a secluded backyard or indoor setting.

6. Viewing the work of fine photographers whose pictures of the nude run the gamut of poses, places, and attitudes lends emotional support to the expressive photographer who needs encouragement.

7. Your attitude toward the model and your appreciation of his or her physical appearance can help create a climate of cooperation, thus shifting the emphasis from self-consciousness to self-confidence.

8. While finding proper models and settings is sometimes difficult, once these obstacles are overcome you then face the problems of interpretation. Are you aiming for sexy, sensual, aesthetic, or frankly erotic images? You might try a little of each category with a helpful model to get them out of your system and to show prospective models your versatility.

9. Study the nude combinations created by Derald Martin and decide how you might best photograph a nude model to make a statement or enchant the eye with literary overtones.

10. The stronger your convictions about shooting nude images and the more thorough your preparations in terms of location, props, or time of day, the less resistance you'll get from prospective models.

1—Reflected light often is preferable to direct light when shooting portraits, because it's soft and nearly shadowless.

Portraits and Self-portraits 13

Assuming you would prefer to take portraits to please yourself first, there may be reasons why another's taste will prevail. Let's separate portraits into categories:

1. The likeness portrait, in which the photographer tries to make the subject look beautiful, handsome, or otherwise attractive. It's a sincere form of flattery and may be posed or candid.

2. The interpretative portrait, in which the photographer tries to indicate more about a person than the mere "geography" of his or her face.

3. The environmental portrait, which includes something of the person's surroundings for added interest.

4. The story portrait, in which the subject plays a role in a situation created by the photographer or the subject. The theme may be drawn from the person's life or it can be fictional—for fun.

Likeness Portraits

Basic portraiture begins with exercises in lighting a face and background and continues into posing, choice of lenses and camera angles, rapport with the sitter, and allied techniques. Familiarity with these principles may be gained through reading and experience. (Portrait lighting is covered in detail in chapter 7 of my book *Photography Today*.)

Photo 1 was taken in my favorite kind of outdoor light—reflected. It may come from a wall or two, as it did here, or from a flat sheet of white cardboard, or an umbrella reflector held adjacent to the subject. Photos 1 and 2 were made for my friend's portfolio, during which time we shot several outdoor variations and then moved indoors to use an electronic flash unit aimed at a white photographic umbrella (photo 2). Shadows are soft and can be manipulated by placement of both subject and reflector. Studio photographers are very much in favor of reflected light for commercial or advertising portraits or groups, because it's soft and smooth. Although it's only one of many ways to shoot a successful likeness, do experiment with reflecting walls outdoors or umbrellas indoors; pleasant results are inevitable.

Likeness portraits are subject to certain formulas, but if you try to please yourself while at the same time meeting these obligations, you're likely to avoid staid, static approaches. In extreme cases people may ask for retouching on negatives—even in color. I make it a practice to announce at the beginning of a session that I'll *diffuse* a portrait but not retouch it. I dislike the artificial contrivance of retouching.

2—The model's appearance and the mood of a portrait are affected by lighting, posing, camera angle, and choice of lens, among other things. Here the same face seen in photo 1 is lighted by reflected electronic flash.

Interpretative Portraits

There's an overlap between interpretative and environmental portraiture, but there are also distinctions. As we discussed earlier, to *interpret* means to photograph with a point of view that stems from your own feelings about the subject. Photo 3 is a rather subtle example of this taken in direct sunlight, which usually tends to create objectionable shadows. In this case shadows help create a mood that seems appropriate to the model and the setting. Shadows can be controlled and softened with

3—Direct sunlight adds its own character to a portrait, but it's not appropriate to some faces.

a reflector or synchroflash, but both have to be handled deftly because the "filled look" can appear phony. Photo 3 was carefully composed with a 4 x 5 view camera but could as well have been shot with a 35mm SLR or medium-format camera.

Both interpretative and environmental portraits are sometimes called "editorial" portraits, a term originating in the early days of *Life* and *Look*. This style is still a vital part of magazines and books, and one of the outstanding photographers in the genre is Arnold Newman. There's a fine selection of his work contained in *One Mind's Eye* (Godine, 1974), which includes such subjects as Picasso, Alfred Stieglitz, Paul Strand, and Jean Cocteau. Newman often composes with a 4 x 5 view camera, as I did for photo 4, because it invites a special discipline and challenge. He works with natural light and adds floods unobtrusively when needed.

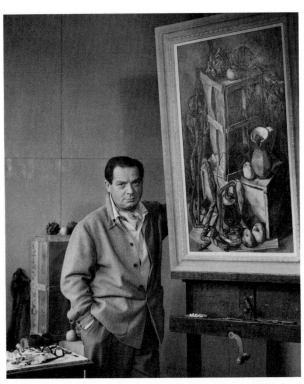

4—A subject who looks directly at the lens confronts the viewer without pretense.

Photo 4 is of an artist and his work, photographed without pretense. (The subject is the late Frances DeErdely.) My interpretation involved making decisions about the pose, props, background, and lighting. The entire painting allows you to see his work, and a few remaining objects are symbolic of his environment. The painter's personality seems more forcefully revealed when he looks directly at the viewer. It's a confrontation that helps one grasp a person's identity better than if he or she were to look away from the lens.

Robert Barclay's interpretation of the late actor Will Geer in photo 5 is a lighthearted approach to depicting the subject's character. Barclay told me, "I spent a couple of hours watching him during a filming session of a TV special, and I think this portrait sums up my impression that he was a warm person to talk to, as well as an expressive actor."

5—Robert Barclay photographed actor Will Geer to sum up Geer's projection of warmth and vitality.

The characterization or interpretation in photo 6 comes from the subject's intense involvement with the moment, whether it's work, conversation, recreation, or crisis. Helen Miljakovich took the picture of a friend whose life, she says, "was in a process of change. She was talking to another woman, and I was especially conscious of the tension in her face as I slowly raised a camera to my eye and took this. I did it quietly, and nobody was affected, because I was still participating in the discussion. I was not an 'outside' person, and I achieved what I often want to do: photograph those moments which are important in my personal life. Kristina is my best friend."

Capturing serious moments on film may be difficult, but you can expect to be accepted with a camera among familiar people to whom you are less the intruder. Express your willingness to share the pictures and assure people that their privacy will be protected through your discretion.

Interpretative portraiture with environmental overtones makes a worthy photo project. Begin with people you know, showing them at home, work, or play. Develop a point of view based on your feelings about the subjects and then branch out to individuals you might like to know. The camera is a key to many doors, and strangers often will open their lives for a while when trust is established. Shoot color or black and white, using natural or artificial light. Make opportunities to represent "the family of man" in much more than mere likenesses.

Environmental Portraits

An environmental portrait shows someone in his or her own setting and can reveal more than a closer view with an anonymous background. It offers the viewer an interpretative link. Typical subjects in their surroundings may be a housewife in her kitchen cooking or reading or a mechanic in his garage repairing a car. How often do you take pictures of friends or acquaintances in their own environments? Whom do you know with an outstanding garden, woodworking shop, or living room full of fine art? Such situations make excellent self-assignments for expressive photographers. Pretend you're shooting for a book, a magazine article, or an exhibit; with such an incentive, a dream could become a reality.

6—In this interpretative portrait, Helen Miljakovich sensitively depicts a close friend during a moment of involved conversation.

My two examples of environmental portraits were made in contrasting circumstances. Photo 7 was taken very casually with a compact 35mm range-finder camera as I talked to my charming literary agent, Ann Elmo, in her New York office. She wasn't posing, and I made only a few shots, from which this best displays her spontaneity. Mood is an important part of environment. In photo 6, mood evolves from the subject's expression, while in photo 7, the setting helps the viewer feel more familiar with an unknown individual.

Photo 8 was planned and posed to depict an artist friend, Nolan Patterson, and his wife Maggie in their den, which serves as a display room for his work. While a 28mm or 35mm wide-angle lens would have been adequate, I decided on a 15mm fisheye lens to dramatize their surroundings. Since I took the picture for myself, I didn't bother to shoot with other focal lengths as I might have for a magazine client and which I suggest you do, if possible, to expand your potential.

Study people and their environments together. Don't be content with showing surfaces if you can probe the depth of emotions or settings. Give viewers something they haven't seen before.

Story Portraits

Duane Michals once did a three-segment "portrait" of Andy Warhol which opens with the pop artist staring fixedly into the camera. In frame two his face is partially blurred, and in frame three it's completely blurred as he moved it from side to side during a one-second exposure. Michals' thesis was that few people know or understand Warhol, and in this way he symbolized his transient identity. "He wiped out his own face," Michals said of this narrative series, which became a novel

7—The author's literary agent, Ann Elmo, was snapped casually in her office with a compact 35mm range-finder camera.

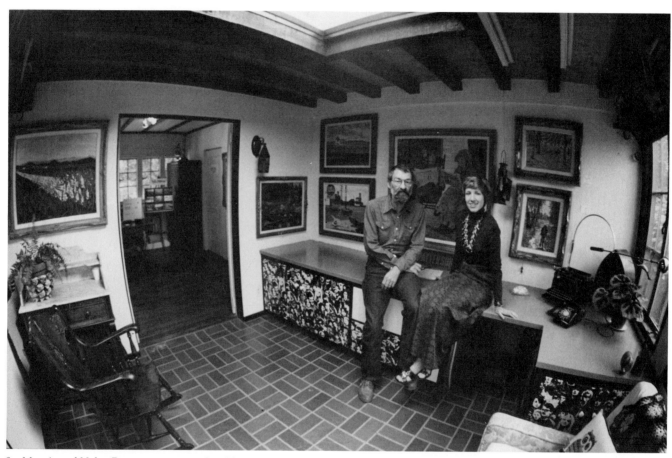

8—Maggie and Nolan Patterson pose comfortably in their home, where the walls are covered with his paintings. The curved verticals are the products of a 15mm fisheye lens.

9—Taking pictures of people should be enjoyable work, as it was when the author photographed a friend whose aesthetic appeal inspired him.

means of telling a portrait story. (See page 25 of *Duane Michals: The Photographic Illusion*, Alskog, 1975.)

When serious planning is supplanted by frivolous invention, the sheer joy of photography comes through. No matter how earnestly I discuss a topic I want the feeling of personal pleasure to dominate the presentation. Photography must be fun to be worthwhile. Using a camera helps satisfy a creative urge, and telling stories about people, or with them, is part of the process. The following images illustrate situation portraits where fun and freedom are happily combined.

Photo 9. We had taken pictures for nearly an hour using action and reaction as a stimulus. By that, I mean we both improvised as Sue danced and was led to, or assumed, various poses. During this time I made blurred and sharp action pictures alternately, after which Sue rested, still stimulated. In this portrait one may still sense her animation even in repose. It's an interpretative one-picture story of a beautiful person.

Photo 10. Mary Beth Hehemann won a Kodak/Scholastic Award with this moody situation portrait of a boy in the midst of thistles. Kodak told me that Mary Beth, then a high school student, submitted a portfolio "that exudes an otherworldly quality of often ethereal, sometimes moody or impressionistic images, including multiple exposures and creative lighting." That description stimulates the imagination and gives one a beneficial glow.

10—Mary Beth Hehemann chose an overcast day to shoot interpretative images of this youngster in a thistle field.

Photo 11. During a seminar on nature photography, friend and photographer Ernest Braun explained certain points to questioners after his presentation. This form of story or situation portrait is also reportage, which was discussed in chapter 8. It's an unposed, largely self-explanatory moment taken with a 35mm SLR and 35mm wide-angle lens in room light. There are dozens of opportunities like this for personal expression at home or on location.

11—A reportage portrait of photographer Ernest Braun talking at a seminar. This kind of realistic situation can be found anywhere and taken on the spur of the moment.

Photo 12. Artist Sue Weinberg took this picture when she began exploring with a camera for paths beyond painting and graphics. "I had set up one floodlight in a room," she explained, "and immediately some friends began playing around, gesturing, and hamming it up for the camera. While this shot characterizes the man, I like it more for its spontaneous energy." It's also a situation portrait in the realm of improvisation discussed and recommended earlier as "frivolous invention."

Photo 13. "Don't pose," Marian Keyser told her young subject. "Just show your feelings about being in the sun and fresh air,

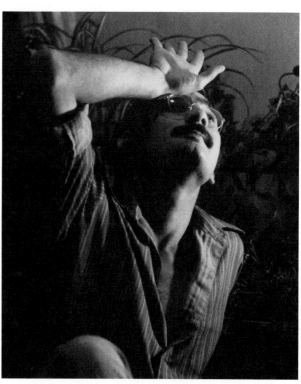

12—Sometimes friends overreact creating amusing opportunities for expressive pictures. This is by Sue Weinberg.

and ignore me and the camera." As a result, Marian caught an impulse that says more than words could. If this were part of a sequence, the impression might be even more vivid.

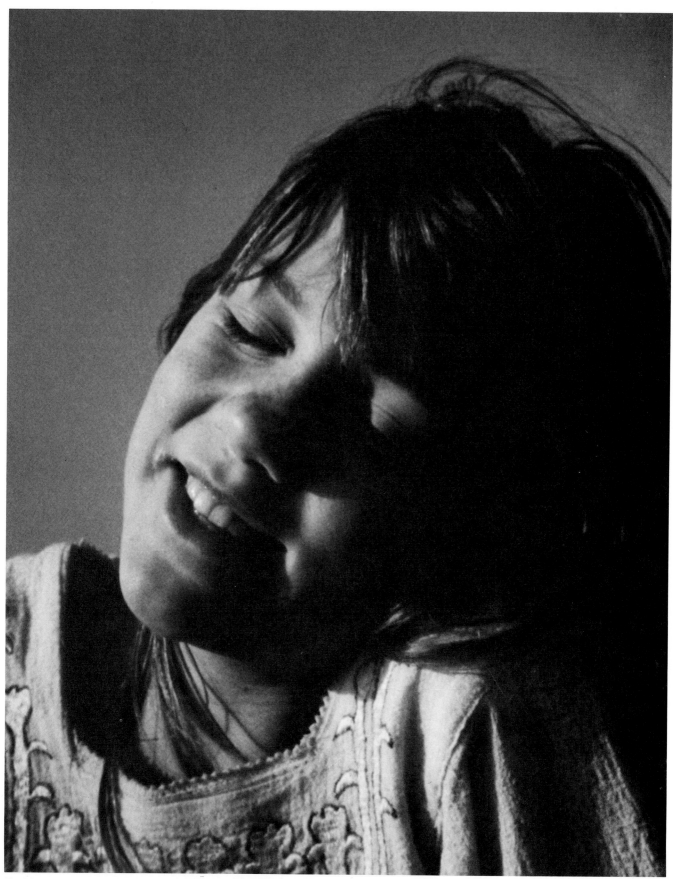

13—Marian Keyser directed her young friend to "feel the sunshine," which she did admirably.

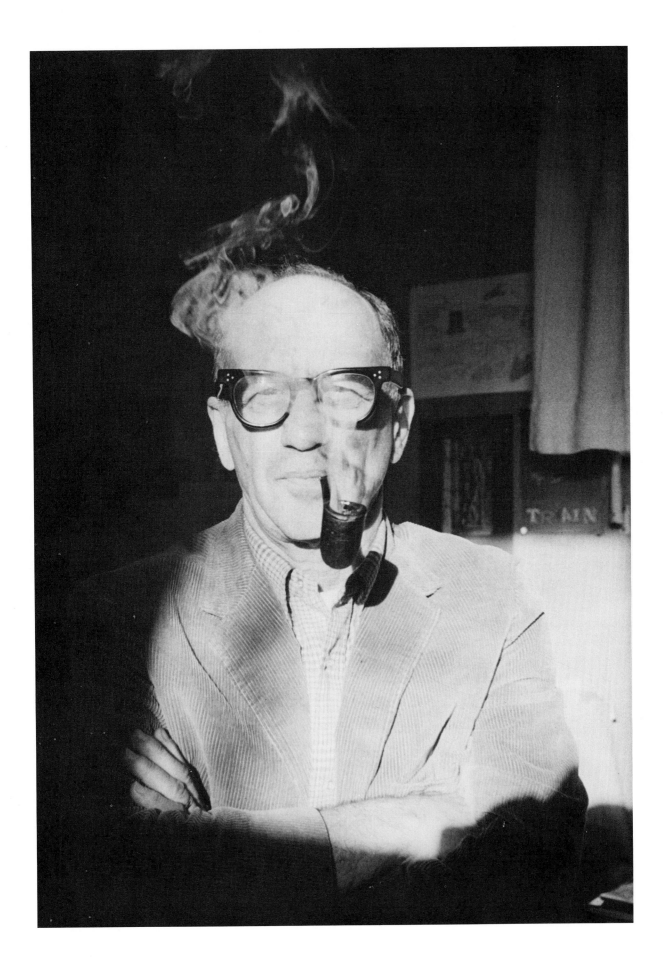

Photo 14. Here's a stylistic portrait of a friend seated in a strong shaft of sun, puffing on his pipe while I experimented with exposure to emphasize contrast. I like the sense of unreality, even if it is contrived and if the picture needs description, I would call it "impressionistic" and say no more.

Photo 15. Ending the story portrait section, this zoom effect was achieved by shooting up at the model with a camera on a tripod. It represents other less conventional ways of picturing people, which may include the use of texture screens, allowing the subject to move, or incorporating incongruous backgrounds and props. Such images can be found throughout the book.

Self-Portraits

Modeling for ourselves, interpreting our own moods and settings, or improvising via self-portraits has become a popular means of self-expression. We can appear in our own pictures in part or in a series, reflected in mirrors, surrounded with symbolism, dressed or nude. If we don't care for the slides and prints, *we* have full veto power. A self-portrait can be a real challenge to taste and sensitivity, as well as a justifiable photographic ego trip. Artists have traditionally immortalized themselves. Edward Steichen photographed himself full length as a painter, and Philippe Halsman made a surrealistic composition in which he appears as his camera.

Start in any comfortable manner—perhaps with a likeness in your own environment. Mount the camera on a tripod and use its built-in self-timer or an inexpensive accessory that will allow you ten or more seconds to get

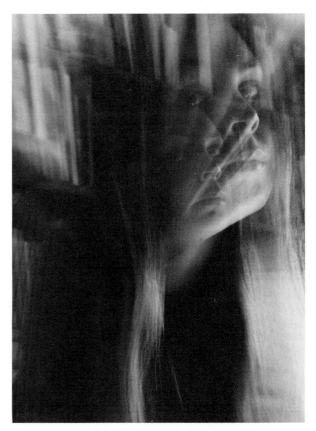

15—An impressionistic portrait made by zooming the lens during exposure.

14—Portrait impact was planned by the author, who overexposed to emphasize contrast.

into the scene in a preplanned position. Use natural lighting at first to avoid technical distractions, and then experiment with flash or floods. Attempt humor, mystery, or any atmosphere that pleases you and evolves from the setting or from imagination. Don't worry about criticism of being egotistical. Photo-graphing how you look, where you live, or situations real or contrived is a unique, personal privilege.

Photo 16 is a peek at myself doing sit-ups in a Boston hotel. I set the shutter speed on ½ second to blur the action intentionally and erase my identity. The picture reminds me of

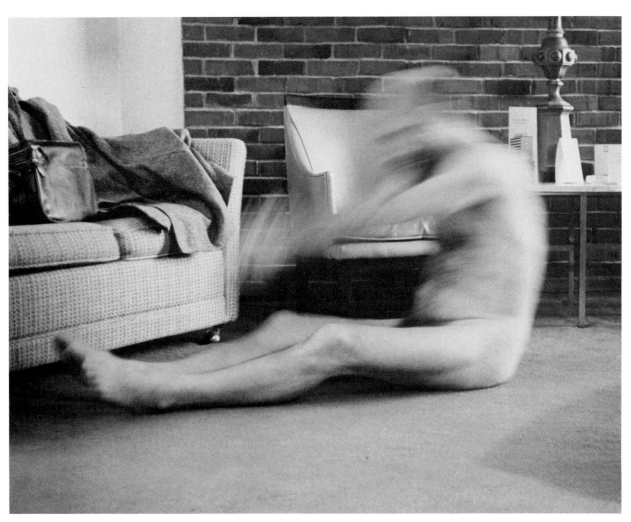

16—Self-portrait by self-timer using a slow shutter speed to accent movement and blur identity.

that visit to the East, and at the same time it records how I looked several years ago.

In another bedroom at home (photo 17) I sat in a strong beam of sunlight playing a role in a scene which needed a figure. On that summer morning the light itself caught my fancy, and I mounted an SLR with 28mm lens on a tripod to capture the feeling. The bright portions of the image were purposely overexposed to obscure myself and implement the visual drama. It's so easy to use yourself as a model that narrative photographs such as this can be designed in many locations with a variety of moods to depict.

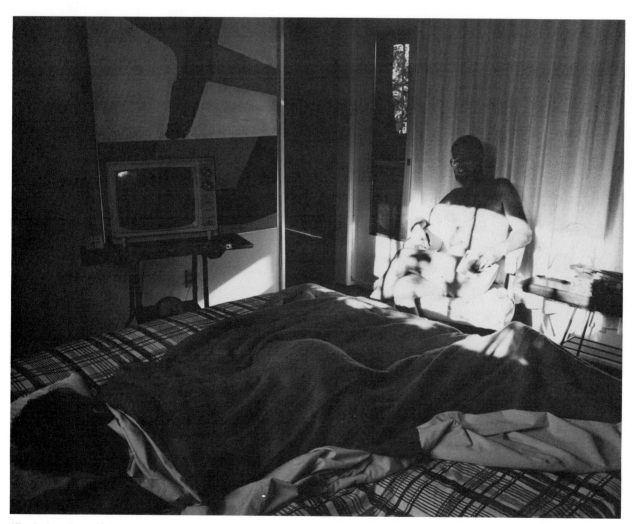

17—A situation self-portrait in which the setting is more important than the subject.

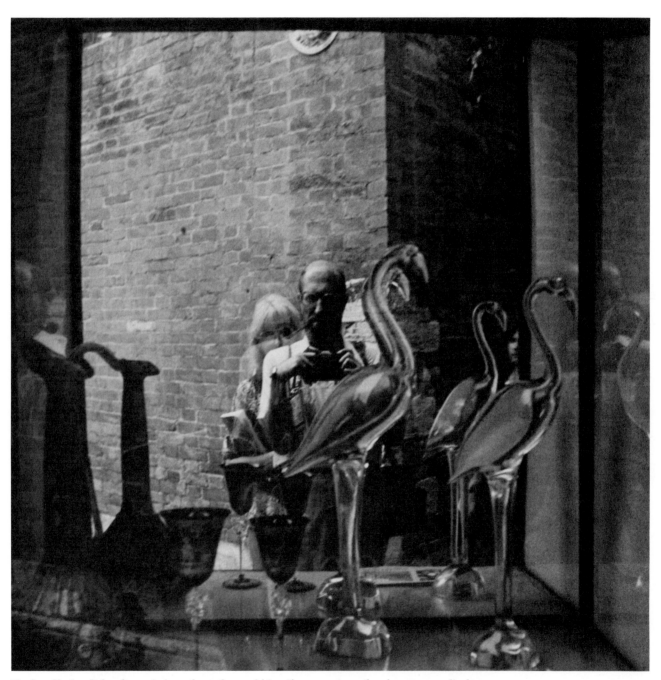

18—In a Venice, Italy, shop window, the author and his wife pose among the glassware on display.

Self-portraits can be a means through which self-awareness is increased, or they may serve as graphic records of places visited—such as Venice, Italy (photo 18). The emphasis here is less on my wife and myself than it is on the total design of this shop window reflecting us and the brick background. This image probably would have been more appealing in color, but I happened to be thinking in black and white at the time, because I like the tonal and cropping controls it offers.

Discover other self-portrait techniques for yourself. Use a mirror and place the camera out of the scene if you wish, or shoot flash into a mirror and blank out portions of yourself and the background (the flash will flare widely). Metallic reflecting surfaces, such as hubcaps and the like, can be found just about anywhere. Consider the possibilities of *positioning* mirrors to create surreal or vivid compositions. If you're self-conscious at the start, take straight pictures into a mirror to get the feel of your own image. This can loosen you up for further experimenting, but if it doesn't, try another path to expression—unless of course you're determined to overcome such psychological obstacles.

Go to an isolated area and play games with the camera by acting roles to fit your own "scripts." Be silly or serious, pose in the center or the side, and choose whatever backgrounds you find interesting. Make faces or turn your head in profile, catch yourself in motion or lying down. Don't worry about facial features, for they're usually secondary to the pose or situation. When you relax in front of your own camera, imagination expands and you become more daring and less self-conscious. The self-portrait process grows on you.

For an excellent article on self-portraiture, I recommend the December 1974 issue of Petersen's *PhotoGraphic* magazine, in which Joan Yarfitz neatly covers the topic and includes intriguing examples, literal and bizarre.

Chapter Checklist

1. A portrait may concentrate on someone's face or include a whole figure plus surroundings. You may shoot a likeness to flatter the individual, or interpret character by means of lighting and expression.

2. Outdoor reflected light is comfortable to the sitter and often very pleasant photographically, because shadows are minimized and detail is clearly seen.

3. Try making several types of portraits of one person—to please the sitter, to show how you see him or her, and to connect the individual with his or her surroundings.

4. It is sometimes easier to be comfortable with strangers after taking some time to talk with them before beginning to photograph. You may also feel uncomfortable with friends or relatives who may have preconceived notions about your ability and may not be willing to relax.

5. An environmental portrait is best made when the subject is involved with something of interest to him or her.

6. A story portrait can be factual or fictional according to your own taste or the model's request.

7. Self-portraiture has a long and noble tradition among painters, but is less popular with photographers. Self-portraits combine many of the styles discussed in this book; they can be realistic, symbolic, obscure, or based in abstraction.

8. Consider working with a friend on portraits of each other, taking turns generating ideas and pictures. Such a project could offer experience in portraiture as well as self-portraits, which might be monitored by your collaborator.

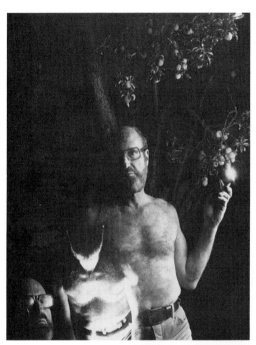

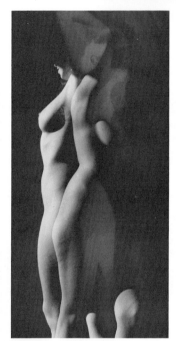

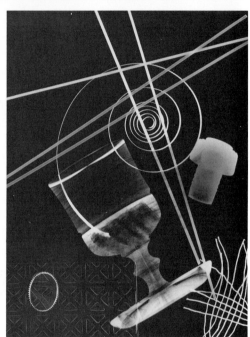

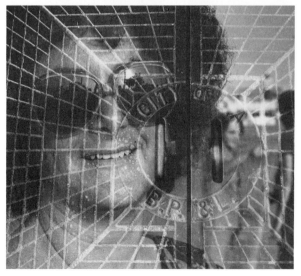

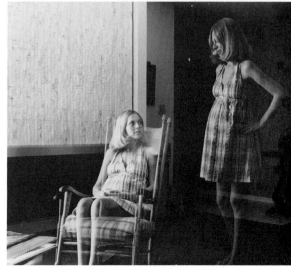

Multiple Images and Darkroom Fantasies

14

Multiple images made in the camera or created in the darkroom are "naturals" in the context of this book. Photo 1 is a recap of what has gone before to jog your memory. So now let's investigate the visual adventure of manipulated images, which are superb means of personal expression with camera or enlarger.

The transition from relatively "straight" photography to subjective imagery begins with inspiration and continues with motivation. As you discover the pleasures and disappointments of exposing one image on top of, or next to, another on a single frame of film or sheet of printing paper, you'll experience personal growth. You may want to play around with flashing light or the use of chemicals on film or paper. You won't always get the results you anticipated, but when techniques go well, the rewards are tremendous. In effect, exercising taste and control through distorting or bending reality stretches creativity as your sense of fulfillment increases.

Photography has many facets. However, too few of them are explored by competent photographers. They're not *afraid* to take chances but may just be indifferent. Knowing

what's involved in photography is the first step toward making it happen—and that's the point of this chapter. It's important to recognize opportunities when they come along. As in other facets of our great medium, to the daring belong the prizes.

Multiple Exposures in the Camera
On the relatively large finder of a 4 x 5 view camera, or even that of a medium-format camera, it's possible to overlay a piece of translucent paper and sketch the relative positions of two or more subjects for a multiple exposure. However, few readers are likely to be thus equipped. Most of us are carefree—or careless. By applying a certain method to your madness and trusting to serendipity, you can experiment with overlapping images and have a ball doing so. Actually, I was turned on to in-camera multiple images by my wife, Barbara, who particularly enjoys experimenting in color slides. She's not especially fond of conventional approaches to sports, action, portraits, or babies, but the mystery of the unknown has a dynamic influence on her creative senses when she plans multiple images. Both Barbara and I are prepared to toss out a lot of slides or pass over a lot of negatives, because the pleasant surprises are worth the selective process.

1—All six of these illustrations seen earlier are either multiple exposures or darkroom inventions.

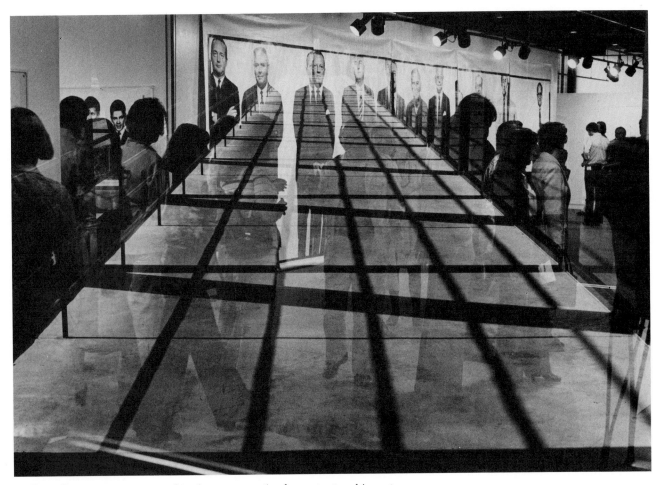

2—Two adjacent scenes were combined on one negative for contrast and impact.

There's no limit to or restriction on subject matter for overlapping images—in the camera or in the darkroom. People, places, and things may relate to one another in several ways, or they may be incongruous. Because you're likely to shoot one image and overlay another soon after, there's usually a relationship of environment to be found in multiple images.

Harmonious describes one agreeable approach to multiple imagery, but subject combinations may be quite different from each other, as seen in photo 2. I first shot the long, empty passageway seen in chapter 10, photo 4, after which I made another exposure of an indoor photo exhibit on the same frame of film. Try to keep in mind the main lines and composition of the first image as you overlay the second one, though memory and mental plotting are subject to error. This accounts for a high percentage of discarded slides or negatives, but it also can be a successful—or lucky—technique. You know the definition of luck: when preparation meets opportunity. In any case, feel free to make combinations for harmony or contrast.

Multiple-Image Techniques

In the camera or in the darkroom, an important guide to the successful overlapping of images is to place *light against dark* or *dark against light* to help distinguish lines, forms, and colors. There's a strong light-and-dark pattern to photo 2, for instance, but contrasts are more subtle in photo 3. Where light-colored flowers and leaves coincide with a darker background, they stand out, but similar tones tend to blend together.

Bright areas such as sky tend to wash out other subjects unless of course they're very dark. Therefore, try to imagine the colors and tones of one image when shooting another on top of it. Sometimes when colors become

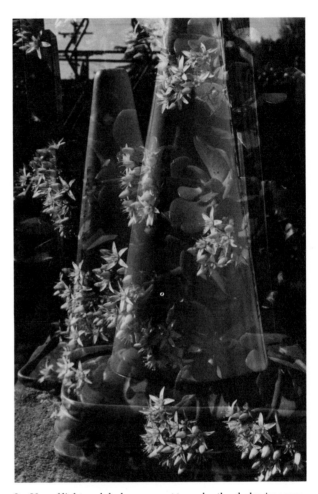

3—Use of light and dark areas next to each other helps improve the success of a multiple image.

fainter, they may still be dominant or at least appealing, but pastel hues tend to disappear in many combinations. Mixtures of color in multiple images are never fully predictable, so shoot variations on a theme to enhance your luck.

When you shoot two images on the same frame of film, each should receive *half* the total exposure. For instance, if a single exposure would have been 1/125 second at f/8, change from 1/125 to 1/250 second or switch f/8 to f/11 for each segment of a double exposure. In this way the film should have normal density of image. When your camera has a built-in meter, *double* the film speed rating to effect half the exposure for each of two shots. Should you plan a triple exposure, double the film speed again. For example, if the original ASA rating is 100, for a double exposure make it 200 and for a triple make it 400. Don't forget to reset to the correct film speed when you return to normal shooting later.

A number of late-model 35mm SLR cameras include a multiple-exposure lever or button which allows the photographer to cock the shutter without advancing the film as often as he or she wishes. Whether you're an addict of this kind of personal expression or not, such a device is a pleasure and a convenience. A medium-format camera with a removable back also makes multiple exposure easy to take. Again, shoot at twice the ASA rating,

remove the back, cock the shutter, replace the back, and shoot again. If your camera doesn't have a provision for multiple exposures, read the instruction booklet for directions on how to use this technique. There are other ways to make multiple exposures, but all of them make it difficult to maintain perfect registry; the film tends to shift slightly, and after a few overlapping pictures, the blank margin between frames is obscured. Some color film processors will return slides unmounted because they don't want the responsibility of deciding where to cut them. However, you can mount the film yourself without too much trouble.

Sandwiching Slides

A slide sandwich is made by placing two slide-film images together in the same mount to create a combination that is more visually exciting than either shot might be alone. In a book called *Art Kane: The Persuasive Image* (Alskog/Crowell, 1975), I wrote about Kane's methods for sandwiching slides, which he advocates on the basis that combining images in the camera "leaves too much to chance," and I agree. However, the choice of techniques depends on how systematic you care to be. Think of the slide sandwich as offering possibilities that in-camera multiple exposures can't achieve—and vice versa.

Art Kane has made an artistic science of sandwiching, a technique he feels is a welcome device "to transcend the deadly reality of the medium." Kane doesn't eschew reality per se, but uses the sandwiched image as a personal approach to fantasy or symbolism. He may create a slide blend when

straight photography doesn't solve a visual problem. The sandwich gives him more control over the final picture, so let's discuss how he does it.

First, slightly overexposed slides are more suitable for blends, because dark areas are more transparent. You can begin with slides already exposed or start a collection from scratch. Kane has a file that includes skies, clouds, sunsets, fields, textures, flowers, and other subjects, all indexed and separated for easy access. Go back over some of the slides you've rejected and select some of the best (slightly pale) images for sandwich experiments.

With a number of slides to work with, spread them on a viewing box or hold them up to a suitable light in search of those that are compatible, graphic, or otherwise worthy. Kane starts by projecting slides of subjects that seem to fit the combined images he has in mind. When the best are selected he removes the transparency from its cardboard mount and places two segments of film together in one plastic mount, supplies of which are available at camera shops. Eventually he has a group of potential sandwiched images, which he spreads on a light table to better reconsider the batch. You can also edit by projecting the sandwiched slides, and Kane does this as well.

During the editing stage Art Kane revises some of his sandwich combinations, handling them carefully with tweezers. Of this procedure he says, "It's a very meticulous, sometimes infuriating process." Once a pair of color images are "married," as Kane describes it, he trims an edge off the top piece of film

along its sprocket holes. Then he fits the two images exactly in register and tapes them along the cut edge. In this way the top segment of the sandwich can later be lifted to dust between the two images, if necessary, without disturbing the relationship. Sandwiches in plastic mounts may also be protected in plastic sleeves.

A number of Art Kane's carefully planned sandwiches can be seen in *The Persuasive Image*. He claims his editing technique is "ruthless," which I can believe, and advocate that yours be just as uncompromising. Two mediocre pictures sandwiched together shouldn't be expected to suddenly blossom into one outstanding photograph. In any event, sandwiching is a delightful way to expand your paths to expressive photography.

Multiple Exposures in the Darkroom

It's possible to sandwich two slides or two negatives in an enlarger to make multiimage color or black-and-white prints, but only if the density of the pair is suitable. If density is excessive and exposure time runs into minutes, you should print the negatives or slides separately. This has other advantages, providing image blends that are more aesthetically in control.

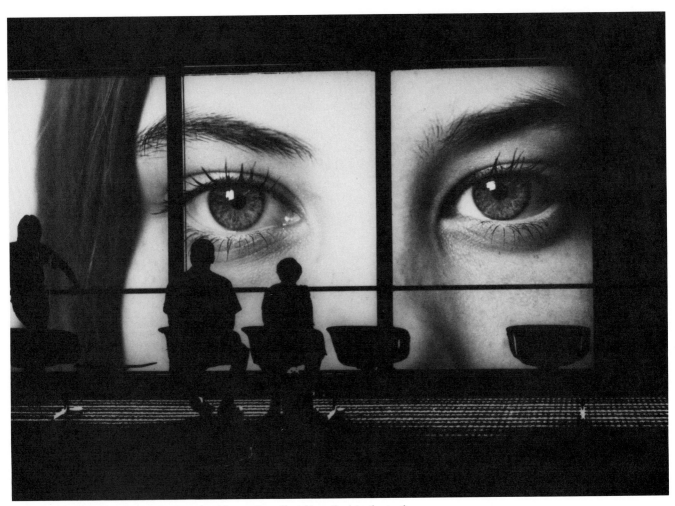

4—David Crosier printed two negatives for this startling effect (described in the text).

A basic method of multiimage enlarging requires masking part of one or both negatives to manage the overlap (a technique discussed below). An alternate method without masks offers a blend similar to ones you make in the camera. Photo 4 by David Crosier is an example that won a Kodak/Scholastic Award. David chose a portrait head and projected it onto a piece of white paper in the enlarging easel, where he sketched its size and position with a pencil. Next he projected the airport waiting room silhouette, in which the outdoor background had no detail. He aligned the dark areas forcefully to feature the girl's out-of-scale eyes. After making exposure tests for both negatives to synchronize their tonality, he projected each image separately to make the single print. Detail in the lower half of the portrait disappeared under the dark floor area, and the result is both surreal and imaginative.

Photo 5 was also created without masking from two negatives that seem synergistic together. Medium contrast in both the girl's face and the fiberglass insulating material resulted in a neat blend and a haunting pictorial effect. I experimented with several exposure times to give the model's face its best visibility and to prevent the grid from overpowering her features. In your own negative file there are likely to be similar potential images for combination. Do some detective work and find out.

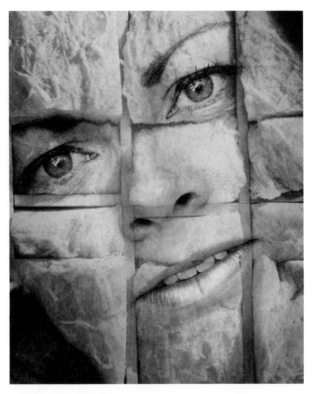

5—When two different images blend well, they'll complement each other in an overall design or offer a unique symbolism, of which this is an example.

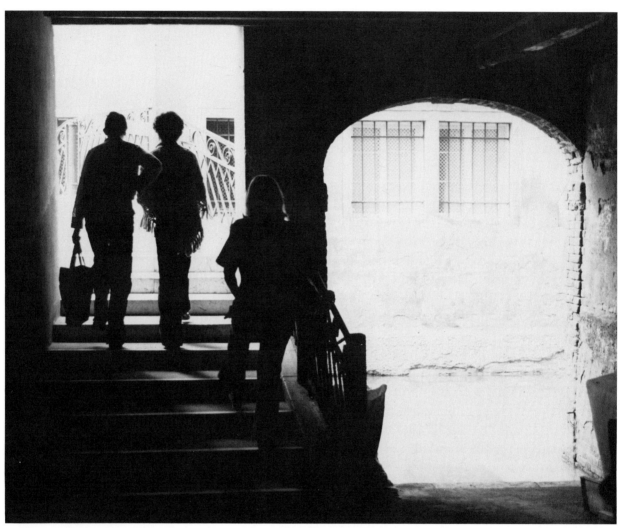

6 (above) & 7 (opposite)—How the author's wife was inserted into the open archway is explained in the text.

Photos 6 and 7 illustrate one masking method for multiple exposure. The right half of photo 6 seemed to be asking for a fill-in image. While projecting the full negative on a piece of blank paper in the enlarging easel, I drew around the white arched area and cut a hole along my drawn lines. Next I placed a negative of my wife in the enlarger and fitted her into the cut-out arch. Then I made exposure tests for each image, after which I

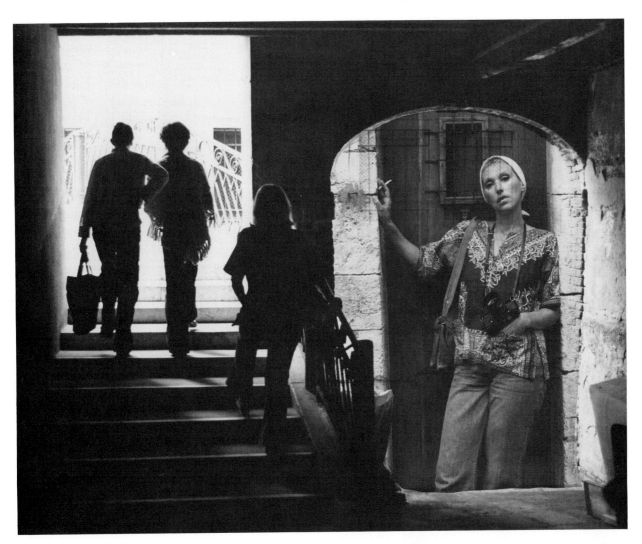

placed a sheet of enlarging paper in the easel, laid the mask on it to cover all but the archway, and projected the image of my wife. When I removed the enlarging paper I indicated its top margin on the back with a penciled arrow. I replaced the silhouette negative in the enlarger, put the full mask in place over the photo paper, lifted out all but the archway portion, and made the exposure. Registry of the archway mask wasn't perfect, but I spotted out a slim white line, and the final combination is seen in photo 7.

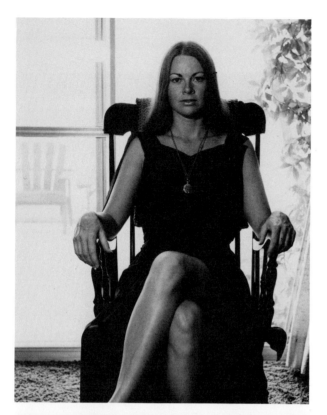

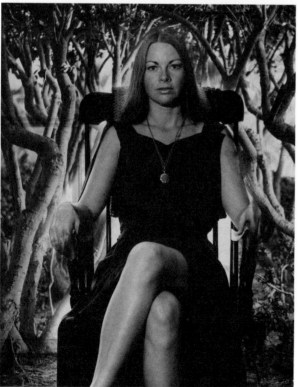

Photos 8 and 9 were accomplished in much the same manner as 6 and 7, except that the mask I cut was more complex around the edges. The original background in photo 8 is meaningless to the picture, but adding the bent trees from another negative to make photo 9 provides a strangeness I like. Though the model's image blends with the background along some edges, this adds to the unreal effect.

A Master of Multiple Imagery

If making multiple images in the darkroom appeals to you, you should be familiar with the artistry of Jerry Uelsmann. His book *Silver Meditations* (Morgan & Morgan, 1975) contains an amazing collection of work that displays an admirable imagination and variety. In another book titled *Darkroom* (Lustrum Press, 1976), Jerry describes the aesthetic and technical aspects of his photography, and his chapter was reprinted in the January 1977 *Popular Photography*. Excerpts from that book follow.

Discussing his feeling that the actual photography and the darkroom experience are thoroughly integrated, Uelsmann states, ''I like the idea of mystery and enigma, or catering to accident. You know your materials, but they themselves have to have a voice in the process. When I'm at my worst, I run things through a prescribed ritual. It's very important to have a playful attitude toward process, a constant willingness to try any alternative you can conceive of.'' When you evaluate your work, he says, don't be so critical that you inhibit yourself.

Combining images in the darkroom is ''postvisualization'' to Uelsmann, who scans proof sheets that are systematically filed along with negatives. Those proof sheets are his

8 (top) & 9 (bottom)—A new background was added to photo 8 to create photo 9.

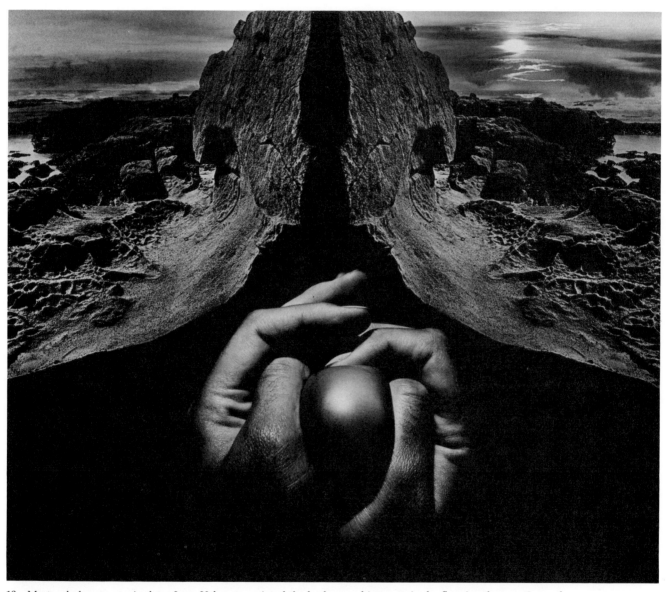

10—Master darkroom manipulator Jerry Uelsmann printed the background image twice by flopping the negative and emliminating altogether the area in which the hands appear from another negative.

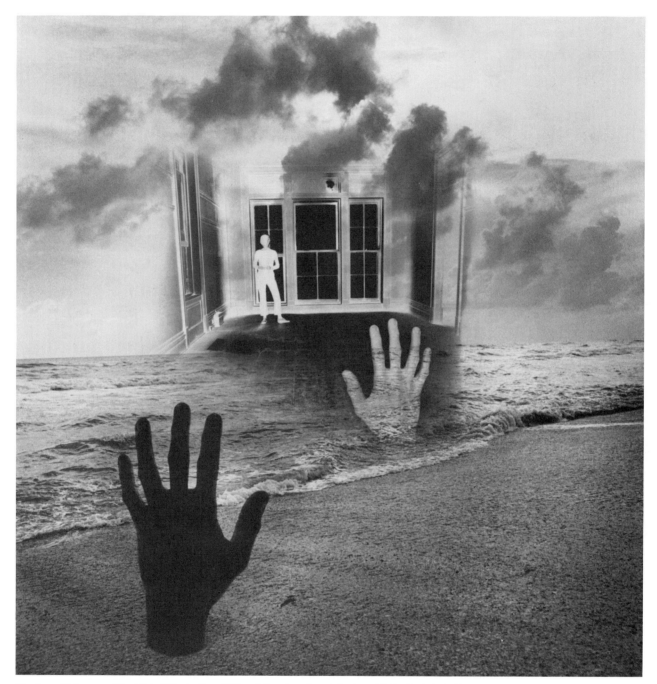

11—Jerry Uelsmann titled this "Navigation Without Numbers" and designed it in his inimitable manner with at least four separate negatives.

"visual dictionary and/or diary. They represent everything I've seen and responded to over a period of many years." When Jerry takes pictures he is making a visual inventory that includes anything which seems meaningful to him for a future composition. He doesn't try to decide how a subject may be used in a specific way at the time he photographs it, but he has a feeling that it may well serve in a future blend. For this type of work he uses a 2¼ x 2¼ camera with several lenses. The square format enables him to get around decisions about horizontal or vertical as he shoots.

Unlike many professionals who own a number of cameras, Jerry has only one, but his darkroom is equipped with half a dozen enlargers. When he gets ready to print he has marked specific images on his proof sheets and can place each negative in a separate enlarger and leave it. Then begins the blending process, which may simply combine one image in the foreground and another in the background, or it might involve a complex arrangement. He tries to stay away from final decisions as he works and experiments, enjoying "the idea that you begin with clues, suggestions, possibilities. When the image finally surfaces in the developer, it's sometimes a disaster; other times you know you're on to something. You have to listen to what the image is saying at that point." Intuition plays an important role in Jerry's multiple imagery, as it does during the original photography.

Rather than cutting masks as I did for photos 6 and 8, Jerry is more apt to block off part of an image by placing a piece of cardboard on a filter holder below the enlarger lens. This provides a soft-edged mask. Previously he has sketched on blank paper the relative position of each image, and once his

exposure and dodging tests are complete, he can make a number of prints of the final composition without disturbing the enlarger setup.

Jerry Uelsmann's work is characterized by artistic and often startling overlap or juxtaposition of image features chosen with consummate taste. I suggest you read his article in *Darkroom*, where you'll also find chapters by other prominent photographers such as Wynn Bullock and Duane Michals. You'll discover that Jerry's spirit and enthusiasm are contagious. To him the doing is much less important than the discovery involved. He has what he considers a "dialog" with his multiple images as they are conceived. "What I'm really making a case for," he concludes, "is risk-taking—the willingness to go out on the limb." For Uelsmann, the "excitement generates a lot of energy."

Photograms

In chapter 2 we discussed the photogram pioneered by Man Ray, who produced some memorable artistic compositions by what at first seem to be quite simple techniques. You don't need a camera, a negative, or equipment other than photo paper, processing trays, and chemicals. You do need materials small enough to lay on the enlarging or contact printing paper in a darkened room where ordinary safelights are advisable.

A photogram is made by placing objects directly on the photographic paper and flashing a white light on them one or more times, usually from above or from an angle (or both). Where the paper is struck by light, it turns gray or black in the developer, depending on exposure and developing times. An opaque object such as a scissors will leave a white "shadow" if it isn't moved, and

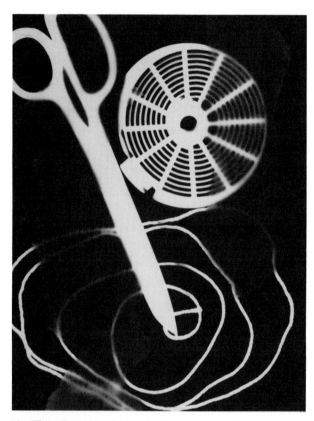

12—This photogram by Martha Grose was relatively
uncomplicated to make.

the imprint of translucent material, such as
glass or colored plastic, will appear in shades
of gray. Edges of photogramed objects may be
sharp if there is close contact with the paper or
fuzzy when edges are raised. In addition, if
you move the object or the light, multiple
forms will appear in various tones that may
add to the aesthetic impression.

Begin a photogram with any materials that
suit your fancy, varying them between
opaque and translucent. If you have an
enlarger, arrange the objects on photo paper
on the enlarger base for a uniform, controlled
light source. Martha Grose used this
technique to win a Kodak/Scholastic Award
for her relatively simple photogram seen in
photo 12. The medium-gray objects were
pieces of edge-torn translucent plastic laid
under the film-developing reel and over the
string where the latter appears gray.

More subtle tones are seen in Stephanie
Phillips' photogram, photo 13, where plastic
clover leaves and a translucent department
store price label were combined. Stephanie
first laid the clover in one arrangement and
flashed the paper very briefly. She then
rearranged the clover and added the label for
the second exposure. In this way we see a
pattern of clover within clover, and none of
the paper is pure white.

While the photogram process is basically
easy, sophisticated variations are possible
through choice of materials, composition,
switching objects, and multiple flashing. Find
some of Man Ray's photograms in books to
see what I mean. Several of this artist's
originals in the Peggy Guggenheim Collection
in Venice, Italy, are remarkable. It's hard to
comprehend just how he accomplished
certain effects.

13—Stephanie Phillips made this photogram using the several
steps described in the text.

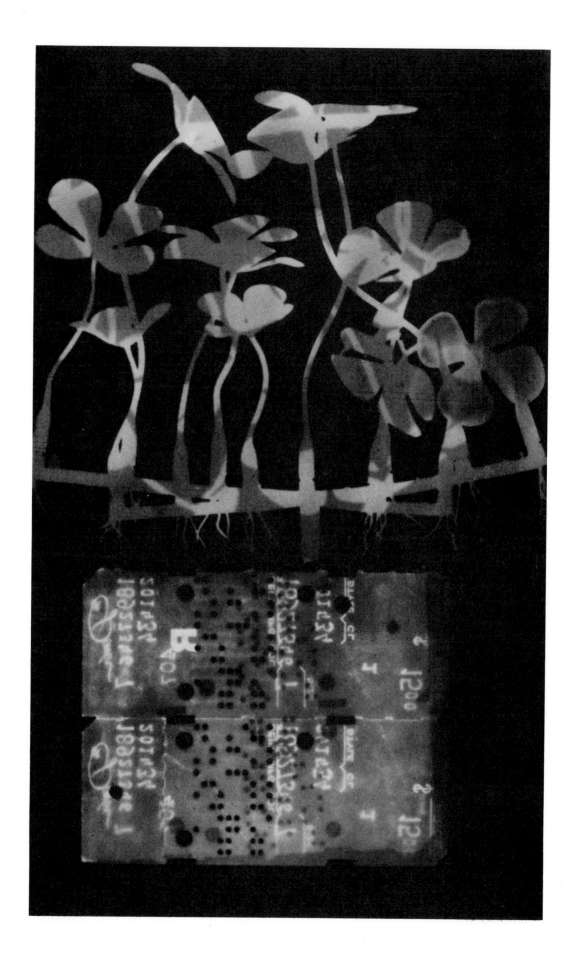

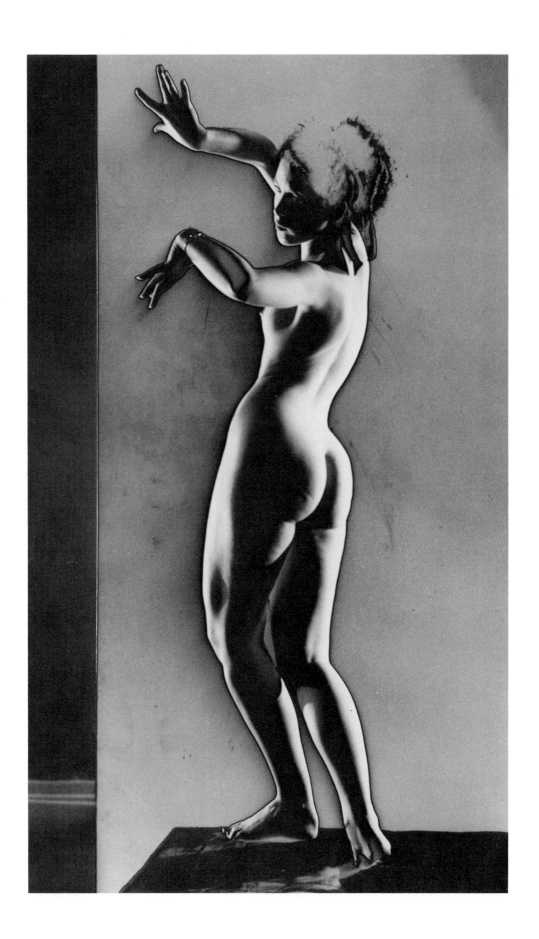

If you're able to assemble objects for a photogram on thin plastic, you may be able to move them intact and reproduce the effect again. However, it's more practical to shoot a copy negative of your best efforts and make duplicate prints from it.

The Sabattier Effect

If a negative is subject to extreme over-exposure, which partially reverses the image in some areas, the phenomenon is known as solarization. That term is sometimes misused to describe the Sabattier Effect, where reversal is achieved by intentionally reexposing the film during development. The Sabattier Effect may be produced with either film or photographic paper, but results on film are superior in contrast, and you can use the negative for duplicate prints.

If you shoot roll film, it can be reexposed to white light during development, but each image on the roll will be affected. Therefore, the most efficient way to enjoy the Sabattier Effect is by using sheet film, which allows you to reexpose one shot at a time and to easily vary developing and reexposure times. This means using a view camera, but if you don't have one, by all means experiment with roll film. Shoot ten pictures, leave a few blank frames, and finish a twenty-exposure roll. Measure the length of ten frames on a developed roll of film and set up a simple jig in the darkroom by which you can snip the undeveloped roll in the dark. With this system you can test reexposing a limited number of images at one time.

14—A 4 x 5 negative of this dancer was reexposed during development to cause the Sabattier Effect, which includes the reversal of tones in some shadow areas.

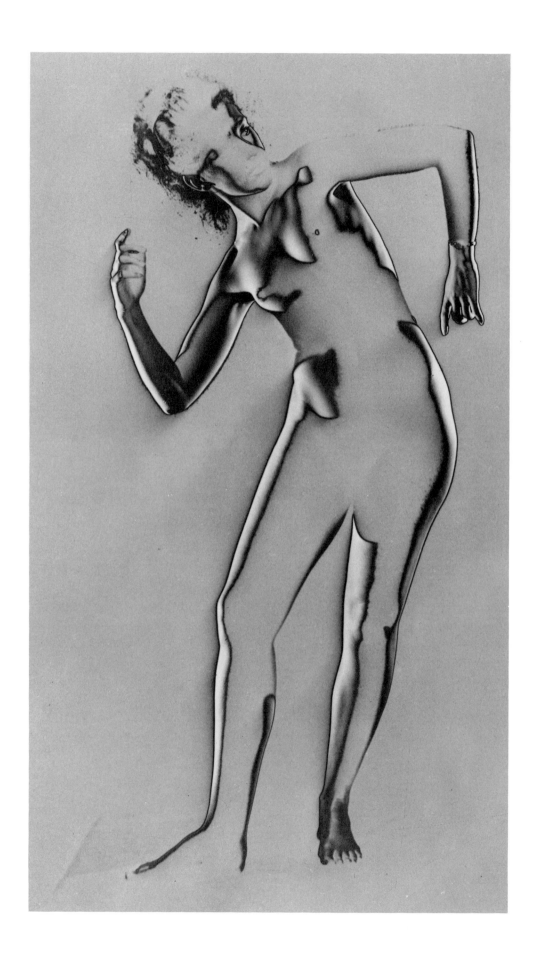

Here are the variables to consider that affect aesthetic quality in the Sabattier Effect process:

1. Contrast in the original subject. A high-contrast subject, such as a figure brightly lit along one edge and fairly dark in shadow areas, is a likely candidate for reversal. The Sabattier Effect produces a narrow line between adjacent highlight and shadow areas, called a Mackie Line, which is seen along the edges of the model's body in photo 15. Chemical concentration at the boundary separating the contrasting tones results in this contour line being so sharp.

2. The amount of reexposure. Films should be developed about one-third the total time before reexposure to white light for two to three seconds. Use a regular 100-watt room light or a 40-watt light closer to the tank or tray that holds the film. Sheets of film may be left in a tray or reexposed separately in developing hangers. To obtain more reversal of tones, increase reexposure time, or reexpose earlier in the development.

3. The extent of development after reexposure. Continue development to the normal limit with the film in total darkness after reexposure. If the fog level of the developed negative is too high, decrease reexposure time, or total development time, or both.

4. The time during development when reexposure takes place. If reversal effects are too strong for your taste, reduce reexposure time, or develop the film longer before reexposing.

Color transparency film may also be partially reversed to obtain the Sabattier Effect using similar techniques, details for which are available in the Kodak book *Creative Darkroom Techniques* (1973), an excellent source full of ideas.

Reexposing Prints

Though results are less dramatic, it's more expedient to experiment with the Sabattier Effect while printing, since original negatives are not affected by failure. The print phase is a good introduction to the process. Here is a brief outline of the steps to take:

1. Choose a negative with better-than-average contrast relationships.

2. Use a grade #4 or #5 enlarging paper, and make an exposure test for a normal high-contrast print developed at least two minutes.

3. Expose the print for the length of time determined in step 2, and develop it about thirty seconds.

4. Pull the print, rinse it briefly in water, wipe or squeegee all moisture from the surface, and expose it to a 15-watt bulb for three to five seconds with the emulsion side about six feet from the light. You may also leave the print in the developer face up to reexpose it, as recommended by Kodak.

5. Continue development of the reexposed print another minute and a half or until it looks right to you.

6. Fix the print and evaluate it for adjustment of exposure, development, and reexposure times as seems necessary.

Variations in exposure and reexposure are tricky, and prints are likely to turn gray too quickly, but trial-and-error efforts to master this process pay off in worthwhile images.

15—This 4 x 5 negative original was reexposed for a longer time than the one used to make photo 14, resulting in a more abstract effect plus the more prominent Mackie Line at the edges of the figure.

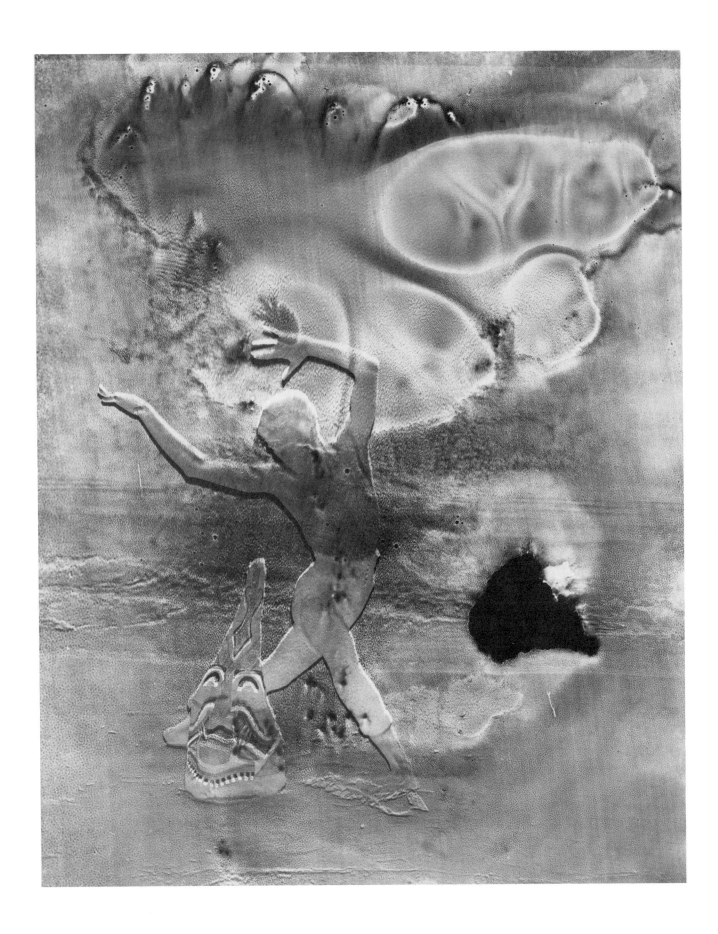

Reticulation

Extreme changes of temperature during film processing cause the emulsion layer to distort or crinkle into an overall texture called reticulation that may be pictorially appealing. Kodak suggests that because films are so stable today, the easiest way to achieve reticulation is to simulate it with a texture screen sandwiched with a normal negative. I'm inclined to agree, but if you wish to play around for yourself, here are steps Kodak gives for reticulating black-and-white negatives:

1. Develop the film normally (starting perhaps with a short roll), and rinse it for a minute in a mild acetic acid stop bath at a temperature of 140° to 150°F.

2. Dip the film in cold water, below 40°F, for one minute.

3. To emphasize the reticulation pattern further, immerse the film in hot water (180° to 190°F) for another minute, and switch it to the 40°F water again for half a minute.

4. Fix, wash, and dry the film normally.

Reticulation is more effective on images with a strong, simple composition, and again, if you use sheet film, one-at-a-time manipulation has its advantages.

Photo 16 is a photographic pun in which a reticulated negative was used. For the overlaid pattern, I pressed a rubber heel against an ordinary ink pad and stamped an impression on a unexposed sheet of 4 x 5 film that had been cleared in hypo. When the ink dried I sandwiched the film with a reticulated negative of the model and printed them together. Try your own version of this pleasant contrivance.

16—The original 4 x 5 negative was reexposed and then reticulated. The bas-relief effect was created by tapping the negative while the emulsion was still soft—and praying.

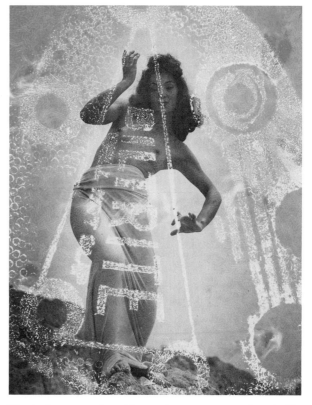

17—A play on words and images began as an experiment with two negatives (described in the text).

Posterization

In its simplest form, posterization reduces a normal continuous-tone image to black and white without gray tones. A beginning method is to print a contrasty negative on high-contrast paper, such as grade #5 or #6. An alternative is to copy a normal print with a 4 x 5 view camera, using Polaroid Type 51 high-contrast film, an example of which is seen in photo 18. None of the above techniques is guaranteed to remove all gray tones, but you come close when the original negative or print is very contrasty.

The guaranteed way to create a posterized image is to print a normal negative on high-contrast film, such as Kodalith Ortho for black and white or Kodalith Pan for use with color slides. To do this, place the negative or slide in an enlarger, compose for a 4 x 5 format, and project the image onto a sheet of 4 x 5 Kodalith film inserted in the enlarging easel. Develop the Kodalith in undiluted Dektol or Kodalith Super Developer and follow instructions with these materials for time and temperature.

If you project a negative, you get a positive image on Kodalith. When it's washed and dried, the positive may be contact-printed with another piece of Kodalith to make another negative. It may take more steps to remove remaining gray tones and produce a stark black-and-white picture, as shown in photo 19 by David Sandoz. Posterization helps to wipe out distracting details in a picture, which can be further retouched with

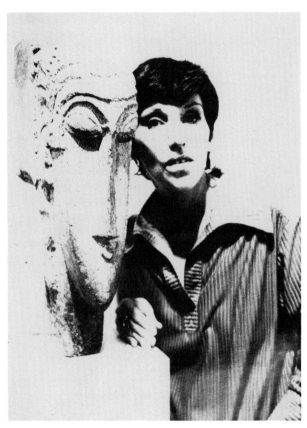

18—A normal print was copied with high-contrast Polaroid film, which offers instant results.

19—David Sandoz projected two separate images onto high-contrast sheet film, enlarged the bird, and created a composition by sandwiching the two 4 x 5 negatives in one enlarger.

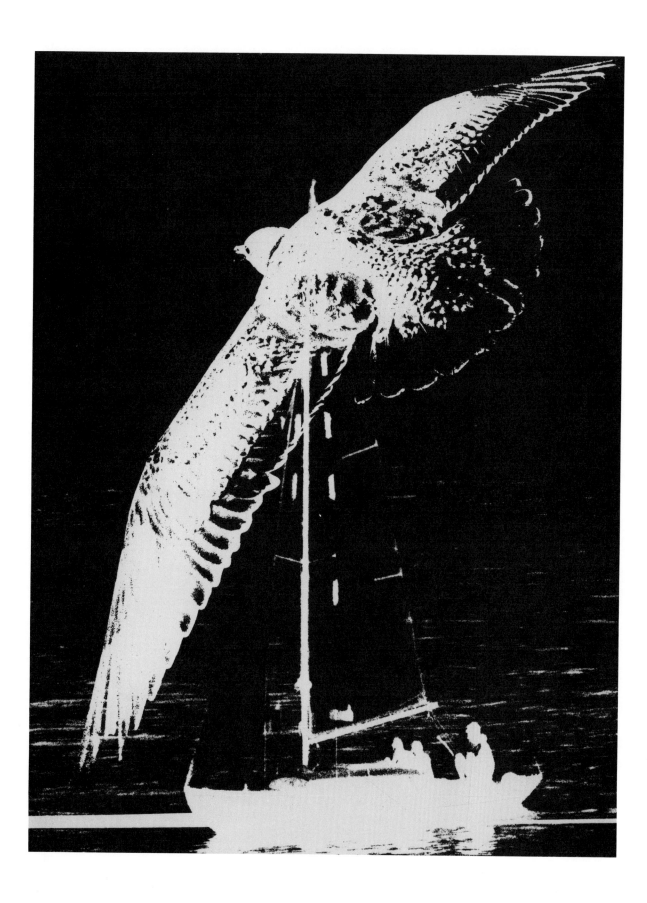

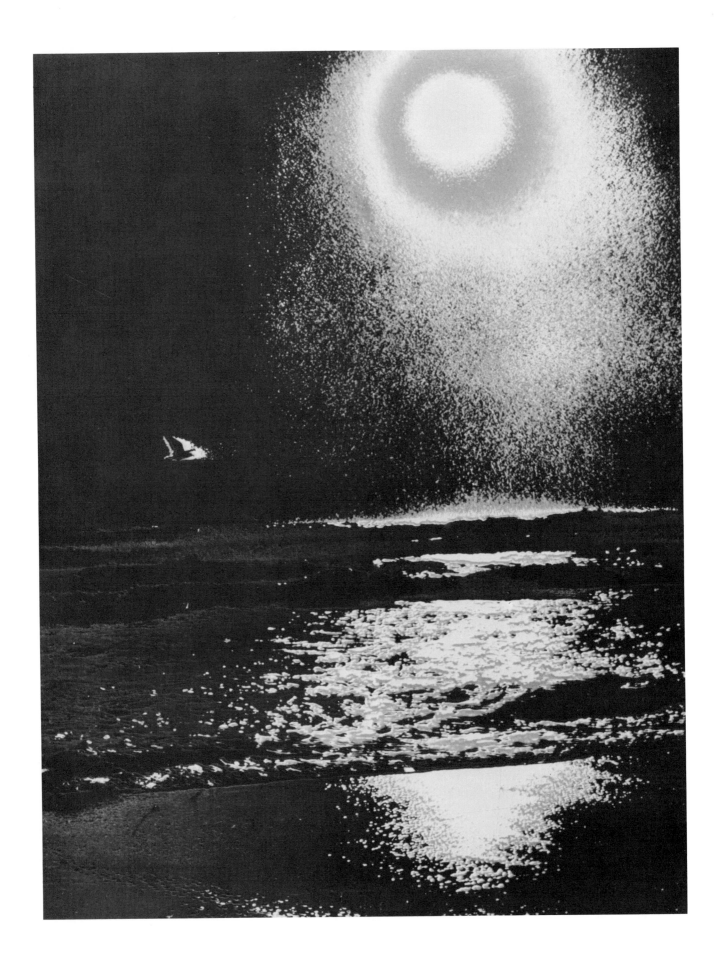

an opaque pigment. As a result you have a new impression with fresh visual vitality.

There are more complex forms of posterization in which tones become jagged lines, backgrounds are gray, or negative and positive images are printed together slightly off register for a bas-relief effect. Black-and-white film combined with colored filters and color printing paper turns reality into fantasy. Numerous technical options are described in *Creative Darkroom Techniques*, and they're also handsomely detailed in a book by Robert D. Routh called *Photographics* (Petersen Publishing Co., 1976), where many darkroom techniques are discussed. Professor Routh's virtuosity is formidable, and his book is a "postgraduate" course in expanding your visual horizons.

In the End

Superficially, the photographic processes covered in this chapter may be considered gimmicks by the purist, but to the open-minded, the effects described are all valid means of self-expression. One process or another may turn your creative energies on without contrivance or pretense.

There are more paths to image manipulation in the camera or darkroom, including diffusion, intentional distortion, using paper negatives, toning prints, gum bichromate printing, or photography combined with silk-screen reproduction. This chapter is a sampler only.

In the end, the options are yours to make the most of your aptitude with a camera and afterwards with film. The only limits you need consider are involved with taste, equipment,

20—Several high-contrast negatives were combined to make this poster effect by Emily Jean Payne, who won a Kodak/ Scholastic Award for her efforts. Similar techniques are used to make dramatic color prints.

materials, and motivation. Personal photography covers a spectrum that is wide and deep. Always remember to:

- Please yourself
- Explore, and take chances
- Ignore the "rules"
- Look everywhere for stimulation
- Express yourself in one style or many styles
- Give your imagination wings, and you will soar.

Chapter Checklist

1. Some creative people are inhibited by not being able to predict the results of their efforts and, thus may avoid some of the multiple-exposure techniques and darkroom manipulations from which exciting images are produced.

2. In-camera multiple exposure is risky because you can't be certain that two or more images will work well together, but the surprises are worth the risks.

3. In planning an in-camera multiple exposure, try to keep in mind the main lines and composition of the first image as you overlay the second one.

4. Remember that *dark against light* and *light against dark* help to distinguish a multiple exposure in color or black and white. Bright areas and colors tend to wash out darker ones, but where they overlap, there may be a handsome blend.

5. If your camera doesn't have a multiple-exposure lever, check the instruction booklet for directions for making multiple exposures.

6. Sandwiching slides is a more systematic way of achieving a multiple image without excessive wasted effort. Slightly overexpose each frame to make it more transparent, and make many combinations until you discover

those that seem most harmonious and effective. Art Kane begins by projecting all the slides he feels are appropriate and continues the process of elimination on a light table.

7. Darkroom multiple exposures or image combinations can be made in several ways. Sandwiching two slides or negatives is limited to those with suitable density.

8. Masking a portion of the printing paper as each of the images is projected is another way to make multiple exposures. This technique offers more latitude for experiment; it's easy to correct mistakes by merely starting over.

9. Jerry Uelsmann is a master of multiple imagery, not only because of his fertile imagination that helps him seek curious and attractive combinations of subject matter, but because he is a highly skilled printer as well.

10. Despite the complexity of his techniques, Uelsmann's images are essentially uncomplicated in their visual impact.

11. Variations of white, black, and gray in assorted shapes aren't difficult to make in the photogram process.

12. Reexposing film to achieve the Sabattier Effect requires careful skill, but solarizing a print is easier and allows you to repeat a technique until you get what you want.

13. If you experiment with reticulation, do it with sheet film. In this way you can work with a few images at a time, and the emulsion is more readily maneuvered than that of roll film.

14. Posterizing a photograph usually takes four or five steps on high-contrast film in order to remove *all* halftones.

15. Expressive darkroom work may rely heavily on serendipity, but experience gives you confidence to try almost anything, knowing that success will fairly often be yours.

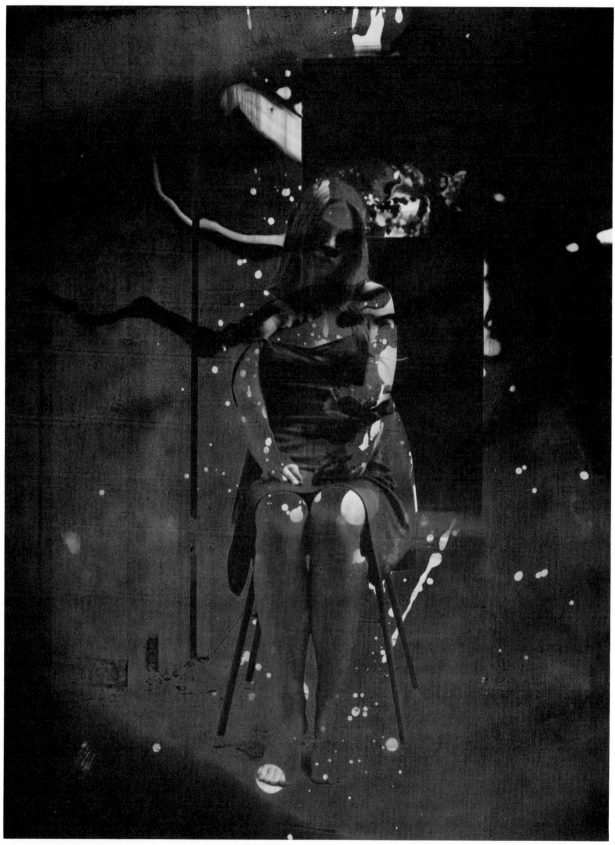

21—A partly developed print was splashed with fixer, reexposed, and allowed to "marinate" for a few minutes in the dark to achieve a one-of-a-kind image. I call the technique "slow burn."

Bibliography

History of Photography

Coke, Van Deren. *The Painter and the Photograph.* Albuquerque: University of New Mexico Press, 1971.

Doty, Robert, ed. *Photography in America.* New York: Random House, 1974.

Gernsheim, Helmut. *A Concise History of Photography.* New York: Grosset and Dunlap, 1965.

Goldsmith, Arthur. *The Nude in Photography.* New York: Ridge Press/Playboy Press, 1975.

Green, Jonathan, ed. *Camera Work: A Critical Anthology.* Millerton, N.Y.: Aperture, 1973.

Newhall, Beaumont. *The History of Photography from 1839 to the Present Day.* New York: Museum of Modern Art, 1964.

Pollack, Peter. *The Picture History of Photography.* New York: Abrams, 1970.

Szarkowski, John. *Looking at Photographs.* New York: Museum of Modern Art, 1973.

————. *The Photographer's Eye.* New York: Museum of Modern Art, 1966.

Thornton, Gene. *Masters of the Camera.* New York: Holt, Rinehart and Winston, 1975.

General Interest and Picture Books

Adams, Ansel. *Images 1923–1974.* Greenwich, Conn.: New York Graphic Society, 1974.

Brandt, Bill. *Perspective of Nudes.* New York: Amphoto, 1961.

Braun, Ernest, and David Cavagnaro. *Living Water.* Palo Alto, Calif.: American West, 1971.

————*Tideline.* New York: Viking Press, 1975.

Bullock, Wynn. *Wynn Bullock, Photographer: A Way of Life.* Millerton, N.Y.: Aperture, 1970.

Callahan, Harry. *Callahan.* New York: Museum of Modern Art, 1976.

Imogen Cunningham: Photographs. Seattle: University of Washington Press, 1970.

Dater, Judy, and Jack Welpott. *Women and Other Visions.* Dobbs Ferry, N.Y.: Morgan & Morgan, 1975.

William Eggleston's Guide. Introduction by John Szarkowski. New York: Museum of Modern Art, 1976.

Erwitt, Elliott. *Photographs and Anti-Photographs.* Greenwich, Conn.: New York Graphic Society, 1972.

Walker Evans. New York: Museum of Modern Art, 1971.

Gibson, Ralph. *Déjà-vu.* New York: Lustrum Press, 1973.

Emmet Gowin. New York: Alfred A. Knopf, 1976.

Green, Jonathan, ed. *The Snapshot.* Millerton, N.Y.: Aperture, 1974.

Haas, Ernst. *The Creation.* New York: Viking Press, 1971.

————. *In America.* New York: Viking Press, 1975.

Haas, Robert. *Muybridge: Man in Motion.* Berkeley, Calif.: University of California Press, 1975.

Lewis W. Hine. Text by Judith Mara Gutman. New York: Viking Press/Grossman Publishers, 1974.

Hurley, F. Jack. *Portrait of a Decade: Roy Stryker and the Development of Documentary Photography in the Thirties.* New York: Da Capo Press, 1977.

Art Kane: The Persuasive Image. Text by John Poppy. New York: Alskog/Thomas Y. Crowell, 1975.

Lange, Dorothea, and Paul Taylor. *An American Exodus.* Reprint. New Haven, Conn.: Yale University Press, 1969.

Clarence John Laughlin. Millerton, N.Y.: Aperture, 1973.

Lewis, Eleanor, ed. *Darkroom.* New York: Lustrum Press, 1976.

Liberman, Alexander. *The Artist in His Studio.* New York: Viking Press, 1974.

Lyons, Nathan, ed. *Photographers on Photography: A Critical Anthology.* Englewood Cliffs, N.J.: Prentice-Hall, 1966.

Maddow, Ben. *Edward Weston: Fifty Years.* Millerton, N.Y.: Aperture, 1974.

————. *Faces.* Boston: New York Graphic Society, 1977.

Duane Michals: The Photographic Illusion. Text by Ronald H. Bailey. New York: Alskog/Thomas Y. Crowell, 1975.

Michals, Duane. *Real Dreams.* Rochester, N.Y.: Light Impressions, 1977.

Newman, Arnold. *One Mind's Eye.* Boston: Godine, 1974.

Newton, Helmut. *White Women.* New York: Stonehill, 1976.

O'Neal, Hank. *A Vision Shared.* New York: St. Martins Press, 1976.

Owens, Bill. *Suburbia.* New York: Simon & Schuster, 1973.

————. *Our Kind of People.* New York: Simon & Schuster, 1975.

————. *Working: I Only Do It for the Money.* New York: Simon & Schuster, 1977.

Parks, Gordon. *Moments Without Proper Names.* New York: Viking Press, 1975.

Penn, Irving. *Worlds in a Small Room.* New York: Grossman Publishers, 1974.

Photography Year. New York: Time/Life Books, yearly.

Plowden, David. *Commonplace.* New York: E.P. Dutton, 1974.

Private Realities: Recent American Photographs. Greenwich, Conn.: New York Graphic Society, 1974.

Purcell, Rosamond W. *A Matter of Time.* Boston: Godine, 1975.

Scharf, Aaron. *Art and Photography.* Baltimore: Penguin Books, 1974.

Shahn, Ben. *The Photographic Eye of Ben Shahn.* Edited by Davis Pratt. Cambridge, Mass.: Harvard University Press, 1975.

Aaron Siskind. Rochester, N.Y.: George Eastman House, 1965.

J. Frederick Smith: Photographing Sensuality. Text by Sean Callahan. New York: Alskog/Thomas Y. Crowell, 1975.

Steichen, Edward. *A Life in Photography.* New York: Doubleday, 1963.

Paul Strand: A Retrospective Monograph. Millerton, N.Y.: Aperture, 1972.

Stryker, Roy, and Nancy Wood. *In This Proud Land.* Greenwich, Conn.: New York Graphic Society, 1973.

Tucker, Anne, ed. *The Woman's Eye.* New York: Alfred A. Knopf, 1973.

Uelsmann, Jerry. *Silver Meditations.* Dobbs Ferry, N.Y.: Morgan & Morgan, 1975.

Weston, Brett. *Voyage of the Eye.* Millerton, N.Y.: Aperture, 1975.

Weston, Edward. *The Daybooks of Edward Weston: Vol. 1 Mexico* (1961) and *Vol. 2 California* (1966). Edited by Nancy Newhall. Rochester, N.Y.: George Eastman House.

Winogrand, Garry. *Women Are Beautiful.* New York: Light Gallery/Farrar, Straus & Giroux, 1975.

Wolfe, Tom. *The Painted Word.* New York: Farrar, Straus & Giroux, 1975.

Technical

Cavallo, Robert M., and Stuart Kahan. *Photography: What's the Law?* New York: Crown Publishers, 1976.

Chernoff, George, and Hershel Sarbin. *Photography and the Law.* New York: Amphoto, 1977.

Craven, George M. *Object and Image.* Englewood Cliffs, N.J.: Prentice-Hall, 1975.

Creative Darkroom Techniques. Rochester, N.Y.: Eastman Kodak, 1973.

Hattersley, Ralph. *Discover Your Self Through Photography.* Dobbs Ferry, N.Y.: Morgan & Morgan, 1971.

Jacobs, Lou, Jr. *Photography Today.* Santa Monica, Calif.: Goodyear Publishing Co., 1976.

————. *How to Take Great Pictures with Your SLR.* Tucson, Ariz.: HP Books, 1978.

Life Library of Photography. New York: Time/Life Books, 1970.

Routh, Robert D. *Photographics.* Los Angeles: Petersen Publishing Co., 1976.

Periodicals

Camera 35. Popular Publications, 150 East 58th St., New York, N.Y. 10022.

Color Photography Annual. Ziff-Davis Publishing Co., 1 Park Avenue, New York, N.Y. 10016.

Modern Photography. ABC Leisure Magazines, 130 East 59th St., New York, N.Y. 10022.

Popular Photography. Ziff-Davis Publishing Co., 1 Park Avenue, New York, N.Y. 10016.

35mm Photography. Ziff-Davis Publishing Co., 1 Park Avenue, New York, N.Y. 10016.

Vestal's Dictionary of Photo-Obscenities

by David Vestal

Author's note: *This lively, perceptive, tongue-in-cheek dictionary appears as "dessert," courtesy of its creator, David Vestal, an outstanding writer on topics photographic. In his August 1978* Popular Photography *column, David paraphrased a short statement he had used with a small exhibit of his images in Seattle in 1975. I borrow those words as an introduction, because they echo so well the essential, valid simplicity of much expressive photography:*

"There are no hidden meanings in the pictures. I'm not trying to transcend anything. I am trying to pass on good seeing as strongly and directly as I can. Look at them for what they are, not for what they're not."

Reprinted by permission of the author.

A few years ago, even writers as *macho* as Hemingway used to say things like "Obscenity you, you obscenity" in novels.

Things have changed. Now everything, to use an elegant current phrase, hangs out. Anyone can and does say anything anywhere to anyone. Whoever doesn't like it is 1) timid, or 2) a no-good repressive fascist obscenity.

Photographers, however, are devious, and a long list of photographic four-letter words of various lengths have been appearing regularly in public print since time immemorial.

What's more, these resourceful devils keep adding to the list. Here are a few of the most common photo-obscenities with explicit definitions that unmask their true meanings for the first time.

As an added bonus, we identify all the standard terms used in the newly emerging and much-talked-about *critical vocabulary for photography*.

Agent: A nonproductive con man who sells photographs to commercial and editorial users. A pusher.

Ambience: (*critical vocabulary*) See *vibes.*

Ambiguity: (*crit. voc.*) The absence of clarity. The most sought-after and most easily available virtue in today's photography.

Archival: 1) In popular use, describes photographs processed so as to last for at least two weeks under optimum storage conditions. 2) As used by the U.S. Bureau of Standards, processed so as to last fifty years with luck.

Art: An exceptionally high level of photography shown in galleries and art museums. Recognizable in that, while viewers, art dealers, collectors, curators, and photographers are equally unable to tell what the pictures are or convey, all of them are mystically convinced of the high dollar value of these photographs. Critics alone know why.

Art dealer, photographic: A nonproductive con man who sells photographs of dubious value to museums and collectors.

Art director: In publishing, a combination shredder and disposal unit for photographs.

Art photographer: One who makes unrecognizable photographs.

ASA: A prefix for American film-speed numbers, established by roulette played in a laboratory according to strict rules.

ASMP: Formerly the American Society for the Prevention of Cruelty to Magazine Photographers. Now known as ASPIC.

Authority: 1) A person who pretends to know. 2) A person who thinks he knows. 3) The ability to induce in other people an irrational belief in one's illusory knowledge.

Autofocus: In high-priced enlargers, the quality of being ingeniously designed so as to be permanently slightly out of focus, so that prints need not be defocused manually to make them unsharp.

Automatic-exposure camera: A camera designed to give the correct exposure automatically without manipulation or thought by the photographer, whether that is the exposure that the picture requires or not.

Available: 1) With reference to light, dim. 2) As used by the photo industry, not obtainable at present.

Avant-garde: (*crit. voc.*) Conservative.

Bad taste: Calculated to give offense. Numerous popular modes of photography exploit this virtue to the limit.

BFA: Bachelor of Fine Arts. An MFA in the larval stage.

Cachet: (*crit. voc.*) Meaningless term used in articles by critics to lend tone and fill gaps.

Camera club: A highly competitive liars' club with a darkroom.

Camp: (*crit. voc.*) Quaint, obviously out of date. A quality cultivated by *avant-garde* photographers who wish to prove themselves ultramodern.

Cinema: (*crit. voc.*) Incomprehensible, repulsive movies made in Scandinavia, France, and Eastern Europe by professional cinematographers, and in the United States and Canada by undergraduates in art schools. See *film*.

Cliché: 1) A basically valid concept misused: the foundation of photography as we know it. 2) Pejorative term used by critics for pictures they cannot grasp.

Collection: A high-priced trash heap.

Collector: A mark or sucker.

Combination print: Two or more incomplete photographs ingeniously combined to make an incomplete whole.

Communications: (*crit. voc.*) The art and the industry of broadcasting or otherwise distributing incomprehensible vital information, largely in photographic form. Synonym, *mass media.*

Composition: 1) Beaverboard. 2) The art of combining the visual elements of a picture within its boundaries so as to obtain a boring result.

Conceptual photography: (*crit. voc.*) 1) Pictures that the photographer talks about but does not make. 2) Photographs with invisible merit.

Conscience: In a photographer, an agent, or a client, a sharpened business sense.

Conservation: The market for color photos of pond scum. See *ecology.*

Content: The identities or labels of things shown in pictures, considered separately from the forms without which they cannot be seen, let alone recognized.

Controversy: A sham battle for publicity purposes.

Correct: As recommended by a photo manufacturer, regardless of photographic quality.

Creation: (*crit. voc.*) The mystical process or activity which produces hack work.

Creative: (*crit. voc.*) Conventional in a salable way; suitable for framing.

Critic: An arbiter of fashion.

Critical vocabulary: 1) Forked tongue. 2) Language conveying minimum meaning in maximum syllables. 3) Commercial jargon in the art business.

Cropping: The art of bleeding photographs to death by amputating vital areas. A prerogative of art directors.

Curator of photography: A janitor in an art museum.

Custom lab: A high-priced drugstore with no prescription counter.

Decisive moment: (*crit. voc.*) That moment when the things in front of a photographer's camera most resemble a picture by Henri Cartier-Bresson. Synonym used in camera clubs, *moment of truth.*

Delicate: In print tones, muddy.

Design: Composition made worse by self-consciousness.

Dialog: (*crit. voc.*) A monolog by a photographer or a critic.

Dig: To misunderstand.

Distortion: 1) The way we normally see. 2) The way a normal photograph shows its subject. 3) An attempt to make things look unlike themselves by showing them as they ordinarily appear.

Double truck: For a published photograph, death by bisection. A martyrdom much desired by photojournalists. The highest achievement of the art director's profession. Synonym, *two-page spread.*

Dynamic: (*crit. voc.*) Flaccid.

Dynamic symmetry: (*crit. voc.*) A rote method for making static, slightly off-center photographs, devised and promoted by one Hambidge.

Ecology: 1) In photography, showing factory chimneys and smoke through long lenses and pond scum in natural or infrared color through macro lenses. 2) In sociology, the study of how photographers devour one another.

Ego: 1) The irresistible force that impels photographers to inflict their theories and grievances on an unprepared world. 2) The immovable obstacle in each photographer's personality that prevents his or her pictures from working.

Empirical: An inferior way to get technical information. Instead of reading the literature as God intended, the benighted empiricist tries out photographic processes, materials, and so on under normal working conditions and sees what happens. The photo industry strongly disapproves of empiricism because it sometimes leads to findings that do not agree with that industry's correct information as carefully published and recommended.

Epiphany: (*crit. voc.*) 1) A sudden glorious insight. 2) A fuzzy picture by a friend of a critic.

Equivalent: (*crit. voc.*) A dull photo by Stieglitz or a member of his posthumous cult.

Essence: (*crit. voc.*) 1) Any incidental aspect of a photograph. 2) French for gasoline.

Establishment: (*crit. voc.*) 1) Us (complimentary). 2) Them (pejorative).

Esoteric: (*crit. voc.*) In artistic photography, difficult to grasp because devoid of meaning.

Exception that proves the rule, the: (*crit. voc.*) 1) The normal course of events. 2) Any anomaly.

Film: 1) The light-sensitive sheet plastic on which we take photographs. 2) Poorly made movies. Synonym, *cinema.*

Film festival: A symposium held in Italy, Bulgaria, or California at which incomprehensible movies are shown, interminably discussed, and awarded prizes for incompetence. See *symposium.*

Fine photographs: (*crit. voc.*) Overpriced photographs in a gallery, a museum, or a collection.

Fine prints: (*crit. voc.*) Black-and-white prints exhibiting full scale of tones from paper white to saturated black, but little or nothing else. Found in galleries.

Fisheye lens: An expensive, conspicuous lens of short focal length, so named because it shows things in a perspective similar to that seen by a normal human eye.

Form: (*crit. voc.*) Shape as separated from substance and meaning.

Gallery: 1) A center of culture and enlightenment. 2) A butcher's counter where both fresh-killed and long-dead photographs are offered for sale.

Genius: (*crit. voc.*) 1) Salesmanship. 2) An especially able salesman. 3) A dead photographer.

Good taste: A cardinal virtue: the art of achieving blandness while avoiding definiteness.

Great: (*crit. voc.*) 1) Mediocre. 2) Dead.

Guru: A photography instructor with a good line of double-talk and a gift for publicity. Often, but not always, bearded. Ability is neither rigidly excluded nor normally present.

High-key: In a print, underexposed.

Hungary: Photography's true country of origin.

Hunger: The normal healthy condition of an accomplished photographer who lacks genius. See *genius.*

Image: (*crit. voc.*) 1) Any recognizable mark made by light on photo film or paper. 2) Any unrecognizable marks made by an art photographer. 3) Any overrated photograph.

Immortal: Dead.

Impact: (*crit. voc.*) A mild decorative quality found in conventional photographs. See *shock.*

In: (*crit. voc.*) About to be out. See *out.*

Innovator: (*crit. voc.*) A photographer who imitates fashions not less than fifty years old.

Je ne sais quoi: (*crit. voc.*) Out of focus.

Kitsch: (*crit. voc.*) A much-sought-after virtue in art photography: that of naive sentimentality carried to a nauseating extreme.

Low key: 1) Dark. Synonym, *profound.* 2) Norse god of mischief.

Mass media: The publishing and broadcasting markets to whose money the intelligent photographer aspires while he rightly deplores their crudity and irresponsibility. The foundation of our culture.

Meaning: An elusive, unknown factor in photographs and explanations of photographs. Like the math concept of the square root of minus one, it's much talked about but seldom seen in life.

Meaningful: Meaningless. In agreement with the opinions of the speaker. Portentously trivial. See *relevant.*

Medium: (*crit. voc.*) A message blank.

Message: Propaganda. See *social realism.*

MFA: Master of Fine Arts. In photography, a very young college instructor with whiskers (male or female).

Mixed media: (*crit. voc.*) Occupational therapy.

Moment of truth: The decisive moment (camera-club version).

Montage: (*crit. voc.*) Obsolete term for combination printing.

Multiple printing: Combination printing in an aggravated form.

Museum: Graveyard for dead pictures.

Naiveté: (*crit. voc.*) A mystical state to which photographers of the utmost sophistication aspire. See *snapshot aesthetic.*

Narcissism: The underlying purpose of contemporary photography.

Natural color: In photography, any combination of three synthetic dyes.

Normal: 1) Correct. 2) Habitual. 3) Optimum. These meanings are mutually exclusive.

Normal lens: A lens of intermediate focal length that shows things out of context and out of proportion. It is said to show things as the eye sees them, but does not.

Nude: 1) Epicenely naked. 2) Pornographically, or more usually, pseudopornographically naked. 3) Artistic photo in which a person with no clothes on is shown as a thing. Includes 1) and 2).

Obscene: Accurate or complete.

Oeuvre: (*crit. voc.*) Body of work by a high-priced photographer.

Optics: Vulgar usage for lenses.

Originality: (*crit. voc.*) A daring degree of conformity, typically within an "in" group.

Out: (*crit. voc.*) 1) The highest possible degree of being in fashion. 2) Out of fashion. Both meanings coincide: "It's In to be Out."

Paparazzi: American free-lance photographers in Italy, invented by Federico Fellini. Recognizable by their Vespas and shades.

Photogenic: A much-desired quality in subjects, which must be both too much photographed and extremely dull. A photogenic subject thus outranks a mere cliché. See *cliché.*

Photographer: A paranoid with a camera. A technological voyeur.

Photographic archive: A dusty attic or damp cellar filled with disused and damaged photographs of dubious value.

Photography: 1) A much-abused medium. 2) A treacherous and misleading profession.

Photography critic: 1) A blind person who writes with authority about politics, philosophy, and trends in fashion. 2) A publicity man.

Photojournalism: An extinct art form that flourished during the late Pleistocene. People with cameras staged events (such as men biting dogs or presenting checks to other men) and photographed them for publication in picture magazines. Photojournalism was fearlessly concerned with *truth,* which overrides mere fact. It has been replaced by TV.

Photo-sculpture: (*crit. voc.*) A mixed medium.

Picture editor: A file clerk.

Picture magazine: A periodical which presented full-color ads promoting many commodities for the good of the public. Unsold space was bridged with photojournalistic pictures, captions, editorials praising the magazine, and, similar filler material. Now extinct. See *photojournalism.*

Plangent: (*crit. voc.*) Poetic word meaning noisy (signifies approval).

Pornography: (*crit. voc.*) Photography which is sexually explicit without being interesting.

Post office: An indispensable government service for destroying and losing photographs in transit.

Professional: Consistently mediocre. Differs from a top pro by being in business.

Profound: (*crit. voc.*) Dark.

Pseudopornography: The most fashionable form of pornography. Photography which pretends to be sexually explicit, but is not, while remaining dull.

Publishing: The habitat of the art director and the picture editor. A way of destroying pictures by using them. There are two schools of thought: that a photograph only begins to exist when published; and that it survives only until published. Both views are equally true.

Purism: (*crit. voc.*) A school of thought in photography consisting of a firm policy of rejecting, as a matter of principle, everything that the photographs need in order to work.

Raison d'etre: (*crit. voc.*) Any excuse.

Relevant: (*crit. voc.*) Abjectly fashionable.

Revolutionary: (*crit. voc.*) 1) Commercial. 2) Noisily conservative.

Self-expression: (*crit. voc.*) The purest and noblest motivation for photography. Made difficult by the fact that the selves of photographers are the most boring subjects on earth. See *narcissism*.

Sequence: (*crit. voc.*) A series of weak photographs assembled so as to add up to a weak whole. The advantage over combination printing is that a sequence occupies more page space or wall space, thwarting competition. Devotees of the sequence hold that single pictures are not legitimate and can have no value. In terms of their own work, they are mostly right.

Serendipity: (*crit. voc.*) In photography, an unfortunate accidental discovery. Opening a can of worms.

Shock: Describes the soothing effect of advertising photographs that show their subjects with a neat combination of aggression and decorative blandness. See *impact*.

Shutter: A perfidious invention that admits light into a camera and wastes film.

Single picture: (*crit. voc.*) A weak photograph used by itself, not as part of a sequence. Devotees of the single picture hold that sequences are neither legitimate nor valid. They are mostly right.

Snapshot aesthetic: (*crit. voc.*) The carefully cultivated art of photographing poorly on purpose.

Social realism: (*crit. voc.*) A harmless popular form of fantasy in which photographers compete to make ordinary subjects seem more depressing than they are. By doing so, they improve living conditions for all mankind.

Soup: Developer.

SPE: Society for Photographic Education. A non-profit talkathon.

Spirit: (*crit. voc.*) 1) The inner essence of a dull photographer. 2) The inner essence of a dull picture. 3) Alcohol.

Strobe: Misnomer for electronic-flash illumination — one of the many forms of available light.

Subtle: (*crit. voc.*) 1) Weak. 2) Muddy in tone. See *delicate*.

Surreal: (*crit. voc.*) In the manner of a Hollywood dream sequence.

Symbolism: (*crit. voc.*) Much-appreciated mode of photography in which a subject is supposed to be something other than it is. Symbolist photographers draw much inspiration from two great symbol-minded masters, Walt Disney and Ingmar Bergman (who, though this has been kept secret for many years, are one and the same).

Symposium: (*crit. voc.*) In photography, a gladiatorial combat or battle royal among a number of assembled egos. Deadly weapons are used: slide shows and speeches at point-blank range.

Talk: The primary activity of photographers.

Telephoto lens: A lens of inverted retrofocus design and long effective focal length that shows things out of context and out of proportion.

Temperamental: Bad-tempered. See *genius*.

Top pro: Any unknown photographer.

Truth: (capital T) My opinion, as distinguished from yours. The triumph of Truth over fact is photography's noblest aim. See *self-expression*.

TV: Television. The highest and most socially useful form of photography, and the one used with the greatest wisdom and responsibility, according to experts from the TV industry. A universal educational forum to inform the public of the truth about many brands of detergent, floor wax, and laxatives. Successor to the picture magazine.

Ultramodern: Out of date, passé.

Vibes: (*crit. voc.*) See *ambience.*

Viewers: Victims.

Visual literacy: (*crit. voc.*) A phrase that identifies its user as neither literate nor visual. The fallacy of thinking of an immediate, direct, all-at-once medium as if it were linear and indirect.

Wide-angle lens: A lens of short focal length that shows things out of proportion and in an excess of context.

With it: (*crit. voc.*) Exhibiting extreme, abject conformity.

Women: (*crit. voc.*) 1) Innocent female sex objects cynically exploited by dirty, chauvinistic male photographers. 2) Photographers of feminine gender and masculine character — an emerging breed.

Workshop: (*crit. voc.*) A short-term photography school on a farm operated by a guru or gurus. The principal photographic activities are prayer, fasting, calisthenics, meditation, and carrot juice.

Young photographer: (*crit. voc.*) Any photographer of any age who is published or exhibited before dying.

Zen: (*crit. voc.*) 1) An Oriental religious philosophy notable for a blunt directness and lack of ceremony in which it resembles unconfused photography. Hence 2) A direction in American art photography notable for being ceremonious, literary, indirect, ambiguous, and obscure. Incense is burned, gongs are whanged, and saffron robes are considered essential.

Index

A

Abstracting, 154
Adams, Ansel, 164
Advertising photographs, 13
Atget, Eugene, 34, 59, 63

B

Blur, 149, 150, 151, 152, 153, 154
Brady, Matthew, 29, 39, 122
Brandt, Bill, 190, 193
Braque, Georges, 154
Braun, Ernest, 105, 214
Bullock, Wynn, 16, 105, 116, 171, 190, 235

C

Callahan, Harry, 94, 102, 103, 105, 119, 160, 161
Cameras, 42
 larger format, 44
 motorized, 179–182
 Polaroid, 47, 109, 110, 155
 rangefinder, 44
 SLR (single-lens reflex), 42
 35mm, 42
 view cameras, 44, 92, 102, 105, 108, 206
Carroll, Tom, 63, 139
Cartier-Bresson, Henri, 83, 84, 99, 132
Closeups, 116, 157
Communication, 139
Cunningham, Imogen, 105, 190

D

Daguerreotype, 29
Darkroom equipment, 53
Darkroom, use of, 227–247
Depth of field, 117
Duchamps, Marcel, 143

E

Eastman, George, 29, 39
Eggleston, William, 83

Exposure
 multiple, 7, 22, 223–226
 slow, 148, 149–151
 time, 97
Exposure meter, 52
Evans, Walker, 16, 105, 124, 136

F

Fantasy, definition, 159, 161
Farm Security Administration (FSA), 15, 16, 121, 124, 125, 140
Feininger, Andreas, 88
Films
 color, 48, 50, 61–63
 black and white, 48, 50, 61–63
Film developing, 48
Filters, 52, 63, 145, 151
Flash, electronic, 53, 126, 204
Floodlights, 53
Friedlander, Lee, 173, 177

G

Gibson, Ralph, 171
Goldsmith, Arthur, 190, 193
Gowin, Emmet, 168, 169, 177
Green, Jonathan, 66

H

Haas, Ernst, 105
Halsman, Philippe, 217
Hine, Lewis, 34, 39, 121, 122, 123, 125
Hopper, Edward, 92, 93

J

Jackson, William Henry, 29, 39

K

Kane, Art, 226–227
Kouwenhoven, John A., 66
Krims, Les, 171

L

Lange, Dorothea, 125
Laughlin, Clarence John, 106, 119, 154
Legal aspects of photography, 131
Lenses, types of, 47–48, 50
 closeup, 53, 116–117
 illusions with, 145–149
 telephoto, 47, 88
 wide-angle, 47, 89, 94, 139, 146, 210
 zoom, 47, 84, 112, 153

M

Mackie line, 241
Martin, Derald, 190, 198–199, 201
Metaphor, visual, 164
Michals, Duane, 161, 177, 182, 199, 210, 212, 235
Miljakovich, Helen, 19, 66, 208, 209
Models, for photography, 188, 193, 197, 199–201
Model, Lisette, 66, 68
Modern Photography, 81
Monet, Claude, 166, 167
Mondrian, Piet, 59, 93, 94, 99
Multiple images
 collection of displayed, 222
 in camera, 223–226
 in darkroom, 227–235
 sandwiching slides, 226–227
Muybridge, Eadweard, 179

N

Newman, Arnold, 41, 206
News photography, 15, 18
Newton, Helmut, 171, 197

O

Obscurity, visual, 173, 175, 182–185
Owens, Bill, 65, 126, 127, 140

P

Papageorge, Tod, 66
Porter, Eliot, 106
Portraits
 environmental, 208–210
 interpretative, 204–209
 likeness, 203–204
 story, 210
 self-, 217–221
Postcard photographs, 13
Posterization, 244–247
Presentation, prints and slides, 53–55
printing, black and white, 50
Product photographs, 13

R

Ray, Man, 34, 59, 92, 235–236
Raymond, Lilo, 143
Reflections, photography of, 143–144, 220–221
Rejlander, Oscar, 30, 39
Reticulation, 243
Reportage, 132
Robinson, Henry Peach, 32
Rothstein, Arthur, 125
Routh, Robert, 4, 41, 74, 247
Riis, Jacob, 34, 121, 122

S

Sandwiching slides, 226–227
Sabattier effect, 239–241, 248
Serendipity, 12, 175
Siskind, Aaron, 106, 107, 154
Smith, J. Fred, 190
Snapshot, 11, 65–81
 imitation, defined, 65, 66
 pro and con, 74
 style, 73
Sports, sequence photography of, 179–180
Steichen, Edward, 34, 217
Stieglitz, Alfred, 34, 164
Still life, 115
Strand, Paul, 39, 94, 102, 105
Stryker, Roy, 15, 121
Szarkowski, John 159, 161, 166, 173, 177

T

Titles for photographs, 169
Tripod, use of, 50

U

Uelsmann, Jerry, 161, 248
 techniques of, 232–235

W

Weston, Brett, 154
Weston, Edward, 16, 32, 39, 102, 105, 119, 164, 190, 192, 193
White, Minor, 154, 164, 166, 177
Winogrand, Garry, 83, 99
Wolfe, Tom, 73–74